weelicious
LUNCHES

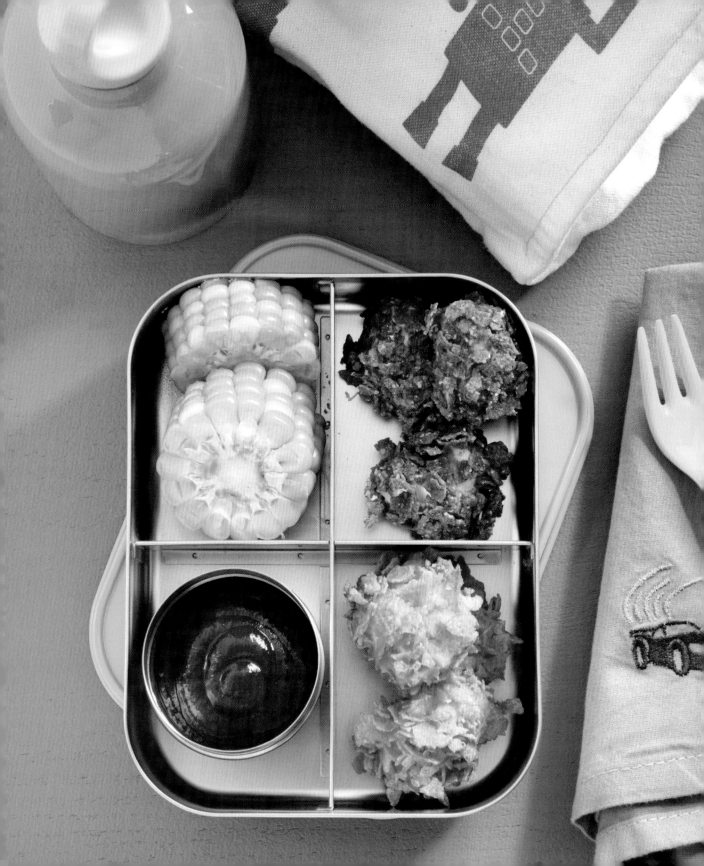

weelicious
LUNCHES

THINK OUTSIDE THE LUNCH BOX
WITH MORE THAN 160 HAPPIER MEALS

Catherine McCord

WILLIAM MORROW
An Imprint of HarperCollinsPublishers

Also by Catherine McCord

Weelicious: One Family. One Meal

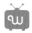

When you see this icon next to a recipe, check out weeliciousbook.com/ extras for step-by-step cooking videos with Catherine!

The photographs on pages 128, 129, 135, 190, 219, 269, and 298 were taken by Catherine McCord.

HarperCollins books may be purchased for educational, business, or sales promotional use. For information please e-mail the Special Markets Department at SPsales@harpercollins. com.

FIRST EDITION

Designed by Kris Tobiassen / Matchbook Digital

Library of Congress Cataloging-in-Publication Data

McCord, Catherine.
 Weelicious lunches : think outside the lunch box with more than 160 happier meals / Catherine McCord. — First edition.
 pages cm
 Includes index.
 ISBN 978-0-06-207845-2 (hardback)

 1. Lunchbox cooking. 2. Children—Nutrition. I. Title.
 TX735.M44 2013

 641.5'3—dc23

 2013015379

16 17 18 19 20 SCP 10 9 8 7 6 5 4

To all the lunch ladies from my childhood,
thank you for always allowing me to hang out and
watch you. You were among my
greatest teachers.

contents

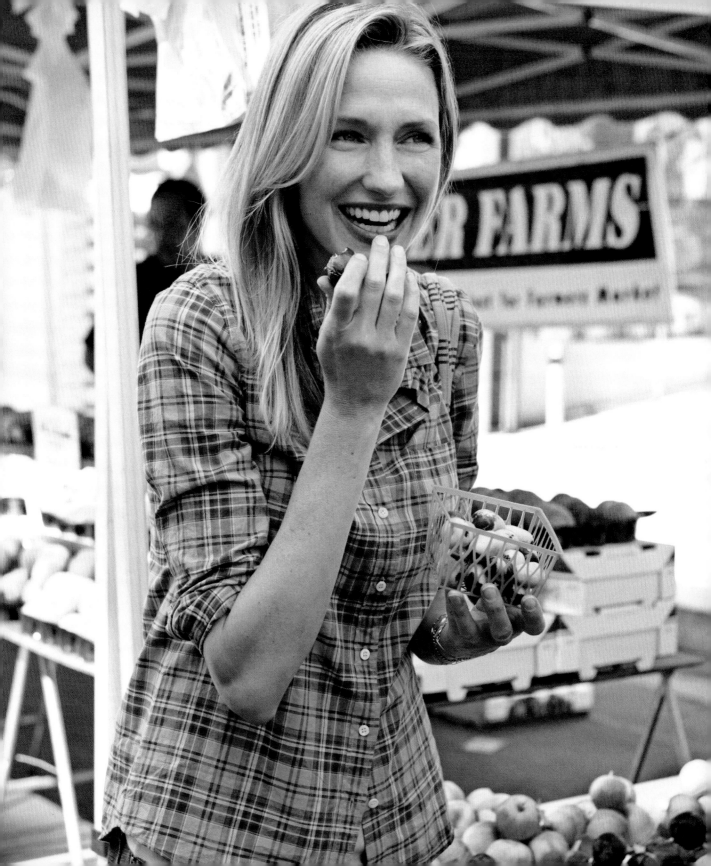

thinking outside the lunch box

I used to wake up in sheer panic every morning thinking about what to make for lunch.

In time I learned a few things.

It's not always about recipes.

It's about using what you already have in your refrigerator and pantry.

And being creative.

It's cooking outside the box.

Or as I like to say, cooking outside the lunch box.

I remember my son Kenya's first day of preschool as if it were yesterday. I was so excited by (and nervous about) the prospect of watching my little baby enter a completely new environment where every day, among other things, he'd be seated at a long table with other little kids, all (hopefully) eating food packed with care by their parents. Then it hit me—what exactly should I pack for him? Those same old nerves I had from his infancy—wondering what baby food purees I should offer him and nervously anticipating his reaction to every new flavor and texture—were coming back to roost. Figuring out how to continue to inspire him to be a great eater during school lunch—the one meal where I wouldn't be there to accompany, model, and encourage him—was feeling like a daunting new challenge.

Was I unwittingly setting up my son to be that kid who trades his entire lunch for a single prepackaged cookie? Would he eat his dessert before even trying the more nutritious food I had so lovingly prepared? Was it realistic to believe I could offer him something different every day and not get stuck in the PB&J rut, so that he'd stay excited about food?

At the same time I was wrestling with all of these questions, I had a newborn at home in addition to my extremely active two-and-a-half-year-old. I was also working full time. It's not as if I had hours in my day to strategize about how to make the perfect lunch. Whatever I was going to

send him to school with every day needed to be fast and easy enough for me to make while contending with two screaming kids in the kitchen. I also wanted what I made to be interesting enough that my son would want to sit and eat it of his own volition and not get distracted by what his classmates were eating or the desire to go out and play.

In those first few weeks of Kenya's preschool, I got to stay with him as he ate and watch as all of the other kids opened their lunch boxes. What I saw almost made my eyes pop out of my head. Why was there so much white food? White bread, white cheese puffs, *peeled* apples? Are we parents so afraid that our kids won't eat the food we make that we either just toss in junk or remove nutrients because it's easier? Some of the most interesting things I heard in those first few days of school were from my son's teachers, who were equally frustrated. This was apparently a common sight for them, and they told me it was difficult for them to watch every day as these tiny kids sat eating empty-calorie food, insufficient to keep their bodies *and* minds working at their full potential.

And then there were the containers. Kids spent so much time struggling to open (and often losing) all their different containers and plastic bags that they really only ate one or two of the foods their parents had packed them. With less than fifteen minutes scheduled for lunch at some schools, kids often never find or make it to the fruit or vegetable at the bottom of the paper sack—assuming there was one there to begin with.

I spent the next few years on a lunch mission. I tried to figure out what makes the "perfect" lunch and how to make sure that a kid's lunch box comes home empty every day. It took me some time but I finally developed an abundance of recipes, strategies, tips, and ideas to master the midday meal. I hope that in the following pages you'll find a bit of inspiration to get out of the day-in, day-out lunchtime blues!

PART I

SCHOOL LUNCH SOLUTIONS

whole grain fruit-filled bars (page 249)

strawberry-cream cheese "sushi" rolls (page 111)

engaging all the senses

I'm guessing that if you bought this book you're probably just hoping for a few new simple school lunch ideas and reliable recipes that your kids will love. If so, you're in luck. That's the main reason I wrote it.

However, my other reason for writing this book was born of necessity. I've found that lunch can cause us parents all sorts of anxiety, since it's usually the one meal of the day we moms and dads *aren't* present for, and even if we're lucky enough to have packed our little ones off to school well, we know (or fear) that once we aren't around, they're subject to all sorts of outside influences, both real and imagined. While we've all heard a horror story about the kid with a Big Mac in his lunch sack or watched with disbelief as Congress passed a bill that equates the nutritional value of pizza sauce with that of a serving of vegetables, more often than not we moms and dads are competing with basic *lunch box envy*, a fear that when the lunch bell rings and the lids are raised on our child's lunch box and those of her friends, *everything* will be more appealing to our little one than the food we sent with her.

The blow of your kid telling you that Max's mom packs the best lunches can be hard enough on a parent's ego, but even if you're evolved enough emotionally to get beyond that kind of rejection (*I'm* definitely not, but maybe you are), deciding what should go into your child's lunch box can be daunting simply on a pure *I just don't want my kid eating crap* level—especially if you're already working your darnedest to set good examples for him. It's easy to feel as if you're fighting an unwinnable battle when your kid's peers bring to school things like Pepperidge Farm Goldfish, Jell-O, and, worst of all in my opinion, Snackables, but I urge you to let go of those fears. If you get caught up in that type of thinking, you're bound to make yourself crazy. All you can do is focus on sending your kids to school with *the best lunches you're capable of* and trust all the research that supports that consistently modeling good examples for your children, both inside your home and out, will pay off with huge dividends in the long run.

That being said, instant success *is possible*. There are ways to stack the deck in your favor, and in many cases have the other kids envious of what's in *your* kid's lunch box. To paraphrase a Kurt Vonnegut quote my husband loves, *good will triumph over evil, if the angels are as organized as the mafia*, and I think it applies here. Getting our kids to want to eat good food requires us parents to be just as clever as those marketers who peddle the stuff our kids (and we for that matter) shouldn't be eating regularly, and I am telling you *it can be done*. I've found this to be true with my own kids and those of so many weelicious readers, and crafting great lunches takes no more time and effort than what you're used to packing.

Still, I've found that when it comes to getting your child to *want* to eat the food you've prepared, it goes way beyond novelty or a clever name for a recipe. A great deal of what goes into creating the perfect lunch has as much to do with how it looks and smells as how it tastes. If you want to raise great eaters, you need to appeal to *all* your child's senses. Sometimes half the battle of making sure your kids eat at school is ensuring that what's *inside* their lunch box is as stimulating as everything you can be sure is going on come lunchtime *outside* of it. Sure, a peanut butter and jelly sandwich is perfectly fine (and is a timeworn favorite of mine), but it's not a sandwich known for its instant eye appeal. However, transform it into something like World's Greatest PB&J (page 164) or Peanut Butter Pancake Sandwiches (page 154), and all of a sudden your kid is going to be happily focusing on what you made rather than what

her friend Amelia has. From how unique food looks and smells, to the ease with which your child can hold it, full sensory engagement at the lunchtime experience is key, and again I promise you, it doesn't require a culinary degree.

Some Sensory Guidelines

When choosing the foods that go into a balanced lunch, consider the following things:

1. **Taste:** Yes, this is an obvious one, but if something doesn't taste good, you'll be lucky if your kid takes one bite. Even bland foods can be given some added zip with a shake of herbed seasoning or a squirt of honey for sweetness as in Roasted Honey Cinnamon Chickpeas (page 244), Toasted Pepitas and Sunflower Seeds (page 263), and Roasted Carrot Coins (page 201).

2. **Sight:** Next to taste, this is the biggest one for me (not to mention my kids). How does your child's lunch look all packed up? Think about his immediate reaction when he takes the lid off—do you think he'll be engaged? Are you using brightly colored fruits and vegetables? How is everything cut? I've seen children (my own, in fact) repeatedly pass on a square-shaped sandwich they are sent off to school with, yet devour the same sandwich when cut into a heart or another eye-catching shape using a cookie cutter.

3. **Touch:** This sense too often gets overlooked, yet it can make a big difference as to whether

what you pack is consumed or not. Make sure lunch items are easy for little fingers to pick up and little hands to hold on to and aren't too big for your child to put into her mouth effortlessly. When foods appear too challenging to negotiate, kids may give up without a try. Same goes for the consistency of food. Be sure not to put, say, a sandwich right next to sliced fruit. An item that can become even the tiniest bit soggy between drop-off and lunchtime will not have much allure when the lunch bell rings.

4. Smell: If you pack salmon or egg in your child's lunch box, you might consider enclosing it separately in a covered container so as to not have its scent and/or flavor permeating other foods. Trust me, fruit salad never comes home "all gone" when it smells like fish!

5. Sound: I'm not suggesting that you make musical food, but sound can be just as important as the other senses when it comes to eating. What is the texture of what you're packing? Is it crunchy or chewy or silky smooth, and what appeals to your child? Many kids need the full sensory experience to get them interested in eating. For example, the child who doesn't enjoy plain yogurt might adore it topped with a handful of crunchy granola (just be sure to pack it separately—see "Touch," left). The same goes for something like chicken, which sliced on its own may seem boring to kids, but baked as Crispy Chicken Bites (page 182) and allowed to cool fully before packing (to preserve that crispy exterior), it becomes a whole different story. Serve them with a flavorful dip or organic ketchup and you have a dish that's engaging every one of your child's senses!

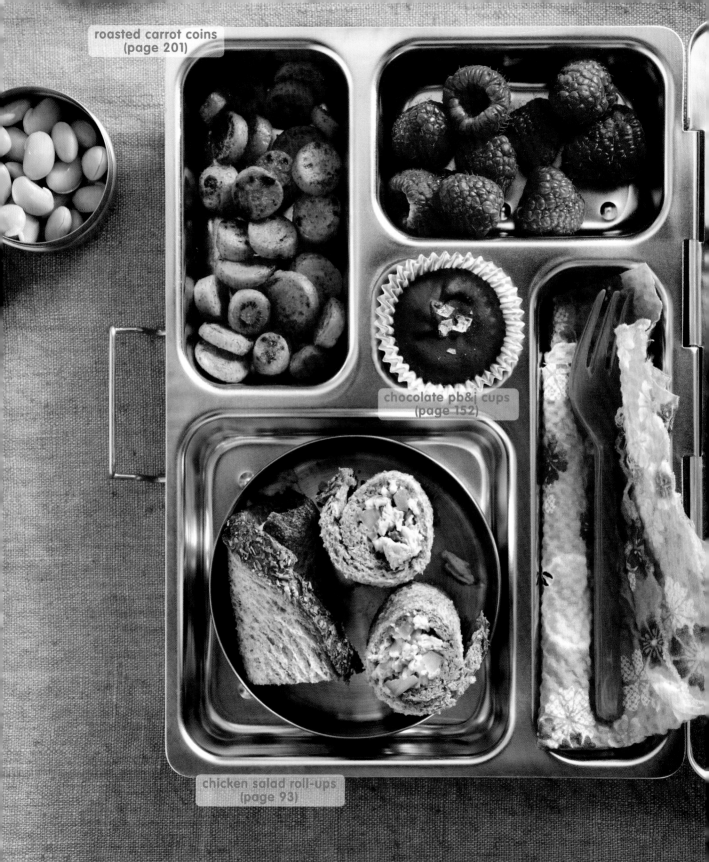

roasted carrot coins
(page 201)

chocolate pb&j cups
(page 152)

chicken salad roll-ups
(page 93)

the principles of the perfect lunch

If I preach about anything, it's the importance of balance in the lunch box. Too much of anything isn't good. It's the same way I feel about life. A little bit of this and a little bit of that can help keep you centered—and hopefully happy and focused as well. When it comes to what goes into making the "perfect" school lunch, balance is key. Put a fruit, vegetable, protein, and carbohydrate into your child's lunch box every day, and you've done your job. If we parents can focus on consistently providing our kids with nutritious foods and getting them excited about eating them, time will do the rest of the work. You can't ask for much more.

Fruit Ideas and Tips

No matter what else I send my kids to school with, the fruit *always* disappears. I'm a big fan of buying fruit in season, so every few months my kids are revisited by old favorites they haven't eaten in a year. Aside from tasting better than their counterparts flown in out of season from thousands of miles away, buying in season is good for the environment, and if you buy local, it helps support your local economy.

View Mother Nature as your best friend when it comes to keeping your lunch rotation fresh, rather than boring and repetitive. Look forward to apples, pears, pomegranates, and oranges in the fall and winter and apricots and blueberries in spring. Even if your child only loves strawberries, in January they won't be as fresh and delicious and nutritious as those grown during the summer, and they'll generally be grown far outside the United States and sprayed with chemicals. Furthermore, a variety of colorful fruits in lunch not only brightens up the meal and gives you that much needed visual appeal (see "Sight," page 6), but also adds a ton of valuable nutrients to your child's meal.

Instead of sliced melon (which is perfectly fine, by the way!), use a baller to make fun, bite-size melon balls.

Add two fruits to your child's lunch instead of just one to give your lunch box layout even more eye appeal. Never underestimate how seductive a colorful lunch can be to kids.

Regional differences in climate obviously mean that the seasons can feel very different depending on where you live, but you can find out what fruits and vegetables are in season when and what's available near you by visiting www.epicurious.com/articlesguides/seasonalcooking/farmtotable/seasonalingredientmap or http://cuesa.org/page/seasonal-foods

Buy fruit in small batches so you can change things up every few days and you're not just sending an apple a day, *every day* (I promise the doctor won't be offended and will likely be even happier with you for offering a wide array of fruits!).

Be brave and buy a fruit your kids have never tried before. Years ago I put dragon fruit in Kenya's lunch and it made him the most popular kid in class on account of the color (it's purple), novelty, and name (I mean, could kids get more excited about dragons?). I buy it all the time now—at both of my kids' insistence—and am guaranteed to always have at least one mom come up to me the next day saying that their child came home talking about wanting to get the purple fruit from Kenya's or Chloe's lunch.

Vegetable Ideas and Tips

Before you tell me your kids hate all vegetables and ask why you should waste your time packing them in your child's lunch box if they're not going to be eaten, I have a few suggestions for you:

Simply changing the shape of a vegetable can shift the way your child perceives it. Try cutting it into sticks, coins (my kids love the concept of edible "coins"), batons, or whatever else strikes your fancy. It makes it look a bit different from what they are accustomed to and can go a long way toward taking the stigma off of many a veggie.

Much to my surprise, I've found that most kids love raw vegetables, especially if you include a flavorful dip alongside them. But if you have kids who don't, roasting and steaming are great ways to transform the texture, flavor, and appearance of veggies kids may be averse to.

Let your kids use a shaker! I keep shakers of sesame seeds and Gomasio and various salt-free seasonings, such as Spike, in my spice drawer to transform ho-hum steamed broccoli into something really special. I find the easy action of allowing kids to "personalize" their food and become an active participant in the preparation of their meal gets them to buy in and eat it.

Instead of reaching for the salt shaker to enhance the flavor of food, I'm a big fan of Bragg's Liquid Aminos. You can find it at most groceries and health food stores, and it comes in a spray (a fun mealtime prop and great for fine motor skills) and a squirt bottle. It tastes just like soy sauce, but is a certified non-GMO liquid protein concentrate that contains sixteen amino acids—and it's gluten-free!

Dip, dip, dip! When you add a nutrient-rich dip next to a serving of veggies, everything changes. It becomes an interactive experience for kids and one that most totally love.

Let your kids decide. Take them to the grocery store or farmers' market, let them choose any

three vegetables they want, and put them into the mealtime rotation. Sometimes their choice may surprise you.

Don't throw away the pickle juice! This is one of my *favorite* veggie tips. Add cut up raw cucumbers, carrots, radishes, and/or cauliflower to what juice remains in the jar from your store-bought pickles. It adds a ton more flavor and novelty to veggies.

Protein Ideas and Tips

Protein is one of the body's main building blocks for muscle, bone, and skin, and it gives kids plenty of stamina and energy. Making sure your child's lunch contains a protein doesn't mean you have to provide him with a big slab of beef. In fact, I would say that eight out of ten lunches I make for my kids contain no meat at all. Simply figure out which foods that your child enjoys fall under the category.

Chicken, canned tuna (albacore and skipjack only, for lowest mercury content), and nitrate-free turkey and ham are staples in my kitchen and can be used in everything from paninis to pastas to salads. For kids who like to eat with their hands, cubes of turkey and ham can be fun, or pop them on Sandwich on a Stick (page 129).

Cheese is a great source of protein to keep on hand. A few of my favorites are cottage cheese, Cheddar, Babybel, and mozzarella.

Yogurt can be served with granola, fruit, or on its own for a protein that feels more like dessert than the main course of a meal, which kids of course love. I generally use plain Greek yogurt because it has more protein and less sugar.

Nuts and nut butters (if permitted at your child's school; see page 35) and seeds and seed butters (sesame, pumpkin, or sunflower) are fantastic as sandwich spreads or mixed into a recipe.

Combined, beans and rice (one of my daughter's weekly favorites) create a complete protein.

Hard-boiled eggs are in our fridge at all times as a quick protein pick-me-up.

Seitan (wheat gluten) is a wonderful vegan option that can be mixed with an array of spices to taste just like meat and added to stir-fries, salads, and sandwiches.

Quinoa is an unexpected powerhouse of whole-grain protein and an excellent replacement for pasta and rice in many dishes.

Carbohydrates

If your kids are anything like mine, it's all about the carbs. But there's a big difference between fiber-, vitamin-, and mineral-rich complex carbohydrates that will give your kids energy, and simple carbohydrates generally made with refined sugars, which will leave them dragging. I do my best to focus on brown carbs instead of white ones—things like whole-grain breads, whole-grain pastas, brown rice, quinoa, and oats—but a good pretzel roll, or pizza now and then is nice, too, to switch things up. I also like Mochi by Grainaissance, a bake and serve brown rice snack that comes in a variety of flavors and is wheat- and gluten-free.

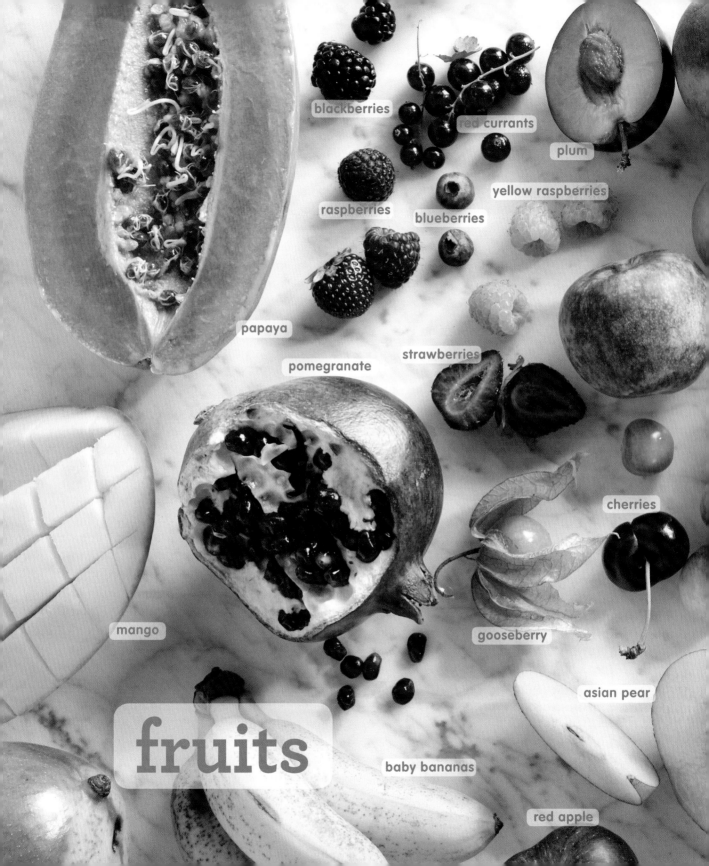

blackberries

red currants

plum

raspberries

yellow raspberries

blueberries

papaya

strawberries

pomegranate

mango

cherries

gooseberry

asian pear

fruits

baby bananas

red apple

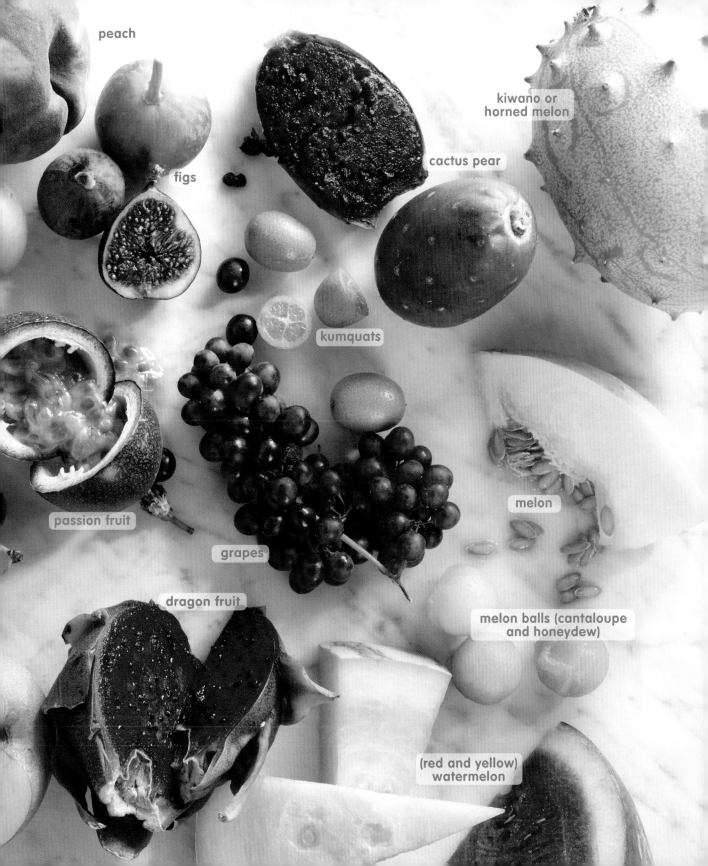

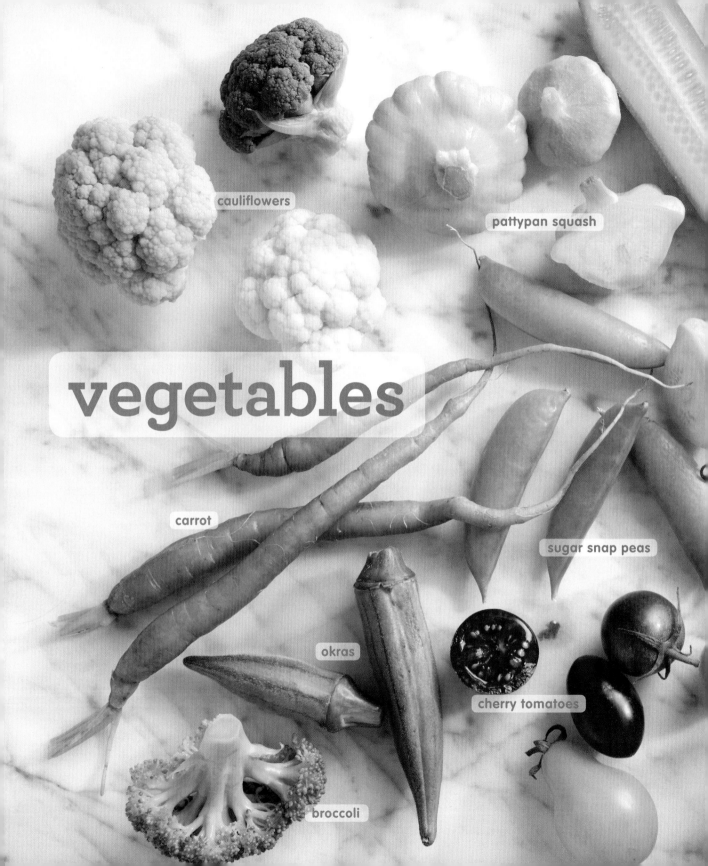

cauliflowers

pattypan squash

vegetables

carrot

sugar snap peas

okras

cherry tomatoes

broccoli

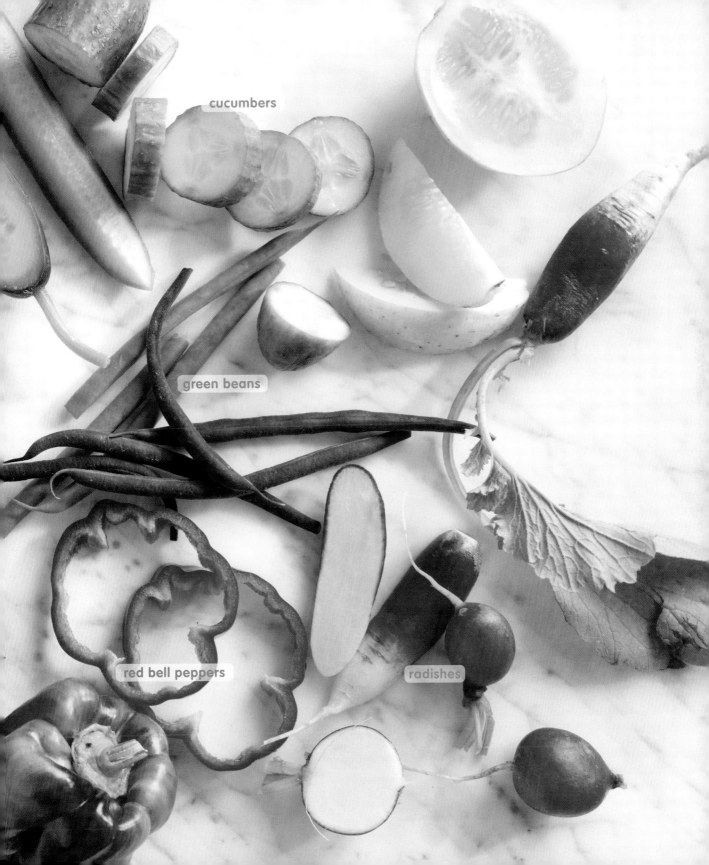

cucumbers

green beans

red bell peppers

radishes

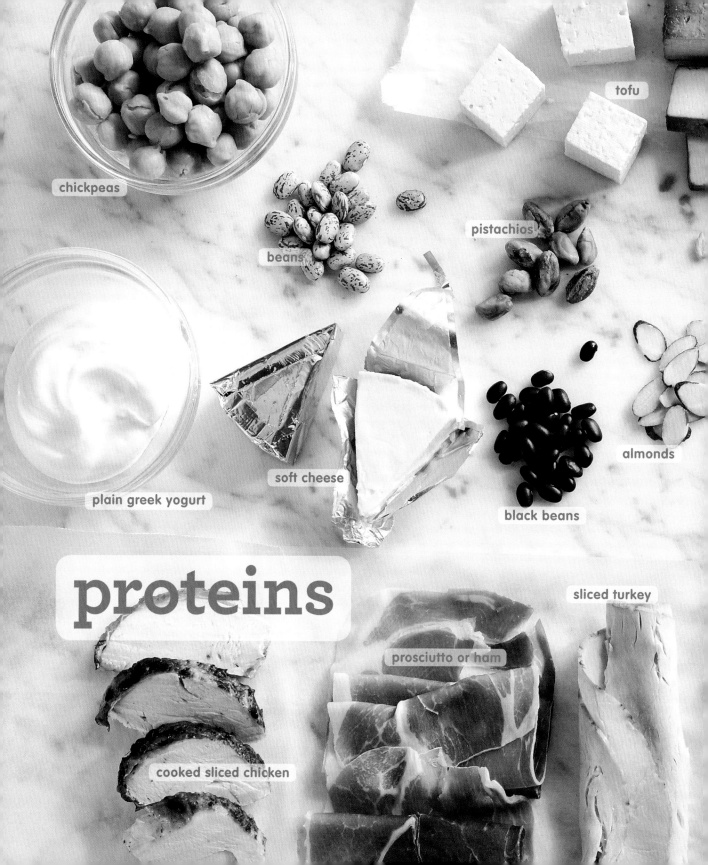

chickpeas

tofu

beans

pistachios

plain greek yogurt

soft cheese

black beans

almonds

proteins

sliced turkey

prosciutto or ham

cooked sliced chicken

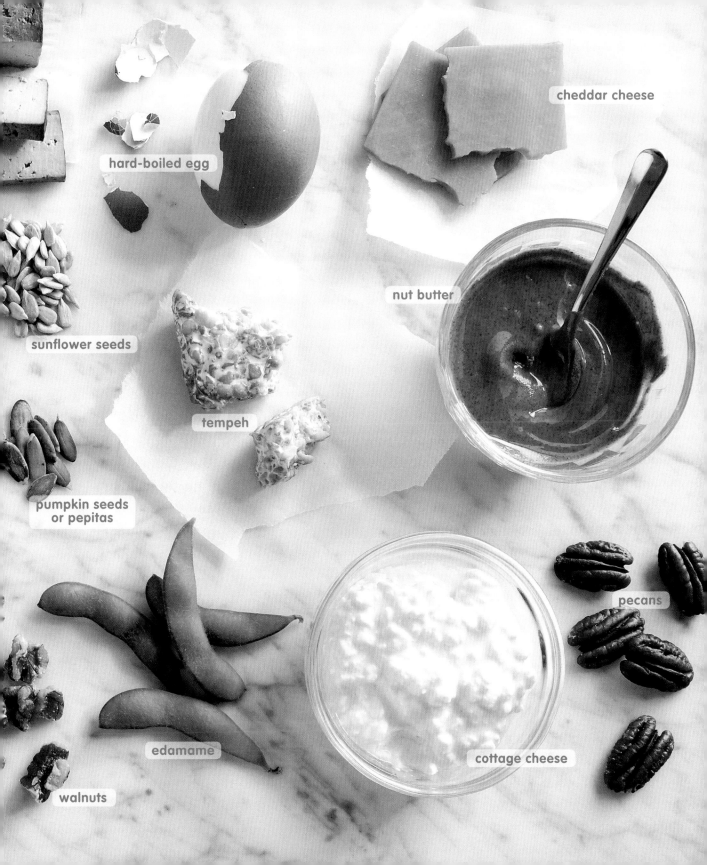

cheddar cheese

hard-boiled egg

nut butter

sunflower seeds

tempeh

pumpkin seeds
or pepitas

pecans

edamame

cottage cheese

walnuts

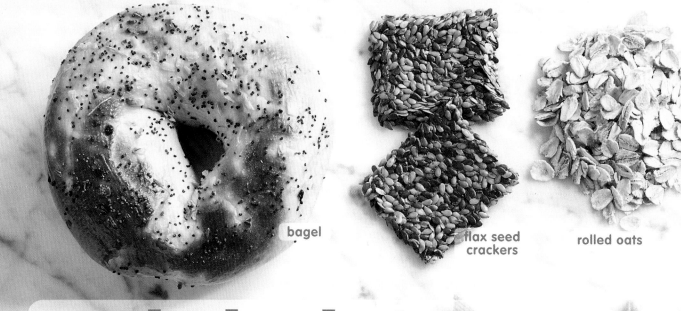

bagel

flax seed crackers

rolled oats

carbohydrates

pasta

whole wheat bread

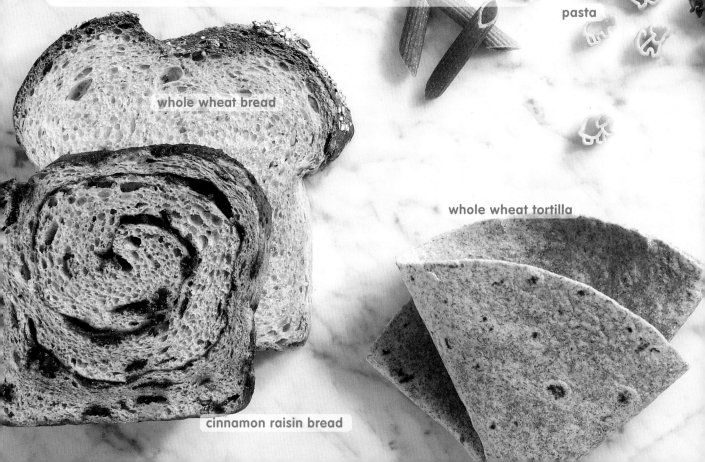

whole wheat tortilla

cinnamon raisin bread

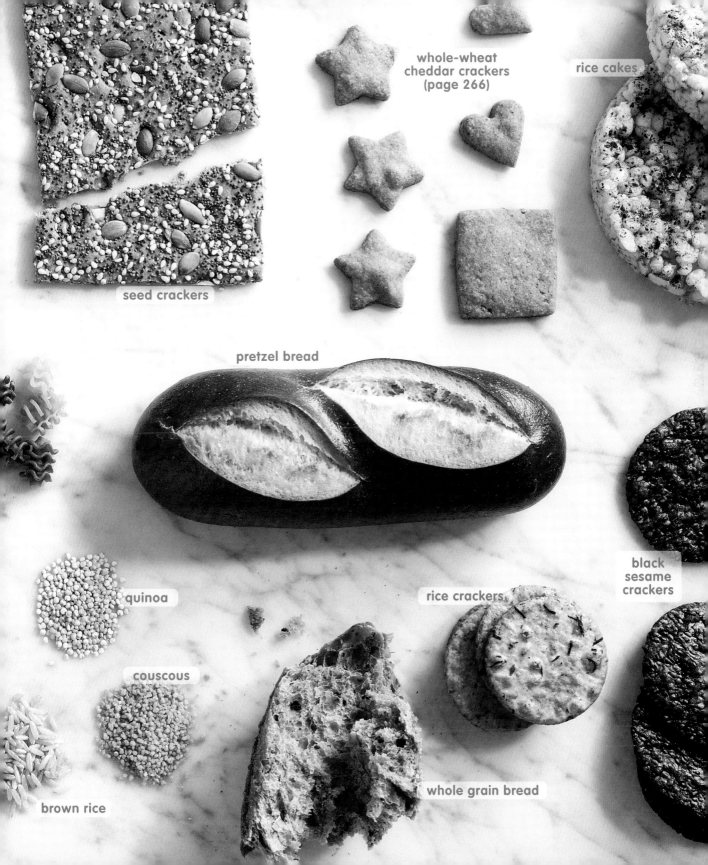

seed crackers

whole-wheat
cheddar crackers
(page 266)

rice cakes

pretzel bread

quinoa

rice crackers

black
sesame
crackers

couscous

whole grain bread

brown rice

from dinner to lunch: reinventing leftovers

I'm about to give you what I consider to be one of my best secrets to preparing an easy-to-make school lunch. Now, make sure the kids are out of earshot, because it may sound like a dirty word. Are you ready?

Leftovers!

When I was a kid, I would run for the hills if I heard my mom mention leftovers. Whatever the reason, it conjured up images of stale, soggy, or dried-out food. I have a feeling I'm not alone. But when I think about it now, why and when did the idea of leftovers become so taboo? Do kids really expect us to make something new at every meal? Maybe age has mellowed me, but now that I'm an adult, I love leftovers. I even feel like some things, such as roasted veggies, chicken, soups, and stews, taste—dare I say—*better* the next day.

Okay, invite the kids back in the room and let's purge our vocabulary of that dreaded word. Instead let's call them *reinvented meals*. After all, that's exactly what you're doing, isn't it—giving new life to foods that are perfectly fresh and tasty? Really, it's all in the presentation.

In fact, I start every week *intending* to have leftovers. I cook too much on purpose. On Sundays I'm the queen when it comes to making batches of brown rice, pots of pasta, and containers full of cooked vegetables, along with a grilled or baked chicken, to use as the building blocks of different meals throughout the week, and to include in my kids' lunch boxes in an assortment of recipes.

Here are a few easy ideas for leftovers, I mean, *reinvented meals*:

Toss cooked pasta with pesto, Parmesan cheese, or tomato sauce.

Mix cooked brown rice with pesto; edamame, soy sauce, and sesame seeds; top it with pressure-cooker beans; combine it with cubed tofu and teriyaki sauce; mix it with honey, cinnamon, and vanilla rice milk; or into the Mexican Mixture (page 170).

Serve grilled or baked chicken sliced on a sandwich or in a wrap; cut into bite-size pieces with barbecue sauce on the side for dipping; chopped on top of salad; or tossed with cooked quinoa, olive oil, basil, and tomatoes.

Slice meatloaf for a sandwich or cut it into cubes for dipping in ketchup or your favorite sauce.

Top a baked sweet potato with a touch of maple syrup, brown sugar, butter, or chopped nuts.

Fill tortillas with beans, rice, cheese, vegetables, shrimp, chicken, tofu, and more to make a burrito.

Chop up roast vegetables and cook them in a quesadilla with shredded cheese.

Mix leftover udon, soba, or pasta noodles with low-sodium soy sauce or Bragg's, sesame seeds, and edamame.

Stir grated carrots and sunflower seeds into quinoa and top with a light vinaigrette.

the well-stocked lunch pantry

Every Monday through Friday I wake up bleary eyed at 6:30 a.m., walk into the kitchen, open the fridge, and on most days, draw a total blank.

Lunch. Again. Ugh.

All too often I have no idea what to make. Fortunately, all I have to do is look at the list of my kids' favorite foods I always stock up on my staples—that I keep taped in my pantry—and the solutions come running to me. That list serves as a constant reminder to me that you don't have to spend a lot of money or buy a bunch of special ingredients to produce a lunch that your kids will get excited about eating. Once every week or so I replenish the items on the list. I know that by keeping these mostly perishable items on hand, I can always come up with forty or more recipes that are not only nutritious, but taste as good as they look.

A well-stocked pantry and fridge makes preparing lunch a cinch—which means my life gets better every day around 6:45 a.m.—and I find it to be an essential tool in creating two- or three-ingredient lunchtime masterpieces with ease.

How can you achieve the same results? Start by making a list of all your kids' favorite foods (the ones you approve of, that is!) and keep them on hand at all times. It's one of my biggest secrets to maintaining constant creativity in the lunch box. Here's my list of top 10 foods that I always try to have around for whipping up something tasty and quick. You'll find these ingredients starring frequently in recipes throughout this book!

Nut butters—almond, peanut, and sunflower are great choices

Cream cheese

Cheddar, mozzarella, or your favorite cheese (in sticks, rounds, triangles, bricks, shredded, or slices)

Pesto—goes great with pasta, rice, quinoa, or as a sandwich spread

Pasta—a variety of shapes, such as ziti, macaroni, bow ties, rotini, and so on

Bananas—to eat on their own, sliced, with honey and nut butter on a sandwich, or added to Banana Dog Bites (page 86) or Banana Upside Down Mini Muffins (236).

Baby carrots, sugar snap peas, edamame, cucumbers, or any of your child's favorite veggies

Dehydrated, freeze-dried, or dried fruit, such as raisins, cherries, apricots, mango, or banana

Yogurt—my favorite is plain Greek yogurt, which you can sweeten with honey, maple syrup, and fresh fruits

Bread—bagels, English muffins, tortillas, or your favorite sandwich bread, preferably whole grain

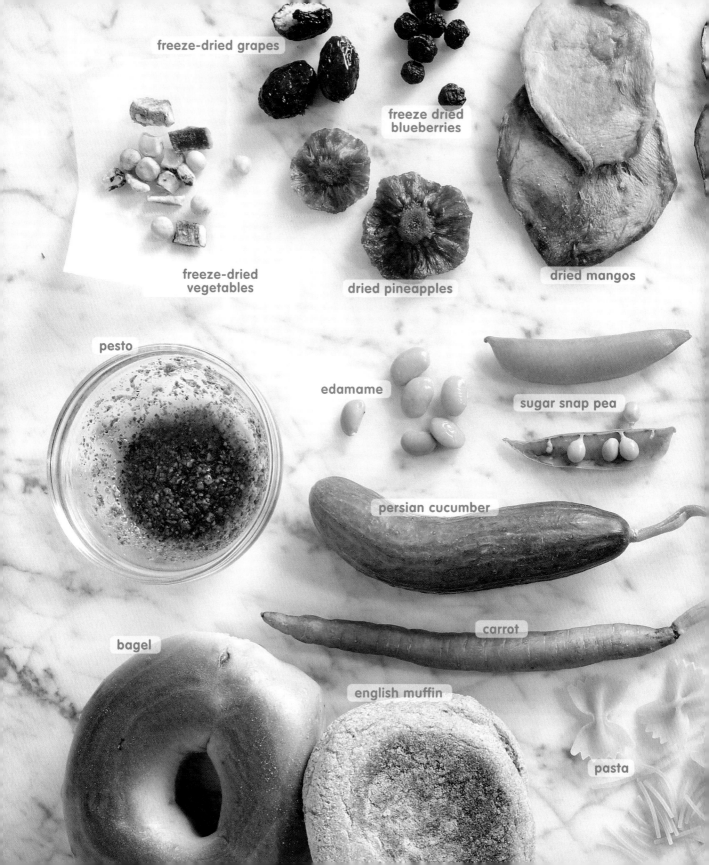

freeze-dried grapes

freeze dried blueberries

freeze-dried vegetables

dried pineapples

dried mangos

pesto

edamame

sugar snap pea

persian cucumber

carrot

bagel

english muffin

pasta

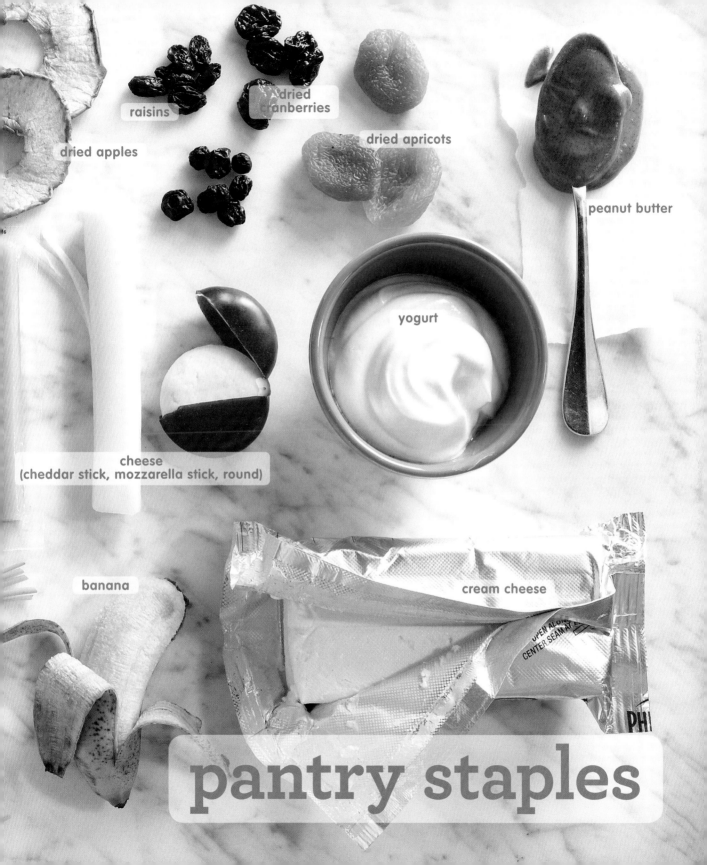

raisins

dried
cranberries

dried apricots

dried apples

peanut butter

yogurt

cheese
(cheddar stick, mozzarella stick, round)

banana

cream cheese

pantry staples

Lunch Box Combination Ideas

Pizza Quesadillas (page 144)
Hubby's Better Than Ice Cream (page 239)
Fresh berries
Sliced cucumbers

Mexican Muffins (page 176)
Jicama sticks with Veg-Wee Dip (page 222)
Grapes
Rice Crispy Treat Balls (page 298)

Cheesy Pasta Salad (page 53)
Broccoli sprinkled with sesame seeds
Orange slices
Nature Cookies (page 290)

Matzo Sammie (page 99)
Sugar snap peas
Apple Cinnamon Charoset (page 50)
Creamy Chocolate Pudding (page 284)

Bananamana–Cream Cheese Sammie (page 88)
Strawberries
Green beans with Caramelized Onion Dip
 (page 213)
Chocolaty Vanilla Wafers (page 279)

Pressure Cooker Black Beans (page 190)
 with rice
Vibrant Chopped Veggie Salad (page 51)
Blueberries
Double Chocolate Whole-Wheat Brownie
 (page 299)

Soft Pretzel Bites (page 256) with cheese cubes
Peach Fruit Leather (page 250)
Sliced mango
Cucumber

Beany and Cheesy Burrito (page 174)
Sliced red bell peppers
Chunks of pineapple
Cocodate Cookies (page 280)

Pizza Bagel Bites (page 137)
Cherry tomatoes
Mandarin segments
Whole Grain Fruit-Filled Bar (page 249)

Prosciutto and Butter Sandwich (page 109)
Whole-Wheat Cheddar Crackers (page 266)
Edamame
Pear slices

Easy Chicken Nuggets (page 178)
Kale Chips (page 199)
Peach slices
Fruit and Seed Bars (page 240)

Mini Bagel Chips (page 242) with Roasted
 Carrot Hummus (page 215)
Steamed cauliflower with Bragg's
 Liquid Aminos
Raspberries
Chai-Spiced Almonds (page 253)

Chicken Soup with Rice (page 72)
Roasted Carrot Coins (page 201)
Asian pear slices
Whole-Wheat Chocolate Chip Cookies
 (page 274)

Asian Mixture (page 171)
Cucumber wedges
Passion fruit
Whole-Wheat Blueberry Muffins (page 300)

Egg Pickle Salad Sandwich (page 106)
Cherry tomatoes
Apples
Animal Crackers (page 230)

Couscous-Carrot-Raisin Salad (page 57)
Kenya's Favorite Pickles (page 246)
Toasted Pepitas and Sunflower Seeds (page 263)
Sliced kiwi

Pretzel sticks with Avocado Honey Dip
 (page 207)
Caprese Salad (page 49)
Cherries
Freeze-dried mango

Pizza Panini (page 142)
Chopped tomatoes and cucumbers
Sliced plum
Roasted Honey Cinnamon Chickpeas
 (page 244)

Pasta with Everyday Basil Pesto (211)
Crispy Chicken Bites (page 182)
Dried apricots
Corn sheets

Theme Meals

Seasons and Holidays

Winter Wonder
Cheesy Pasta Salad (page 53)
Broccoli sprinkled with sesame seeds
Orange slices
Nature Cookies (page 290)

Soup's On
Chicken Soup with Rice (page 72)
Roasted Vegetables (page 203)
Asian pear slices
Polenta Berry Muffins (page 254)

Valentine's Love
Raspberry-Mascarpone Heart Sandwiches
 (page 126)
Strawberries
Red bell pepper strips
Chocolate PB&J Cups (page 152)

Spring Fling
Veggie Tortilla Roll-Ups (page 122)
Radish Salad (page 197)
Fruity Delight (page 282)
Seaweed snack

Passover Celebration
Matzo Sammie (page 99)
Sugar snap peas
Apple Cinnamon Charoset (page 50)
Roasted Honey Cinnamon Chickpeas
 (page 244)

Summer Foodie

Mini Bagel Chips (page 242) with Roasted
 Carrot Hummus (page 215)
Peach slices
Fruit and Seed Bars (page 240)
Kenya's Favorite Pickles (page 246)

All-American

The World's Greatest PB&J
 (page 164)
Red, White, and Blue Salad (page 66)
Cheese cubes
Chocolate Graham Crackers
 (page 277)

Picnic Spread

Egg Pickle Salad Sandwich (page 106)
Cherry tomatoes
Sliced plum
Animal Crackers (page 230)

Fall Fare

Couscous-Carrot-Raisin Salad (page 57)
Toasted Pepitas and Sunflower Seeds
 (page 263)
Dried apricots
Grapes

Halloween Happiness

Crispy Chicken Bites (page 182)
Chai-Spiced Almonds (page 253)
Pear slices
Pumpkin Pie "Pop-Tarts" (page 296)

Fun Themes

Molto Italiano

Pasta with Everyday Basil Pesto (page 211)
Caprese Salad (page 49)
Sliced apple
Chocolaty Vanilla Wafers (page 279)

Fiesta Fun

Mexican Muffins (page 176)
Jicama sticks with Veg-Wee Dip (page 222)
Grapes
Rice Crispy Treat Balls (page 298)

Pizza Pizza

Pizza Quesadillas (page 144)
Mini Doughnut Muffins (page 292)
Fresh berries
Sliced cucumbers

Très Français

Easy Croque Monsieur (page 98)
Beet Carrot Salad (page 48)
Quartered strawberries
Creamy Chocolate Pudding (page 284)

Loving Lunch

Bananamana–Cream Cheese Sammie (page 88)
A whole apricot
Green beans with Caramelized Onion Dip
 (page 213)
Chocolaty Vanilla Wafers (page 279)

Snack Sensation

Pizza Panini (page 142)
Edamame
Sliced apple
Whole-Wheat Cheddar Crackers (page 266)

Food Sensitivity/Allergy Themes

lunch box love

One of the biggest school lunch questions facing moms is what kind of lunch box they should buy. I probably never would have thought about the importance of this decision had I not spent so much time talking about it with my kids' preschool teachers and witnessed with my own eyes that when it comes to getting your kids to eat their lunch at school, *what* you pack the food *in* matters almost as much as the food itself. From the size and shape, to the ease with which the container opens and closes, to how the design impacts portioning—the details really can influence what food is eaten . . . and what *isn't*.

Especially when you're sending little kids (two to five years old) to nursery school or day care, an unwieldy lunch box or a sack filled with assorted plastic zipper bags and containers can be daunting for them. Those first few weeks at Kenya's preschool I recall getting anxious just looking at the random assortment of Baggies, loose lids, and Tupperware littering the lunch table. Aside from the mess and, ultimately, garbage it creates (just think about all that discarded plastic sitting forever in a landfill), imagine being a teacher having to help an entire class of kids open all this packaging in the little time they have allotted to eat and then trying to keep track of which tops and containers, water bottles, and zipper bags belong to whom. Or how about that food you packed with care and love that never even gets eaten because it's buried at the bottom of the brown paper bag, and your kid doesn't see it (let alone bother to look for it)? Or with the five and older set, one might open the first Baggie to find a cookie on top, start talking to their friends, and never bother to explore further. But I'd argue that it's not just kids who benefit from a good lunch box. Sure, a brown bag is absolutely fine—it's done such a good job over time, in fact, that somewhere along the way it became a verb—but even an adult packing her lunch to take to the office can benefit herself and the environment by using a good lunch box—one that's simple and reusable.

Fortunately there are a lot of great lunch boxes on the market that eliminate all these problems and, even better, help make lunchtime a delight for both parents and kids. They're definitely an investment, but one that is totally worth it in my opinion. For the same amount of money or less than you would end up spending in a school year on two hundred-plus Baggies, brown paper sacks, and other plastic containers, you could have one gorgeous and durable lunch box that will more than pay for itself over time.

The best part about many of my favorite containers is that they store the perfect amount of food without any clutter or confusion—kids just pop open the lids and can see all of their food choices neatly arrayed right in front of them.

And if all that's not reason enough to convince you, think about the ownership and pride kids take in having their own lunch box. It becomes part of their daily identity. I gave my friend Staci's son, Flynn, a lunch box and joyfully watched as he hugged it like a new toy. Flynn was starting kindergarten, and having a brand-new lunch box that was all his gave him such a sense of dignity and responsibility, something he could carry (no pun intended) with him throughout his day.

Lunch Product Roundup

Lunch Boxes

Having a hard time deciding what box is best for your child? Here are a few of my favorite lunch boxes, reusable napkins, water bottles, and other container gems:

Laptop Lunches Kenya's first lunch box came from Laptop. His teachers told me it was their favorite of all the boxes they saw kids bring, and it didn't take long to understand why. Featuring brightly colored containers in various sizes that fit inside a bento-style case, Laptop lunch boxes are dishwasher safe, free of PVC and other harmful chemicals, and easy for kids to negotiate. They can see all of their food choices by just opening the one cover. Laptop also has a wide variety of long-lasting, washable cases with designs that have major kid appeal.
www.laptoplunches.com

PlanetBox The PlanetBox systems have an all-in-one design that feature separate compartments for your food. They also have magnets that your kids can use to customize their lunch boxes to reflect their personalities. Made from stainless steel, they are seriously durable, food safe, recyclable, and all you have to do to clean them is toss them in the dishwasher and they're ready for the next day!
www.planetbox.com

Yubo One of my girlfriends has three kids and swears by Yubo. Not only are their lunch boxes dishwasher safe, recyclable, and BPA-free, but they have built-in ice packs to keep food cold, different-size containers to help you mix and match the perfect lunch, and changeable faceplates that are customizable, so kids can change the covers on them as often as they want. Very cool.
www.getyubo.com

hot or cold? *that* is the question

"Should I send my child to school with food that's hot, cold, or room temperature?"

Believe it or not, this simple question is one of the most frequently asked on the weelicious website. Understandably, it can be a real stress for parents. I usually send Kenya and Chloe to school with cool to room-temperature lunches, but recently Kenya has started to ask for warmer food, such as soups, stews, even mac and cheese. I love the idea of switching things up and adding a bit more variety to what I send for lunch, especially in the cooler months. But sending a hot meal takes a little more effort, and it's worth keeping a few things in mind.

Obviously, the first thing to think about is what you're going to serve. The second is your choice of container, as you want to keep the food at an appropriate temperature.

1. I highly recommend avoiding anything plastic when storing hot foods (while I don't like putting any food in plastic, harmful chemicals leach more easily into hot foods). Stainless thermoses keep food warm for hours, and are also good choices when it comes to food safety.

2. If you're sending your child to school with food that needs to be reheated, make sure the container is absolutely microwave safe and that a teacher is able to help him heat or warm it to an appropriate temperature that won't burn his mouth.

3. On most days, especially if lunch can't be refrigerated at school, using a reusable ice pack inside the lunch bag is essential to keep food at a safe temperature.

HOT TIP: If you want to keep food really warm, fill a thermos with boiling water, place it on the counter, screw on the lid, and let it sit for five minutes. Pour out the hot water, fill with warm or hot food, and replace the lid. Your food will stay piping hot for hours!

COOL TIP: Place fruit squeeze pouches such as Ella's Kitchen, Mott's Snack and Go, or Plum Organics in the freezer overnight then use it as an ice pack for your child's lunch box. They will defrost by lunch and be ready to eat!

Reusable Bags

If you really love using something more along the lines of an old-fashioned lunch bag, or prefer the containers you already use, take a peek at these washable bags:

graze organic Heather Jacobs and Leslie Sarracino's company specializes in these "reusable, reclosable snack and sandwich bags" made from 100 percent organic cotton featuring cool whimsical artwork silkscreened with water-based inks. They also make lunch totes and cloth napkins (no more wasting paper). Everything is extremely well made, washable, and great for packing sandwiches, sliced veggies, dried fruit, cereal, and pretzels. In addition to lunch, I also have to provide Kenya with a snack every day at school. I generally pack a whole piece of fruit, pretzels, a Chocolate Chip Granola Bar (page 233) baby carrots, sugar snap peas, or another treat in graze's Velcro closure snack bags. (P.S. They're great for holding makeup or money in Mom's purse too!) www.grazeorganic.com

Funkins These charming cloth napkins come in a variety of kid friendly patterns that you can wash time after time.

SoYoung SoYoung makes cooler bags, diaper bags, backpacks, and really beautiful coated linen lunch boxes that can be worn backpack style! Like everything I recommend here, they are PVC-free, phthalate-free, and lead safe. www.soyoung.ca

Containers

Maybe you already have a bag you like and just need some great, safe, leak-proof containers. Here's a bunch I like that should fit perfectly inside most bags.

Square nesting trio. These BPA-free, leak-proof containers are perfect for holding everything from sandwiches, to yogurt, snacks and more. store.kidskonserve.com/Square-Leak-Proof-Nesting-Trio-Set-of-3-p/uko13.htm

Stainless Steel ECOlunchbox Three-in-one, stackable and easy to safely toss right in the dishwasher after every use, these bento-style lunch containers are stainless steel, easy to use and food safe.
www.amazon.com

For snacks on the go, LunchBots are a mom's dream. The easy to click in place lids are drip proof, so even foods like yogurt travel well. Toss some trail mix, cut-up veggies, or fruits right in the food containers, throw them into your purse, and you're ready to go.
www.lunchbots.com

We were given a Think feeding set when Kenya was a baby and still use it today. These stainless and BPA-free travel containers have withstood a ton of wear and tear and still look great!
www.thinkbabybottles.com

Bottles

Why spend tons of money on water in plastic bottles and juice boxes when you can easily fill a reusable bottle? We have them for the whole family, and they're a great investment. All of the following are stainless steel and BPA-free.

Klean Kanteen stainless steel bottles are free of BPA, Phylalate, lead, and other toxins. They come in a wide range of colors and sizes to fit all ages.
www.kleankanteen.com

Wawabots are a ton of fun because you can personalize them. Instead of writing your kid's name on his bottle with a Sharpie, how about putting his picture on the outside instead? Guaranteed no more confusion at school as to which bottle belongs to whom.
www.wawabots.com

Fashionable and functional, I've had the same Sigg stainless bottles for years and they're still in great shape.
www.mysigg.com

strategies for "picky" eaters

One of the queries I get most often from stressed-out moms is, "What do I offer my picky eater for lunch?" I explore this topic in detail in my first cookbook, but let's examine it here for a moment.

Instead of labeling our kids with terms like "difficult" or "stubborn" or "picky" or looking at the associated behaviors as a negative, try instead to spin it into a positive. What are the foods your children enjoy most? Start by making a list of their absolute favorites, then include the foods you think they might enjoy and expand from there. Often when you focus on the positive and take the pressure off by not labeling a child "picky," kids will start feeling good about their choices rather than chastised for their perceived failings.

I've also seen selective eaters become much more open-minded when they're away from their parents. You'll likely be surprised to discover what things your kid will eat when you're not around. I always say that I'm blessed with two great eaters, but plenty of times I've taken a chance and put a certain food in my kids' lunch box that I was sure would come home untouched, only to find zero trace of it at the end of the day. Maybe it's because not having a parent there removes the pressure, or it's the fact that your kid is hungry and has no other choices, or that your child is around friends who are enjoying their lunches and is simply swept up in the moment—but I've found that very often, even the "pickiest" of kids can change her tune.

Of course some kids present bigger challenges than others. The reasons can vary greatly, but I don't believe that any of us should give up hope.

Helpful hints

Include your child when shopping for what you'll make him for lunch. Offer a few nutritious choices and allow your child to choose from them.

Feel free to tell your child that you're not going to buy fried potato chips, but he can choose from baked potato, pita, or bagel chips. A little choice can go a long way.

Remember that it can take *up to ten times* for children to enjoy a new food or vegetable, so if your child doesn't eat something new on the first or second try, have patience and don't give up on offering it. You could otherwise be missing out on the discovery of a new favorite!

Seasonings can go a long way with so-called picky eaters. Let your child jazz up her own lunch with something tasty that makes her feel like she helped prepare her meal. Top steamed vegetables with Bragg's Liquid Aminos, or sprinkle toasted sesame seeds on top for visual appeal and an added crunchy texture.

Frequently I'll offer my kids a second attempt at their untouched lunch after school. I fully understand the importance of schedule and routine for parents and having kids eat only at set mealtimes, but it's important to allow growing bodies and minds a chance at refueling with nutritious foods on their own clock. As most parents know, little ones often don't offer a lot of explanation about what happens at school during the day, so pay attention to other factors that might make kids "picky." Not eating their lunch may be less about disliking the new thing you made than it is the fact that they were having a bad day or were just not hungry at lunchtime because they needed to use the bathroom, were distracted by friends, weren't feeling well, and so on.

Even though it can be tough on parents, remember that kids self-regulate with food and generally get the nutrients they need. You may be surprised to learn that kids are able to manage their bodies much better than adults do. As long as you're providing them with balanced meals every day, you're doing your job and your kids will be fine.

Most important, keep trying and don't give up. If you hate the fact that your child eats chips, but you keep buying them and eat them yourself, it's not really your kid's fault if that's what he wants to eat. I would probably want chips instead of green beans too if they were constantly available to me. Parents need to avoid buying too many processed foods and model good eating habits for their kids. Offering nutritious food, making and eating meals together, and educating your little ones are the best tools for raising a great lifelong eater, leading to good mealtime habits both at home and school for life!

One of the greatest joys about the weelicious website is the dialogue I'm able to have with my readers. Whether they're new moms, veteran moms, or moms-to-be, I cherish and am always inspired by these women's amazing stories, questions, and above all, feedback. I've included some of their comments alongside many of the recipes throughout the book. To me, their stories reflect what kindred spirits we moms are and read like words of encouragement, something we can always use in the kitchen!

food allergies
at the lunch table

One day early last October, while I was picking up Chloe from school, I overheard an aggravated mother complaining to another mom about what she believed to be our school's gross overreaction to food allergies. A few weeks prior, all the parents in my daughter's class had received an email informing us that one of the children was allergic to a number of foods and asked that we please refrain from including any of them when packing our kids' lunches and bringing snacks for the class (the latter of which all parents at the school are responsible for year 'round). The conversation between these two moms was *heated*, and while I normally don't like to eavesdrop, school lunch *is* my business and I was very curious to get a sense for how different parents perceive food allergies—a subject that increasingly interests me.

This mother went on to say how incredibly annoying she found it to have so many restrictions put on what she was allowed to put in her

child's lunch box. She believed that the food choices deemed acceptable by the school were unreasonably limited, and not only did it put an unfair burden on her to figure out how to work within the guidelines, her child's favorite foods—the things she took comfort in knowing he would actually eat—were among the very things now prohibited in the classroom. The mom felt that the allergic child's parents should be the ones responsible for educating their son about what he should avoid eating while at school. "Why should the rest of us suffer?" was the remark that finally sent me over the edge.

Now, while it would be easy to single this mom out as unreasonable, insensitive, or just an isolated case, in my experience, she's definitely not alone in her belief. A refrain I often hear these days from parents is, *people are so over-reactive now, when we were kids no one was allergic and school lunchrooms served everything*. It's a reasonable statement to be sure, given that food

allergies have been on the rise, with the number of reported cases doubling every five years since 1996. The *Journal of Pediatrics* reported that about one in thirteen children in the United States has a food allergy and nearly 40 percent of those suffered severe reactions.

Considering how inadequately most of us are educated on this most serious of subjects—I include myself at the top of that list—I can understand the frustration of any busy parent, already concerned about the diversity of her child's diet and responsible for getting a balanced school lunch made every day, stymied by what seems like an increasingly long list of restrictions being imposed on her. Yet if we all truly comprehended food allergies—how serious they are, the grave risks they can present to children and adults alike, and the emotional toll they can take on both the afflicted children and their parents—our views might change drastically. For the better.

Food allergies are a most serious issue that requires the attention of *every* parent. I've spoken with countless moms with allergic children who literally fear for their kids' lives daily. Many schools have taken a stance and banned nuts altogether, and the fact that EpiPen sales have gone through the roof, with a 76 percent rise in sales in 2011 alone, is a compelling statistic.

When I started weelicious, I did some basic research about food allergies merely as a matter of course. It wasn't until my kids entered school and both of their classes contained children with food allergies that I fully grasped the severity and decided to delve deeper into the challenges these children and their parents face. The first

thing I learned was that there is a difference between airborne and nonairborne nut allergies. Children with an airborne nut allergy can get extremely sick simply from being in the proximity of a nut. Children with nonairborne nut allergies are generally safe sitting next to a child who has nuts in her lunch, but could have an adverse reaction if they accidentally ingest them. It can be extremely tricky when it comes to younger kids, where the two forms of nut allergy can be equally dangerous. Since foods such as nut butters spread without much effort to common classroom objects via sticky fingers, a child with a nonairborne nut allergy can easily and unknowingly ingest nuts by touching a contaminated surface and putting her fingers in her mouth. She could become immediately ill or worse. In the hands-on environment of a school, it becomes obvious that whether allergies are airborne or not, the risk of a child getting sick is almost equal.

Since PB&J is probably the most popular and easy to make lunch for parents and arguably the most delicious sandwich in the world, not to mention ideal for vegetarian families who are already faced with fewer options and ways to make sure their kids get protein, allergies in the classroom pose a problem for most parents (a far less serious problem than an allergy, but a headache nonetheless). The good news for parents of children with nut allergies (as well as for parents of nonallergic children in nut-free schools) is that many seeds—sunflower, pumpkin, sesame, and flax among them—are *fantastic* high-protein substitutions for nut-free classrooms and can be used in almost any recipe calling for a nut butter. I've substituted

sunflower butter for years in recipes like World's Greatest PB&J (page 164), PB&J Yogurt Swirls (page 159), and Banana Dog Bites (page 86), and not only do my kids frequently not notice that I substituted something for their beloved peanut or almond butter, but they've actually *requested* seed butters on occasion.

And while parents are aware primarily about nut allergies, they certainly aren't the only kind of food allergy. Dairy, gluten, and other foods present a risk of easy exposure in the chaos of the school lunchroom. What follows is a list of good, widely available alternatives in almost all these categories. Even some people without allergies *prefer* these options for reasons of either taste or diet.

The best way for kids with allergies to stay safe is for them to learn to advocate for themselves. The good news is that even when certain foods are prohibited, there are plenty of alternatives and one way to empower kids is to focus on what they can have, not on what they can't. Once when I was out of town and my husband was responsible for packing Kenya's lunch, Kenya stopped his dad from putting walnuts into a snack bag of trail mix. "Julian can't have nuts, Daddy. You can put seeds in instead." My surprised husband was moved as he realized that until then he had kind of viewed food allergies as a burden on the parents and kids unaffected by them, while our son and his peers felt a great sense of responsibility, pride, and camaraderie about protecting their friends. What a great lesson in how educating and involving kids in food choices can empower them.

Some Common Allergenic Foods and Substitutions

Cow's milk: rice milk, almond milk, soy milk, goat milk, hemp milk, oat milk, coconut milk

Nuts and nut butters: sunflower seed butter, sunflower seeds, pumpkin seeds, flax seeds

Eggs: flax "egg" (1 tablespoon ground flax mixed with 3 tablespoons water, allow to sit for 5 minutes); 1 mashed banana works in many baked goods; Vegenaise instead of mayonnaise

Gluten: Bragg's Liquid Aminos or tamari instead of soy sauce, King Arthur Flour gluten-free flour, Bob's Red Mill gluten-free oats, gluten-free pastas (rice pasta, cellophane noodles, soba noodles)

If you suspect you or your child have a food allergy, consult your physician or an allergist who has medical expertise.

resources

School Lunch Initiative: www.schoollunchinitiative.org/downloads/sli_eval_exec_summary_2010.pdf

Fruit and Vegetable Sources: cuesa.org/seasons/autumn

Sugars: www.fitday.com/fitness-articles/nutrition/carbs/simple-vs-complex-carbohydrates.html#b

Lentil Chili Recipe: en.wikipedia.org/wiki/Lentil (lentil protein fact)

Avocado Quesadilla: www.naturalnews.com/034370_avocado_nutrition_facts_health.html

Pediatric food allergies: Stat that one in thirteen kids in the United States has a food allergy, via Robyn O'Brien, *New York Times*: www.nytimes.com/2012/09/08/business/mylan-invests-in-epipen-as-child-allergies-increase.html?pagewanted=all&_r=0

pediatrics.aappublications.org/content/early/2011/06/16/peds.2011-0204.abstract

PB&J Yogurt Swirls: http://health.usnews.com/health-news/diet-fitness/diet/articles/2011/09/30/greek-yogurt-vs-regular-yogurt-which-is-more-healthful

Weelicious Lunches Allergy Guide

	GLUTEN-FREE	NUT-FREE	EGG-FREE	DAIRY-FREE
Salads				
Beet Carrot Salad	X	X	X	X
Caprese Salad	X	X	X	
Apple Cinnamon Charoset	X		X	X
Vibrant Chopped Veggie Salad	X		X	X
Cheesy Pasta Salad		X	X	
Shredded Chinese Chicken Salad	X			X
Greek-Israeli Couscous Salad		X	X	
Couscous-Carrot-Raisin Salad		X	X	X
Tangy Seasame-Cucumber Salad	X	X	X	X
Mexican Corn Salad	X	X	X	X
Three-Bean Salad	X	X	X	X
Tuna Pasta Salad		X		X
Crunchy Tomato Bread Salad		X	X	X
Winter Fruit Salad	X	X	X	X
Fruity Cottage Cheese Salad	X	X	X	
Red, White, and Blue Salad	X	X	X	X
Summer Melon Salad	X	X	X	X
Soups				
Chicken Soup with Rice	X	X	X	X
Minestrone Pasta Soup		X	X	X
Zippy Lentil Chili	X	X	X	X
Silky Tomato Soup	X	X	X	X
with Grilled Cheese Crouton Bites		X	X	
Mom's White Chicken Chili	X	X	X	X

	GLUTEN-FREE	NUT-FREE	EGG-FREE	DAIRY-FREE
Sandwiches				
Apple, Honey, and Cheese Quesadilla		X	X	
Turkey, Bacon, Cheddar, and Tomato Melt		X	X	
Banana Dog Bites			X	X
Bananamana-Cream Cheese Sammie		X	X	
Banana Chocolate-Hazelnut Spread Lavash Wheels			X	X
Cheesy Waffles		X		
Chicken Pesto Panini			X	
Chicken Salad Roll-Ups		X		X
Cinnamon Roll "Sushi"		X	X	
Egg Pesto Melt				
Easy Croque Monsieur		X		
Matzo Sammies		X	X	X
Eggplant Burger		X		
Grilled Cheese and Pickle Panini		X	X	
Ooey-Gooey Mozzarella Pesto Melt			X	
Egg Pickle Salad Sandwich		X		X
Pimiento Cheese Sandwich		X		
Mediterranean Pita Sammie		X	X	
Prosciutto and Butter Sandwich		X	X	
Pumpernickel Tuna Melt		X		
I ♥ Grilled Cheese		X	X	
Strawberry–Cream Cheese "Sushi Rolls"		X	X	
Swiss Avocado Turkey Quesadilla		X	X	
Tapenade–Cream Cheese Pinwheel		X	X	
Turkey BLTA Wraps		X		X
Turkey-Cheddar Panini		X	X	
Turkey-Cheese Rolls	X	X	X	
Turkey Cranber-wee Bagel Sandwich		X		X
Veggie Burgers		X	X	
Veggie Tortilla Roll Ups		X	X	X

	GLUTEN-FREE	NUT-FREE	EGG-FREE	DAIRY-FREE
Whole-Wheat Pancake Mix		X		
Raspberry-Mascarpone Heart Sandwich		X	X	
Smoked Salmon and Cream Cheese Bites		X	X	
Amazing Veggie-Packed Sandwich			X	
Sandwich on a Stick		X	X	
Pizza				
White Wheat Pizza Dough		X	X	X
Veggie-Heavy Pizza Sauce	X	X	X	X
Homemade Pizza Your Way		X	X	
Pizza Bagel Bites		X	X	
Pizza Balls		X	X	
Pizza Muffins		X	X	
Pizza Panini		X	X	
Two-Cheese Pesto Pizza			X	
Pizza Quesadillas		X	X	
Stuffed Pizza Rolls		X	X	
PB&J				
Apple Ring PB&J	X		X	X
Chocolate PB&J Cups	X		X	
Peanut Butter Pancake Sandwiches				
PB&AB Pancake Sammie				
PB&J Cupcakes				
PB&J Pinwheels			X	
PB&J Yogurt Swirl	X		X	
PB&J "Pop Tarts"			X	
PB&J Croutons			X	X
The World's Greatest PB&J			X	X

	GLUTEN-FREE	NUT-FREE	EGG-FREE	DAIRY-FREE
Mains				
Mexican Mixture	X	X	X	
Asian Fusion Mixture	X	X	X	X
Greek Mixture		X	X	
Italian Mixture		X	X	
Beany Cheesy Burritos		X	X	
Healthy Refried Beans	X	X	X	X
Mexican Muffins		X		
Easy Chicken Nuggets		X	X	
Chicken Satay Bites			X	X
Chicken Teriyaki on a Stick	X	X	X	X
Crispy Chicken Bites	X	X	X	
Falafel Bean Patties		X	X	X
Tex Mex Rice Cakes		X		
Veggie Meatballs		X		
Pressure Cooker Black Beans	X	X	X	X
Mexican Spiced Rice Balls	X	X	X	
Veggies				
Corn Wheels	X	X	X	
Jicama Sticks	X	X	X	X
Radish Salad	X	X	X	X
Kale Chips	X	X	X	X
Crunchy Potato Chips	X	X	X	X
Roasted Carrot Coins	X	X	X	X
Roasted Vegetables	X	X	X	X
Dips and Spreads				
Avocado Honey Dip	X	X	X	
Avocado Hummus	X	X	X	X
Super Easy Hummus	X	X	X	X

	GLUTEN-FREE	NUT-FREE	EGG-FREE	DAIRY-FREE
Everyday Basil Pesto	X		X	
Black Bean Hummus	X	X	X	X
Caramelized Onion Dip	X	X	X	
Roasted Carrot Hummus	X		X	X
Carrot Ginger Miso Dip	X	X	X	X
Cucumber Yogurt Dip	X	X	X	
Chocolate-Hazelnut Spread	X		X	X
Cheesy Olive Tapenade	X	X	X	
Zippy Yogurt Tahini Sauce	X	X	X	
Veg Wee Dip	X	X	X	
Veggie Cream Cheese Spread	X	X	X	
Kale Pesto	X		X	
Pure Strawberry Preserves	X	X	X	X

Snacks

	GLUTEN-FREE	NUT-FREE	EGG-FREE	DAIRY-FREE
Animal Crackers		X		
Chocolate Chip Granola Bars		X	X	X
Banana Upside Down Mini Muffins		X		
Cinnamon Pita Chips		X	X	X
Cranberry Cheese Balls	X	X	X	
Hubby's Better Than Ice Cream	X		X	
Fruit and Seed Bars	X	X	X	X
Mini Bagel Chips		X		X
Savory Chex Mix			X	
Roasted Honey Cinnamon Chickpeas	X	X	X	X
Kenya's Favorite Pickles	X	X	X	X
Whole Grain Fruit-Filled Bars		X	X	
Peach Fruit Leather	X	X	X	X
Pineapple Fruit Leather	X	X	X	X
Chai Spiced Almonds	X		X	X
Polenta Berry Muffins		X		

	GLUTEN-FREE	NUT-FREE	EGG-FREE	DAIRY-FREE
Soft Pretzel Bites		X	X	X
Ham and Cheese Muffins		X		
Spinach Cake Muffins		X		X
The Perfect Hard-Boiled Egg	X	X		X
Toasted Pepitas and Sunflower Seeds	X	X	X	X
Baked Whole-Wheat Raspberry Doughnut		X		
Whole-Wheat Cheddar Crackers		X	X	
Sunflower Butter Bran Muffins		X		

Desserts

	GLUTEN-FREE	NUT-FREE	EGG-FREE	DAIRY-FREE
Apple Cinnamon Muffins		X		
Blueberry Oat Muffins		X		
Whole-Wheat Chocolate Chip Cookies		X		
Chocolate Graham Crackers		X	X	
Chocolaty Vanilla Wafers		X		
Cocodate Cookies	X	X	X	X
Fruity Delight	X	X	X	
Creamy Chocolate Pudding	X	X	X	
Birthday Lemon Cupcakes with Blueberry Frosting		X		
My Kind of Candy	X		X	X
Nature Cookies				
Mini Doughnut Muffins		X		
Oaty Muffins		X		
Pumpkin Muffins with Cream Cheese Icing	X	X	X	
Pumpkin Pie "Pop-Tarts"		X	X	
Rice Crispy Treat Balls	X		X	X
Double Chocolate Whole-Wheat Brownies		X		
Whole-Wheat Lemon Blueberry Muffins		X	X	
Whole-Wheat Crepes		X		

PART 2
RECIPES

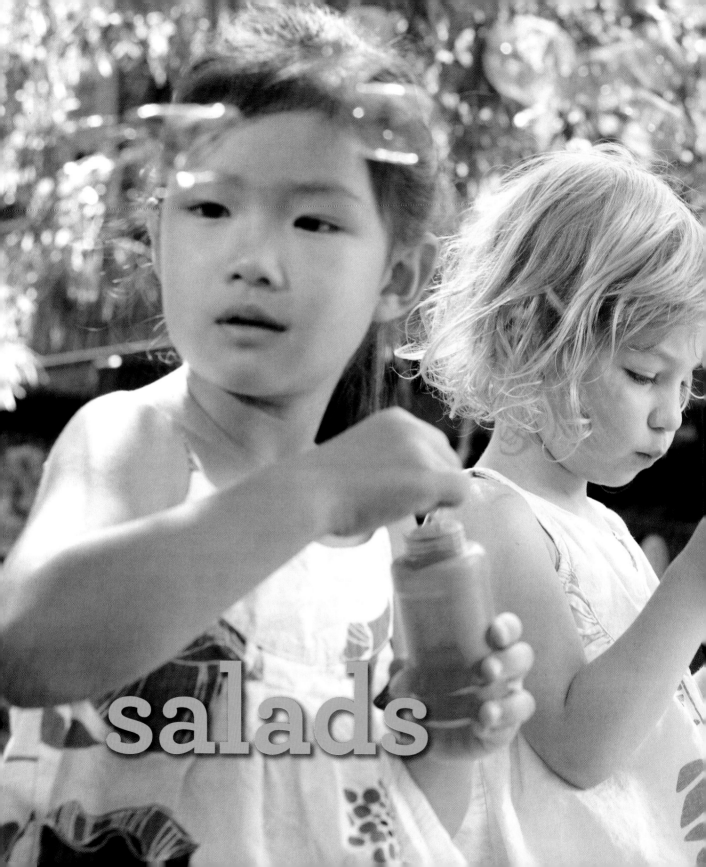

salads

beet carrot salad

Makes 2 servings

1 large carrot, peeled

1 large beet, peeled

⅛ teaspoon salt

1 teaspoon rice vinegar

1 teaspoon honey

My mother started taking me to Europe when I was very young. I'm not talking about the fancy-pants *Eloise in Paris* type of trip that you might envision; it was closer to the hostel and budget bed-and-breakfast variety. What was truly important to my mom was that I experience different cultures by just walking around, visiting museums, and enjoying local cuisines.

There, at about age twelve, I was introduced to a side dish found frequently on French menus: a simple salad of grated beets and/or carrots. I'd never wanted to eat beets at home, but when served grated with just a tiny bit of added sweetness, they were transformed into something truly special. Similarly, when I started weelicious, I quickly discovered how simply changing the look of a vegetable that kids normally avoid can turn it into something they will enjoy.

1. Using a hand or box grater or the grater attachment of a food processor, grate the carrot and beet to your liking (either fine or coarse will work).

2. Combine all the ingredients and toss to mix well. Eat immediately or keep it in the fridge for up to 3 days.

TIP: If you prefer you can use all grated beets or carrots in the recipe.

caprese salad

We have a small edible garden at our home but sadly, unlike my mother and grandmother, I seem to have two brown thumbs.

When I had Kenya I was determined to boost my gardening abilities and over the past few years I've been fortunate to learn a thing or two from my friend Lauri Kranz, from Edible Gardens LA (having a friend who's a gardener is never a bad idea). But my greatest joy has been watching Kenya and Chloe learn through their exposure to the fresh fruits and vegetables they help to grow at home. And if I'm naturally hopeless in the garden, the talent skipped a generation, because both kids seem born to do it.

In the summertime we literally have pounds of cherry tomatoes growing in our garden. The kids are constantly grabbing handfuls from the vine and popping them into their mouths, occasionally wrapping them up first in leaves from our basil plants. It just goes to show that you don't need to do much to a good tomato to make it tasty, so I keep things simple in my preparation, too. With just a dash of olive oil and a few plump bites of mozzarella cheese, you can create one simple yet very special salad in no time at all.

Place all ingredients in a bowl and toss to combine.

Makes 2 servings

1 cup halved cherry tomatoes

½ cup halved mozzarella balls (bocconcini)

1 tablespoon olive oil

1 tablespoon chopped fresh basil

½ teaspoon salt

apple cinnamon charoset

Makes 4 servings

2 Granny Smith apples (peeled or unpeeled), cored and roughly chopped

½ cup chopped walnut pieces

2 tablespoons honey

1 teaspoon ground cinnamon

"Charo—*what?*"

Charoset (pronounced *Ha*-ro-set) is made from apples, honey, walnuts, and cinnamon and it's traditionally eaten at the Passover seder. I grew up with many Jewish friends, so I first encountered charoset at a young age, but I wasn't reminded of it until our family celebrated Passover last year. Wanting to introduce Kenya and Chloe to one of his childhood favorites, my husband lovingly made them a big batch of this addictive dish.

I figured the kids would enjoy it for the holiday and forget about it, but to my surprise, Kenya asked for it for weeks on end. Since then we make it regularly and it quickly became an all-time favorite lunch box recipe!

Place all the ingredients in the bowl of a food processor and pulse to finely chop and combine.

TIP: Since charoset is almost like a dip, serve with matzo (the traditional way), with crackers, or on its own.

vibrant chopped veggie salad

In the summertime, when vegetables are in abundance, I get Kenya and Chloe to make this salad with me. Since it's impossible to mess up, I pull the kids up to the counter with cutting boards and kid-safe knives and let them go to town practicing their chopping techniques. I'm always amused watching them eat as they help prep the various vegetables that go into this hearty vegetarian salad.

Place all the ingredients in a large bowl and toss to combine.

See the salad pictured on page 123.

Makes 3 or 4 servings

1 carrot, peeled and diced

1 celery stalk, diced

½ cup chopped broccoli florets

½ cup quartered cherry tomatoes

¼ cup sweet corn kernels

¼ cup chopped green beans

¼ cup sliced almonds

1 tablespoon olive oil

1 tablespoon lemon juice

½ teaspoon salt

cheesy pasta salad

Most Sundays I make a big batch of plain cooked pasta to use throughout the week in lunch dishes like this one. Tossed with a handful of cheese and your favorite vinaigrette, this salad is a great way to jazz up ordinary left-over pasta.

In a bowl, combine all the ingredients. Toss to coat and serve.

NOTE: You can make your own Italian dressing by whisking together 4 teaspoons olive oil, 2 teaspoons red wine, sherry, or cider vinegar, a pinch of salt, and dried Italian herbs.

TIP: You can use a mix of your favorite cheeses as well.

TIP: When making cooked pasta ahead of time, toss it with a touch of olive oil so the pieces don't stick together.

Makes 2 servings

2 cups cooked pasta, such as farfalle, elbow macaroni, or campanelle

2 tablespoons Italian salad dressing (prepared, or see the Note left)

¼ cup grated sharp Cheddar cheese

¼ cup grated mozzarella cheese

2 tablespoons grated Parmesan cheese

shredded chinese chicken salad

Makes 4 servings

SALAD

1 boneless, skinless chicken breast

1 large carrot, peeled and sliced into thin coins

1 head napa cabbage, chopped

½ red bell pepper, sliced into ½-inch strips

2 tablespoons chopped cilantro

2 teaspoons toasted sesame seeds, plus more for garnish

DRESSING

½ teaspoon toasted sesame oil

1 tablespoon Bragg's Liquid Aminos, tamari, or soy sauce

½ teaspoon minced fresh ginger

1 tablespoon rice vinegar

1 tablespoon almond butter

1 tablespoon Vegenaise or mayonnaise

2 tablespoons canola or olive oil

When I first moved to Los Angeles more than fifteen years ago, several of my friends introduced me to their favorite restaurant, Chin Chin, which is famous for its Chinese chicken salad. One bite of this crisp, crunchy, fresh salad and you'll immediately understand why it's so darned popular. I'm always trying to think of recipes that our entire family can eat together, and this one has a lot of fans in my house.

It couldn't be easier to make. In no time you'll have a tasty salad that's filled with vitamin-packed veggies. Many people would never imagine their kids eating salad, but trust me; this one will change their minds.

1. Place the chicken breast in a steamer pot over boiling water. Cook for 8 minutes, or until cooked through. Cool and pull apart into bite-size pieces.

2. In a large bowl, combine the chicken, carrot, cabbage, bell pepper, cilantro, and sesame seeds.

3. Place the dressing ingredients in the bowl of a food processor and pulse to combine.

4. Add the dressing to the salad and toss to combine. Top with additional sesame seeds, if desired, and serve.

NOTE: Add slivered almonds, chopped cashews, or peanuts if you like.

greek-israeli couscous salad

Makes 4 servings

1½ cups Israeli couscous

3 tablespoons olive oil

2 tablespoons lemon juice

½ teaspoon salt

½ cup crumbled feta cheese

2 Persian cucumbers or 1 English cucumber, seeded and diced

1 large tomato, seeded and diced

1 tablespoon chopped parsley

I went to the grocery to buy ingredients for a Greek tabbouleh salad, and while looking for bulgur wheat, my attention was caught by Israeli couscous. Couscous is actually a pasta (not a grain like bulgur), and if there's one food all kids seem to love, it's pasta, so I thought it would be an interesting twist for my recipe.

The addition of the toasty beads of couscous to the traditional flavors and textures of a tabbouleh salad, like the creamy tang of feta cheese and crunch of cucumbers, make this a great late-summer salad. It's simple to prepare and ideal in the lunch box. Just don't forget to pack a spoon!

1. Place the couscous and 1 tablespoon of the olive oil in a pot and toast for 5 minutes over medium heat.

2. Add 2 cups water and bring to a boil, then reduce the heat to medium-low and simmer for 12 minutes.

3. Transfer the mixture to a large bowl and set aside to cool.

4. Add the lemon juice, salt, feta, cucumbers, tomato, parsley, and the 2 remaining tablespoons of olive oil and stir to combine.

DEVORAH: Greek-Israeli Couscous Salad is absolutely delicious and can be easily tailored to fit the needs of more fussy eaters. A very good summer choice, or you can go with a warm dish for winter.

couscous-carrot-raisin salad

I was first introduced to couscous when I was living in Paris. On a tight budget, I had to come up with healthful, inexpensive foods that were simple to prepare, and couscous quickly became one of my staples. This simple pasta lends itself to many different treatments, but I liked tossing it with chopped tomatoes and basil or serving it Moroccan style with plump, sweet raisins and colorful grated carrots. Here I've created the latter version for you.

1. Place the stock, salt, and 1 cup water in a small saucepan and bring it to a boil over high heat.

2. Add the couscous and raisins, cover, and turn off the heat.

3. Let the couscous sit, covered, for 5 minutes.

4. Add the grated carrots, olive oil, and lemon juice, and fluff the couscous with a fork.

See the salad pictured on page 83.

Makes 4 servings

¾ cup low-sodium chicken stock, vegetable stock, or water

1 teaspoon salt

1 cup couscous

⅓ cup raisins

2 medium carrots, peeled and grated

1 tablespoon olive oil

1 tablespoon lemon juice

tangy sesame-cucumber salad

Makes 4 servings

4 Persian cucumbers, thinly sliced (see Note)

2 tablespoons rice wine vinegar

2 teaspoons sesame seeds

When it comes to kids, sometimes the most basic recipes turn out to be the most popular. It always amazes me how something so simple can be one of my kids' favorite dishes, but that's why this easy cucumber salad is constantly in our family's lunch rotation.

I like to use Persian cucumbers for this recipe because they're seedless and have thin skin so you don't need to peel them, but you can use any variety you have on hand. I use a mandoline slicer to cut the cucumber into very thin slices and toss it with a bit of vinegar and some sesame seeds. When I pack this dish in Kenya and Chloe's lunch boxes I'm instantly the world's greatest mom. Who knew that's all it took?

1. Place all the ingredients in a bowl and stir to combine.

2. Serve immediately or refrigerate up to 2 days.

BETH: Very refreshing and a bit of a change from typical salads. If you have a toddler like mine who is absolutely *obsessed* with cucumbers, this salad is a must in your repertoire.

NOTE: You can also use English or hothouse cucumbers that have been peeled, cut in half, seeded, and thinly sliced.

mexican corn salad

I'd bet your family has at least one type of cuisine that you all can agree on eating. For my family it's Mexican. When Latin flavors are added to almost any dish, it generally gets a thumbs-up from my whole crew. This composed salad makes a balanced meal that's crazy good. Or in this case, *loco bueno*.

In a bowl, mix together all ingredients and toss to combine.

4 servings

1 cup thawed frozen corn kernels *or* cooked fresh corn kernels

1 avocado, diced

1 can (15 ounces) black beans, drained and rinsed *or* 1 cup black beans, cooked and cooled

1 small tomato, diced

1 teaspoon chopped cilantro

1 teaspoon salt

Juice of 1 lime

three-bean salad

1 can (15 ounces) black
beans, drained and
rinsed

1 can (15 ounces) red
kidney beans, drained
and rinsed

1 can (15 ounces)
garbanzo beans,
drained and rinsed

½ cup cherry tomatoes,
halved or quartered

½ cup diced celery

1 tablespoon apple
cider vinegar

2 tablespoons olive oil

1 teaspoon Dijon
mustard

1 teaspoon honey

½ teaspoon salt

1 tablespoon chopped
parsley

Three-bean salad was one of those school lunch offerings that I loathed as a child. I don't know how such a simple and potentially delicious dish could be made so unappealing, but there it would sit on the salad bar every day, lonely, untouched, and drowning in a thick dressing made from who knows what.

Luckily, having a child who would happily survive on beans if she could, I cook with them as often as possible. In my resolve to revive with dignity this dreaded bean salad from my past, I came up with the addition of crunchy celery and supersweet cherry tomatoes.

If only they had served *this* in my school cafeteria, lunchtime would have been much more memorable.

1. In a large bowl, combine the beans, tomatoes, and celery.

2. In a small bowl, whisk together the remaining ingredients and toss with the bean mixture to coat.

tuna pasta salad

You have a great recipe in mind. Excited, you head into the kitchen to get out all of your ingredients and . . . oh, no! You're missing one!

Has this ever happened to you? It often does to me, and having my meal plans ruined because I'm out of that one key ingredient drives me *crazy*. Just the thought of having to drag two kids to the market for a single item is beyond frustrating to me (not to mention unfair to the kids).

I love this Tuna Pasta Salad because it's rare that I'm ever out of any of the ingredients. If you do happen to be missing anything, the dish will still hold up (unless of course the one ingredient you're out of is tuna!). While I can't solve "missing ingredient syndrome," this dish is pretty close to fool-proof.

1. Combine the lemon juice, mustard, mayonnaise, and salt in a bowl to make the sauce.

2. Mix the remaining ingredients in a large bowl, pour the sauce on top, and combine.

TIP: Serve on top of lettuce, in a wrap, or with crackers.

Makes 4 servings

3 tablespoons lemon juice

1 tablespoon mustard

2 tablespoons mayonnaise

1 teaspoon kosher salt

Two 8-ounce cans water-packed tuna, drained

4 cups cooked pasta, such as penne, rotini, or campanelle

½ cup peeled and shredded carrot

½ cup seeded and diced cucumber

¼ cup diced dill pickle

1 tomato, seeded and diced

crunchy tomato bread salad

Makes 4 to 6 servings

½ loaf French bread or rustic artisan bread, cut into 1-inch pieces (4 cups)

¼ cup olive oil

4 beefsteak or heirloom tomatoes, cut into 1-inch chunks

1 cup sliced cucumbers, peeled or unpeeled

1 ear corn (uncooked), sliced off the cob

½ red onion, thinly sliced

2 tablespoons fresh basil, cut into a chiffonade

½ cup pitted kalamata olives, sliced

2 tablespoons balsamic vinegar

1 teaspoon kosher salt

When you grow your own fruits and veggies, it's always exciting to see what will pop up when combing through your garden. My kids have become little detectives, hunting amid the leaves and vines in our pots and planters and pointing out whatever looks ready to be picked. In summer we grow a variety of tomatoes—yellow, red, heirloom, cherry, and more. Coming up with different recipes to use them in is essential, so nothing goes to waste. Utilizing the plentiful tomatoes, cornucopia of cucumbers, and bountiful basil covering our yard, this summery salad is quite literally the fruits of our labor.

The preparation is simple, and because the crusty bread cubes are filling, it goes a long way toward feeding a large family, making this superfresh meal affordable on any budget. If you're looking for a dish that screams "summertime," you have to try this one. And if by now I haven't convinced you to start your own edible garden, this salad certainly will.

1. Preheat the oven to 400°F.

2. Place the bread cubes on a sheet tray, drizzle with 2 tablespoons of the olive oil, and toss to coat.

3. Bake for 12 to 15 minutes, or until golden, and set aside to cool.

4. Place the tomatoes, cucumber, corn, onion, basil, olives, and bread in a large bowl.

5. In a small bowl, whisk the remaining 2 tablespoons of olive oil, the vinegar, and salt. Pour onto the salad and toss to coat.

MELISSA: **We eat the tomato bread salad all summer long! It's simple and so delicious. We've served it for several events and this dish always stands out.**

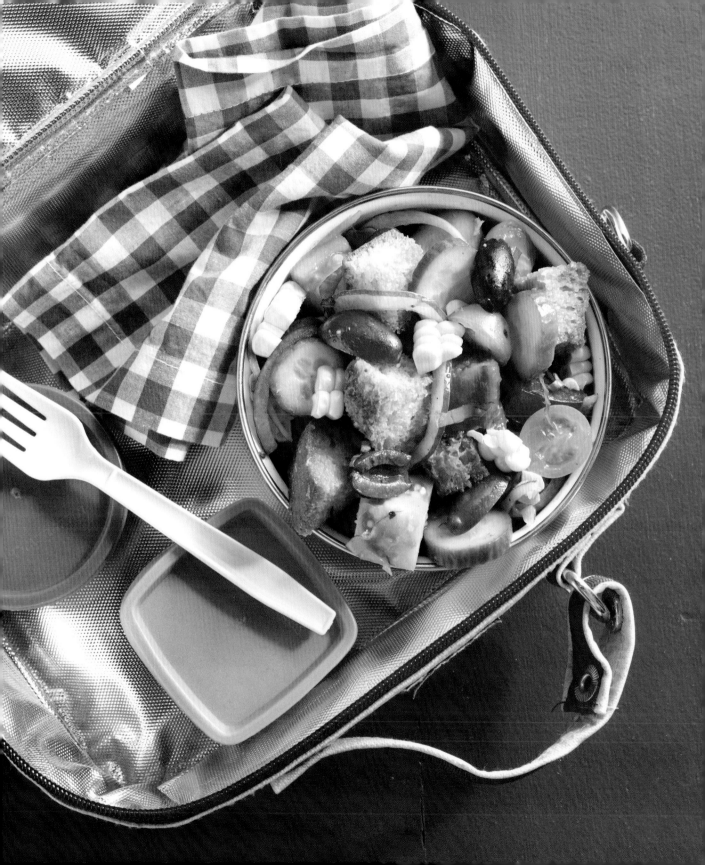

winter fruit salad

Makes 2 servings

1 apple, any variety you enjoy

1 pear

¼ cup dried apricots

¼ cup raisins

2 teaspoons lemon juice

This is my jazzed-up version of a winter fruit salad. It's one of those minimal effort, maximum flavor recipes. Just a gentle squeeze of citrus on the apples and pears (which brings out the flavor and prevents them from turning brown) and a light toss with dried fruit turn this fruit salad into something truly out of the ordinary.

1. Core the apple and pear and cut them into ½-inch cubes.

2. Dice the apricots and raisins.

3. Place all the ingredients in a bowl and toss to coat with the lemon juice.

NOTE: You can also add pomegranate seeds, dried cherries, or dried cranberries.

fruity cottage cheese salad

I *detested* cottage cheese as a kid . . . that is, until I saw someone eating it topped with mandarin oranges and pineapple at the salad bar of one of our family's favorite restaurants. The next thing you know I was asking my mom to serve me cottage cheese adorned with fruit every morning. Even now, I'm not the biggest lover of plain cottage cheese, but top it with assorted sweet fruit and I'll hoover every last bite. Which is exactly what my kids tend to do, too, whenever I put this dish in their lunch boxes.

Place all the ingredients in a bowl and toss to combine.

Makes 2 servings

1 cup cottage cheese
½ cup diced apple
¼ cup diced pineapple
¼ cup diced dried apricots

red, white, and blue salad

Makes 2 cups

½ cup diced strawberries

½ cup raspberries

½ cup diced red apples

½ cup blueberries

2 teaspoons honey

2 teaspoons lemon juice

I don't want my kids consuming food coloring. Let's face it, there's nothing foodlike about it. It's just chemicals. But when it comes to the holidays I still want my kids to be able to celebrate at mealtime. This Red, White, and Blue Salad was born one Fourth of July from the desire to make something traditionally colorful but still good for my kids' bodies.

Declare your independence from food coloring by making this naturally delectable and festive fruit salad. You don't even need a holiday to enjoy it.

Place all the ingredients in a bowl and toss to combine.

summer melon salad

On Sunday mornings in the summer, I can't wait to jump out of bed. Just the thought of our local farmers' market and the incredible variety of amazing fruit in season gets me so excited, I can't take it (it also makes me feel like a huge nerd, but hey, it's what floats my boat).

We're very lucky to have such diversity in our fruits and vegetables in southern California. Take melons, for instance. In addition to the delicious cantaloupe, honeydew, and watermelon that are abundantly available, there are numerous other varieties that also smell and taste like heaven: Crenshaw, French, Galia, casaba, and more. Every time we're at the market, I am so wowed by all the succulent samples, I end up buying several types because I can't make up my mind.

Personally, I can sit down merely with half a melon and a spoon and be happy, but if you want to give your melon a little extra zip, try out this gorgeous recipe and see if your family gets as enthusiastic about melon as I do on Sunday summer mornings!

1. Cut the fruit into 1-inch chunks, or use a melon baller.

2. Combine the fruit with the remaining ingredients.

TIP: You can use any type of melon for this salad.

Makes 4 to 6 servings

½ small seedless watermelon

½ small honeydew melon

½ small cantaloupe

Juice of 1 lime

2 tablespoons minced mint

soups

chicken soup with rice

Makes 6 to 8 servings

One 4-pound whole chicken

¾ cup long-grain brown rice

4 quarts cold water (enough to cover the chicken)

4 teaspoons kosher salt

1 small onion, peeled and halved

1 bay leaf

3 carrots, peeled and diced

3 celery stalks, diced

2 tablespoons finely chopped parsley

I started reading Maurice Sendak's classic book *Chicken Soup with Rice* to Kenya when he was two and it quickly became one of his favorites. It's the story of a little boy who loves chicken soup with rice so much that he eats it month after month in a host of imagined settings.

Kenya's not too far away from that level of affection for chicken soup himself. I often make a huge batch and freeze it in individual containers so that whenever either of my kids feel under the weather, I just defrost some and heat it up to make them feel warm and nourished. As Maurice Sendak made clear, "all seasons of the year are nice" for this healthful soup, but it's especially heartwarming on those chilly days when your little ones have a runny nose.

1. Place all the ingredients except the parsley in a large soup pot and bring to a boil over high heat. Skim the foam and fat off the surface of the soup as necessary as it's coming to a boil.

2. Cover, reduce the heat to a simmer, and cook for 1 hour.

3. Turn off the heat, remove the halved onion, bay leaf, and chicken from the pot, and let cool.

4. Discard the skin and bones from the chicken and cut or shred the meat into small pieces.

5. Add the chicken and parsley to the soup, reheat, and serve.

OLESYA: Chicken Soup with Rice is easy to make, our go-to recipe in the winter. Freeze it to have on hand for when anyone in the family starts to get sick!

ASHLEY: A great lunch for a cold winter day. I can make a big batch, freeze it in smaller portions, and heat it up quickly in the morning while the boys are eating breakfast. Then just pour into a thermos and a hearty meal that I know they'll gobble up is ready to go to school!

minestrone pasta soup

Coming up with recipes that include a carbohydrate, protein, and vegetables is not the easiest feat. When I do manage to conjure one up and it turns out this delectable, it feels like a major achievement. Every spoonful of this classic hearty Italian soup is a dose of vegetarian bliss.

Don't be bashful with this recipe. Feel free to improvise and toss in any other veggies, beans, or types of pasta you enjoy to make it your own. You seriously can't go wrong.

1. Heat the oil in a medium saucepan over medium heat. Add the onions, carrots, celery, and garlic and sauté for 5 minutes, or until the vegetables are softened.

2. Add the remaining ingredients to the pot and stir to combine. Turn the heat to medium-low and simmer for 30 minutes, or until the pasta is cooked through and the vegetables are tender.

Makes 6 servings

1 tablespoon olive oil

1 onion, diced

2 carrots, peeled and diced

2 celery stalks, diced

2 garlic cloves, minced

1 zucchini, diced

One 15-ounce can cannellini beans, drained and rinsed

One 15-ounce can diced tomatoes or 2 cups chopped fresh tomatoes

4 cups (one 32-ounce box) vegetable stock or chicken stock

¾ cup small pasta such as mini farfalle, elbows, or rotini

1½ teaspoons Italian herbs or a mix of dried basil, oregano, and thyme

1½ teaspoons salt

zippy lentil chili

Makes 8 servings

1 tablespoon vegetable or canola oil

1 medium onion, chopped

2 medium carrots, peeled and chopped

2 celery stalks, chopped

2 garlic cloves, minced

1 tablespoon chili powder

½ tablespoon ground cumin

1½ cups dried brown lentils

One 28-ounce can diced tomatoes in juice

4 cups water or vegetable stock

1 bay leaf

1 teaspoon salt

1 cup frozen corn kernels

OPTIONAL VEGGIES

chopped zucchini, chard, spinach, or other veggies

In the winter months, when it's cold and dark outside, there's nothing more satisfying for lunch than a thermos full of hot soup. And for busy moms there's no better time-saver than tossing everything into a Crock-Pot in the morning and having dinner ready to go within hours. You can also make this recipe in a pot on the stove, but Crock-Pots are a lifesaver, producing perfectly cooked soups, stews, and chilis.

I love using lentils because they're a powerhouse of nutrition (they have the third-highest level of protein by weight of any legume or nut) and they cook quickly compared to other beans and pulses. Unlike dried beans, which can take hours to soak and cook, lentils don't need to be presoaked, and they're ready in just forty minutes, in this case creating a thick heart-warming chili that explodes with flavor.

Crock-Pot Directions

1. Heat the oil in a large sauté pan over medium heat, add the onions, carrots, celery, and garlic, and sauté for 5 minutes, or until softened. Remove from the heat.

2. Transfer to the Crock-Pot, add the remaining ingredients, and stir to combine.

3. Cover and cook the chili on low for 4 hours.

4. Remove the bay leaf and top with the desired accompaniments and serve.

Stovetop Directions

1. Heat the oil in a large saucepan over medium heat. Add the onions and sauté for 2 minutes. Add the carrots and celery and sauté for 2 more minutes, or until softened. Add the minced garlic and sauté for 1 minute. Add the chili powder and cumin and sauté for an additional 30 seconds.

2. Stir in the remaining ingredients and increase the heat to bring the mixture to a boil.

3. Reduce the heat, cover, and simmer for 20 minutes. Uncover, remove the bay leaf, stir, and simmer for 20 minutes more to thicken.

TIP: Freeze this chili in individual containers for easier defrosting and a thermos full of soup that's almost no work for you!

OPTIONAL ACCOMPANIMENTS

grated Cheddar cheese, sour cream, Greek yogurt, or crème fraîche

silky tomato soup with grilled cheese crouton bites

Makes 4 cups

2 teaspoons olive oil

1 small onion, diced

1 large carrot, peeled and diced

2 garlic cloves, diced

2 large tomatoes, diced (about 2 cups)

2 cups vegetable or chicken stock

1 tablespoon tomato paste

1 teaspoon paprika

1 teaspoon salt

Growing up, my family's pantry could have been a standing advertisement for Campbell's soup. We had at least twenty cans stacked on the shelf at any given time. I would inhale a big bowl of the creamy tomato soup along with a crunchy, gooey grilled cheese on the side weekly.

It's fairly simple to make classic tomato soup homemade. My own personal twist for this recipe—which I'm darn proud of—are mini grilled cheese crouton bites for dipping or to place on top of your soup.

1. Heat the oil in a large soup pot over medium heat. Add the onions and sauté for 2 minutes, or until translucent. Add the carrots and garlic and sauté for 2 minutes more.

2. Add the remaining ingredients to the pot and stir to combine.

3. Bring to a boil, then reduce the heat to low and simmer, uncovered, for 20 minutes.

4. Carefully move the soup to a blender and blend until smooth. You can also use an immersion blender to blend the soup in the pot.

NOTE: If you do not have fresh tomatoes, you can use one 28-ounce can diced tomatoes and decrease the stock to 1 cup.

grilled cheese croutons

1. Butter a skillet and heat it over medium heat.

2. Sandwich 2 slices of cheese between 2 slices of bread and place in the hot skillet. Cook for 2 minutes on each side, or until the bread is browned and the cheese is melted. Repeat with the remaining bread and cheese.

3. Cut each sandwich into 12 pieces and serve with the tomato soup.

NOTE: For crunchier croutons, place the sandwich cubes on a baking sheet and bake them for 5 minutes in a 400°F oven.

Makes 24 croutons

Butter, for the pan

4 slices bread (any type you prefer: whole-wheat sandwich, French baguette . . .)

4 packaged slices Cheddar cheese

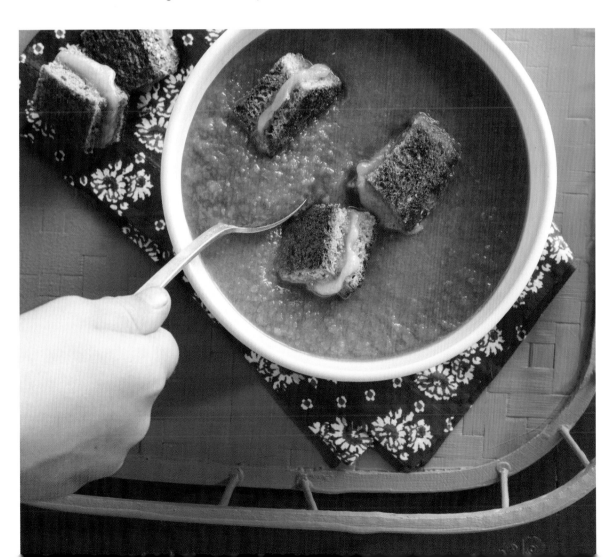

mom's white chicken chili

1 tablespoon olive oil

1 small onion, diced

1 garlic clove, minced

2 pounds chicken
breasts, bone-in,
skinless (about 2 large
breasts)

4 cups (one 32-ounce
box) chicken stock (low-
sodium preferred)

1 teaspoon salt

1 teaspoon ground
cumin

One 15-ounce can
white (cannellini)
beans, drained and
rinsed

1 cup frozen shoepeg
white corn or yellow
corn

One 4-ounce jar or
can diced green chilies
(don't worry, they're
mild)

Juice of 1 lime (about
2 to 3 tablespoons)

OPTIONAL
ACCOMPANIMENTS

sour cream, tortilla
chips, Cheddar or
Monterey Jack cheese

I assume that all of us have at least a few favorite recipes from our childhoods, and for me it was my mother's white chicken chili. Whatever the season, a bowl of her stewlike soup always made me feel comforted and happy.

This version of my mom's recipe is supereasy to make and very wholesome. It also freezes beautifully, so you can enjoy it on those days that you're just too tired or busy to cook. I'm sure plenty of you can relate to that.

1. Heat the olive oil in a large saucepan over medium heat.

2. Add the onions and cook for 4 to 5 minutes, or until translucent. Add the garlic and cook 1 minute more.

3. Add the chicken breasts, stock, and salt, cover, and bring to a boil.

4. Reduce the heat to a simmer and cook for 18 to 20 minutes, or until the chicken is cooked through. Remove the chicken to a plate to cool.

5. While the chicken is cooling, add the cumin, beans, corn, chiles, and lime juice to the pot.

6. Remove the chicken from the bone, chop it into bite-size pieces, and add it to the pot. Cook for 1 or 2 minutes to heat it through.

7. Serve the chili with the desired accompaniments.

NOTE: To freeze the chili for later use, allow to cool, place in glass container or ziplock bags, label, and freeze for up to 4 months. Defrost in a pot over medium-low heat.

JULIE: I always have to make a double recipe of this white chicken chili. My family loves it (along with some corn bread), and we're dying for the leftovers the next day, too.

sandwiches

apple, honey, and cheese quesadilla

Makes 4 servings

1 Granny Smith apple, peeled and sliced thin, or ⅓ cup applesauce

4 whole-wheat or spelt tortillas

1⅓ cup grated Cheddar cheese

Honey, for drizzling

I love devising recipe ideas based solely on what's in my fridge, and whenever I arrive upon something fun, I keep making it nonstop until my family burns out on it for a while. One recent obsession of mine was creative quesadillas.

While you rarely see sweet quesadilla recipes, I thought this cheesy quesadilla with apples and honey was a neat idea, and Kenya really enjoyed helping me experiment with it. We made some with applesauce and others with thinly sliced apples. We couldn't decide which version was more delicious. If you're in need of a quick recipe that will satisfy a sweet *and* savory craving, make your kids some of these.

1. Place half of the apple slices (or 3 tablespoons of the applesauce) on a tortilla and top with half of the cheese and a drizzle of honey.

2. Cover with another tortilla.

3. Slide the quesadilla into a sauté pan over medium heat and cook for 3 minutes on each side. Cut the quesadilla into wedges using a knife or pizza cutter.

4. Continue with the rest of the tortillas and serve warm.

HOLLY: **This is a perfect sweet and savory snack we like to have for dessert!**

LEAH: **My family was skeptical at first. When it was time to eat it was an instant hit.**

BRITTANY: **I was having difficulty getting my two-year-old son to eat quesadillas. I ran across this recipe and decided to give it a try. After the first bite, there was no stopping him. My son will now eat any kind of quesadilla I offer him.**

Couscous-Carrot-Raisin Salad (page 57)

turkey, bacon, cheddar, and tomato melt

Makes 2 servings

4 slices whole-wheat bread

4 slices cooked bacon

1 small tomato, sliced

2 slices roast turkey, thinly sliced

2 slices Cheddar cheese

Our family doesn't eat a lot of meat, but whenever we go out for brunch with my in-laws and they order bacon, the kids go *c-r-a-z-y*. So much so that they've been known to order extra servings to satisfy their cravings.

When you mix crispy bacon with roasted turkey, fresh slices of tomato, and a hearty slice of Cheddar, it's a classic combo that's pretty darn out of this world. But don't take my word for it—just ask my two bacon lovin' babies.

1. Preheat a panini maker.

2. Place 2 slices of bread on a plate and top each with 2 slices of bacon and tomato and 1 slice of turkey and Cheddar.

3. Top the sandwiches with the remaining 2 bread slices.

4. Place the sandwiches in the panini maker and grill for 4 minutes, or until the cheese is melted and the bread is golden.

TIP: To make crispy bacon, place bacon on an ovenproof rack over a sheet pan lined with foil and bake at 400°F for 20 minutes or heat a large sauté pan over medium heat and cook for 8 minutes, or until golden brown and crispy. Place the bacon on several layers of paper towel to drain off excess oil.

Crunchy Potato Chips (page 200)

☷ banana dog bites

Makes 4 servings

2 tortillas (any variety will work; see Note)

¼ cup peanut butter or almond or sunflower butter

2 bananas, peeled

Have you ever thought about how many peanut butter–and–something sandwiches you've made for your kids? I lost count about two years ago. To alleviate the monotony of day-in, day-out sammie making, I started whipping up these Banana Dog Bites.

Kenya couldn't stop laughing the first time I asked him, "You wanna make banana dogs?" He just kept shrieking, "What's a banana dog? That's so silly!" But he loved spreading the nut butter on the tortillas, peeling the banana, laying it in its "tortilla bed" (that got another big laugh), and rolling it up so the banana could "sleep tight" (still more giggles). Then I simply sliced the banana dogs into adorable half-inch sushi-style pieces and sent him off to school with them. But it wasn't until his lunch box came home totally empty that I realized just how yummy they were!

1. Place 1 tortilla on a flat surface and spread 2 tablespoons of peanut butter on the tortilla to coat it evenly.

2. Place one whole banana near the edge of the tortilla and roll it up.

AMANDA: **An instant hit with my daughter! A quick and easy breakfast when we're short on time and also a portable breakfast or snack when we're on the go!**

3. Slice the banana dog into ½-inch rounds.

4. Repeat to make a second banana dog and serve.

NOTE: If your tortillas are stiff, you can put them in the microwave between 2 pieces of moist paper towel and heat for 15 to 20 seconds, or until softened.

MELISSA: **My son's lunch box favorite! We experiment with different spreads like homemade Nutella and peanut butter with strawberry jam, and they're always a hit!**

bananamana–cream cheese sammie

Makes 2 sandwiches

1 banana

¼ cup cream cheese

4 slices whole-wheat bread

My husband is really into eating breakfast sandwiches for (what else) breakfast, so of course Kenya and Chloe always want whatever he's having. Although this Bananamana–Cream Cheese Sammie is ideal first thing in the morning, it isn't exclusively for breakfast. This gratifying carb-filled treat is perfect for lunch and should keep everyone full of energy until dinner!

1. Cut the banana in half crosswise, then cut each half into thin lengthwise strips.

ELISHEVA: **My family eats plain bananas only when they are "just ripe," so I am constantly looking for creative ways to use up bananas that are a bit softer. The Bananamana–Cream Cheese Sammies and Banana Dog Bites are two great ways to use up those extra bananas and both are big hits with my daughter!**

2. Spread 2 tablespoons cream cheese on 1 slice of the bread and top with half the banana slices. Place another piece of bread on top to make a sammie.

3. Repeat to make the second sammie.

banana chocolate-hazelnut spread lavash wheels

My kids love lavash, a soft Middle Eastern flatbread sold in many supermarkets, and they're game to put almost anything in it as a roll-up for lunch. While meat, vegetables, and spreads such as hummus are all good filling options, combining bananas and luscious weelicious Chocolate-Hazelnut Spread (page 218) (or store-bought Nutella) is pretty irresistible.

1. Spread 2 tablespoons of the hazelnut spread on each piece of lavash and top with half of the mashed banana. Leave a ½-inch border on the 2 long sides of the bread and a 1-inch border on one short side.

2. Starting on the end with no border, roll up the lavash. Cut each roll into 8 even wheels.

NOTE: A bit of the filling will get pushed out during rolling. Enjoy this excess for your own little taste test!

Makes 2 servings

¼ cup Chocolate-Hazelnut Spread (page 218) or Nutella

Two 8 x 10 pieces whole-wheat lavash

2 ripe bananas, mashed

cheesy waffles

Waffles aren't just for breakfast anymore! My kids love when I make them mini waffle sandwiches for their lunch boxes. It's a great way to make breakfast leftovers stretch into lunch, especially when you're out of bread but still want to make a sammie. I put everything from tuna salad to turkey to cream cheese inside.

I would imagine you've had sweet waffles before, but have you ever tried savory cheese waffles? They're a great choice when you're on the go and need a complete energy boost. Whether you eat them on their own, as the bread for your sandwich, or just alongside some eggs and bacon, these Cheesy Waffles are a fun change of pace from the traditional waffle you're used to seeing on your plate.

1. Preheat a waffle iron.

2. Combine the flour, baking powder, baking soda, and salt in a bowl and whisk to combine.

3. Add the cheese and coat it thoroughly with the flour mixture (this will help keep the cheese from getting gloppy).

4. In a separate bowl, whisk the eggs, milk, and oil.

5. Add the dry mixture into the wet mixture and whisk to combine. Do not overmix.

6. For each waffle, pour about ⅓ cup of the batter into the greased waffle iron and cook 3 to 5 minutes, or until golden.

7. Serve with the desired accompaniments.

TO FREEZE: After the waffles have cooled, place them in a ziplock bag, label, and freeze. Defrost or pop into a toaster oven or oven at 300°F for 10 minutes.

TIP: To make two mini sandwiches, quarter the waffles, spread two quarters with filling, and top with other halves.

Makes 12 waffles

2 cups all-purpose flour

2 teaspoons baking powder

1 teaspoon baking soda

½ teaspoon salt

1 cup grated Cheddar cheese

2 large eggs

1½ cups milk

3 tablespoons vegetable or canola oil

OPTIONAL ACCOMPANIMENTS

ham, scrambled eggs, and bacon, or serve as a sandwich with cream cheese and sliced turkey

chicken pesto panini

Makes 2 servings

4 teaspoons Everyday Basil Pesto (page 211)

4 slices sandwich bread

2 slices mozzarella cheese

1 cooked chicken breast, sliced

We have a garden full of fresh basil most of the year, which in turn means we always have a freezer full of pesto. That's a very good thing, since pesto is a mealtime lifesaver. It gives zip and zing to anything from pasta to rice and really distinguishes this mouthwatering panini.

1. Preheat a panini maker.

2. Spread 1 teaspoon of the pesto on each slice of bread.

3. Layer cheese and chicken on 2 of the slices and top with the remaining slices.

4. Place each sandwich in the panini maker for 3 minutes, or until cheese is melted and bread is golden brown and crisp.

5. Cut into quarters and serve.

chicken salad roll-ups

This recipe came about one day when I had planned on making wraps, but ran out of tortillas. I'm a bit type A when it comes to a plan, so I was compelled to become creative. Out came my rolling pin and a piece of whole-wheat sandwich bread to fashion my own "flat bread." I liked the results of this recipe so much that I still make this sandwich this way even when I have tortillas on hand!

1. In a bowl, combine the chicken, celery, mayonnaise, Dijon, lemon juice, and salt and toss to mix well.

2. Using a rolling pin, roll the bread to ¼ inch thick.

3. Spread ¼ cup of the chicken salad mixture on each slice of bread and roll it up.

TIP: If you have younger kids, you can secure the roll-ups by gently putting a rubber band around them.

Makes 4 roll-ups

1 cup chopped cooked chicken

2 celery stalks, diced

1 tablespoon mayonnaise

1 teaspoon Dijon mustard

2 teaspoons lemon juice

¼ teaspoon salt

4 slices whole-wheat sandwich bread

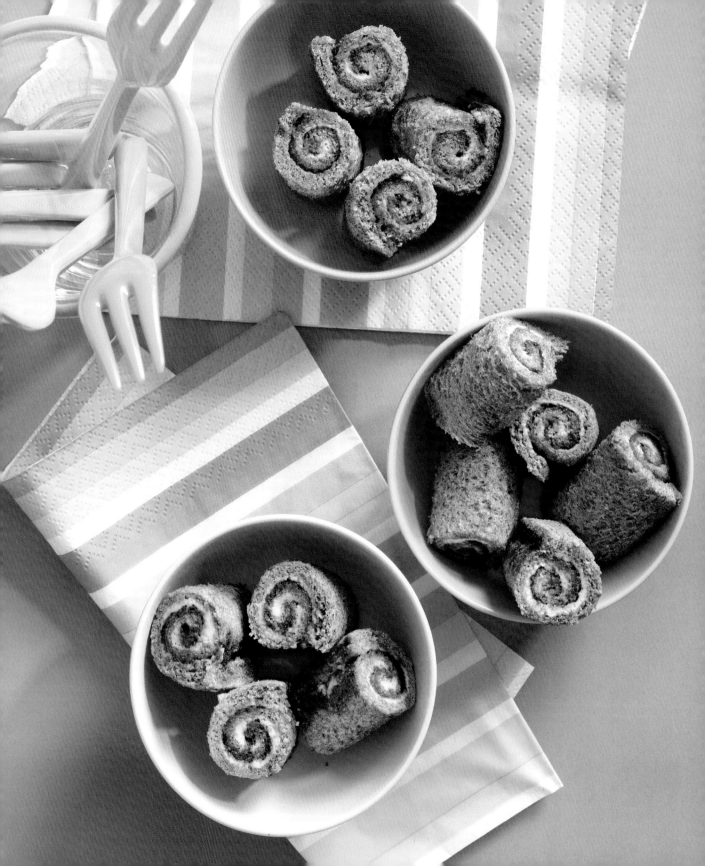

📺 cinnamon roll "sushi"

All the credit for these "sushi" sandwiches belongs to Kenya. As he's gotten older, his interest in what gets packed in his lunch box has grown. Some days he tells me exactly what type of lunch he wants and other days he takes matters into his own hands. He especially loves rooting through the pantry to improvise interesting new combinations for sandwich fillings.

I wasn't so sure about his addition of cinnamon to this roll, but Kenya proved me wrong. Mixed with the cream cheese and honey, it totally pulls the whole thing together. These little bites are easy to pop in your mouth one after another. The only hard part is stopping.

1. Using a rolling pin, roll the sandwich bread to ¼ inch thickness.

2. Spread 1 tablespoon of cream cheese on each piece of bread, making sure to spread all the way to the edges, as it will act as a glue to hold the sushi together.

3. Drizzle with honey and lightly sprinkle with cinnamon to taste.

4. Roll each piece of bread lengthwise to create a log, cut it into "sushi" pieces, and serve.

Makes 2 servings

4 slices whole-wheat sandwich bread

4 tablespoons whipped cream cheese

Honey

Ground cinnamon

egg pesto melt

Makes 1 sandwich

1 large egg

1 tablespoon Everyday Basil Pesto (page 211) or Kale Pesto (225)

½ teaspoon vegetable or canola oil

¼ cup shredded mozzarella cheese

2 slices whole-wheat bread

I adore pesto, eggs, and bread. They're all always present in my fridge, and they have long shelf lives. I like to marry them to quickly make a sandwich my gang goes gaga for, like this Egg Pesto Melt.

The EPM is one of my most reliable and comforting lunch recipes and one of Kenya's and Chloe's favorites. It's easy, unique, and vegetarian. A perfect sammie that is equally enjoyable hot or at room temperature.

1. Whisk the egg and pesto in a bowl.

2. Heat the oil in a small sauté pan over medium heat. Pour in the egg mixture, tilting the pan to spread it evenly across the bottom.

3. Allow the egg to cook undisturbed for 1 minute. Using a rubber spatula, gently pull the egg away from the sides of the pan so the rest of the liquid egg can continue to coat the pan and cook until egg is set.

4. Using the spatula, fold the edges of the omelet inward into a square shape (to fit the bread).

5. Remove the square omelet to a plate. Place half the cheese on a slice of bread and transfer the bread to the pan, cheese side up.

6. Top with the omelet, remaining cheese, and remaining slice of bread. Cook for 1 minute on each side, until golden.

SARAH: **The first time I made my three-year-old daughter an Egg Pesto Melt, she said, "Mommy, this is the best sandwich ever!" It has now become a lunchtime favorite for her and for me!**

EMILY: **I love how the Egg Pesto Melt is quick and easy, yet has a sophisticated taste!**

easy croque monsieur

Makes 1 sandwich

2 slices whole-wheat sandwich bread

2 teaspoons Dijon mustard

2 teaspoons mayonnaise

2 slices Gruyère cheese

2 slices ham

While living in France as a teen I had my first bite of a croque monsieur and I was totally bowled over. Warm melted cheese, a creamy sauce, and salty ham sandwiched between crusty toasted bread was an irresistible combination that made me feel très Parisienne.

Now as a busy mom, I'm not interested in pulling off a béchamel sauce at 7 a.m. before school, but I don't let that stop me from making this simplified version of the classic croque monsieur.

I figure if you can't bring your lunch box to France, bring a little bit of France to your lunch box.

1. Preheat a waffle iron.

2. Spread the Dijon mustard on one slice of bread and the mayonnaise on the other slice.

3. Place a slice of cheese on 1 slice of bread. Layer on the ham and another slice of cheese and top with the remaining slice of bread.

4. Place the sandwich in the waffle iron and cook for 6 minutes, or until the cheese is melted and the bread is golden brown and crisp.

5. Cut into quarters and serve.

matzo sammies

My kids are nuts about matzo. I buy it even when it's not Passover, and they particularly like when I make them sandwiches with it. This matzo sammie is eyecatching, crispy, and full of flavor.

1. Using a sawing motion with a serrated knife, cut each matzo sheet into 4 even squares.

2. Spread 1 tablespoon of the avocado hummus onto 4 pieces of matzo. Sandwich together with the remaining 4 pieces of matzo.

Makes 2 servings

2 whole-wheat matzo sheets

4 tablespoons Avocado Hummus (page 208)

eggplant burgers

Makes 8 burgers

1 tablespoon plus 1 to 2 teaspoons olive oil

1 medium eggplant, cubed

1 garlic clove, minced

½ teaspoon salt

¼ cup chopped parsley

1 large egg

⅓ cup grated Parmesan cheese

1 cup whole-wheat bread crumbs

OPTIONAL ACCOMPANIMENTS

whole-wheat bagels, hamburger buns, sliced cheese, tomato, lettuce, ketchup, pickles

Since having kids, I've started doubling many of my recipes and freezing half of what I make. That's a real plus when I'm craving apples or pears in summer or peaches or tomatoes in winter. It also means that on cold days when I'm dreaming of these Eggplant Burgers, they're only minutes—not months—away. These scrumptious burgers have a meaty texture that's moist inside, with a crisp outer crust. They're perfect on a bun with some melted cheese and are ideal for freezing—no matter what time of year it is!

1. Heat 1 tablespoon of the olive oil in a large sauté pan over medium heat and sauté the eggplant cubes for 3 minutes.

2. Add the garlic and salt and sauté for another 2 minutes.

3. Add 1 tablespoon water, cover, and cook for 3 minutes, or until the eggplant is fork tender. Allow to cool.

4. Place the eggplant and the remaining ingredients in a food processor and puree until smooth.

5. Form the eggplant mixture into patties, using about 2 tablespoons of the mixture for mini burgers and ¼ cup for bigger burgers.

6. Heat the remaining 1 to 2 teaspoons of oil in a large sauté pan and cook the eggplant patties for 2 minutes on each side, or until golden brown.

7. Serve with the desired accompaniments.

TO FREEZE: Place the cooked patties on a baking sheet in the freezer for 1 hour. Then place in a ziplock bag, label, and freeze for up to 3 to 4 months. When ready to serve, place the patties on a baking sheet in a 300°F oven for 10 minutes, or until warm.

ELISHEVA: **Eggplant Burgers were how I got my daughter to be willing to try eggplant. The burgers were a hit and now she is open to eating eggplant in other forms as well!**

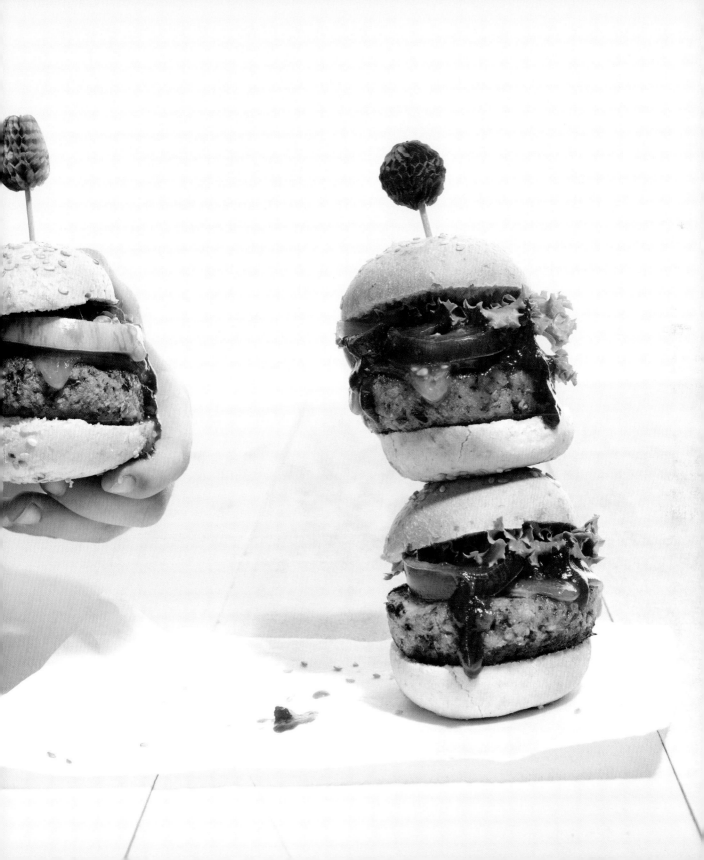

grilled cheese and pickle panini

Makes 2 servings

4 slices Cheddar cheese

4 slices whole-wheat bread (or your favorite sandwich bread)

2 mini kosher dill pickles, or 2 Kenya's Favorite Pickles (page 246), thinly sliced lengthwise

We always buy hearty whole-grain sourdough bread and sharp Cheddar cheese at the farmers' market, then come home and make paninis. Sometimes we'll add a slice of heirloom tomato or avocado to jazz them up, but one weekend Kenya asked if we could use pickles. Pickles. Not as a garnish to accompany the tomato and avocado, mind you, but as the sole costar to the cheese. At first it sounded so silly that we all (even Kenya) started giggling, "Grilled cheese and pickle?" But then Chloe asked for it too. Never one to ignore a culinary request, especially one from my kids, I thinly sliced a bunch of kosher dills and started building the sandwich.

Well, my munchkins are definitely on to something. Who knew you could up the ante on the classic grilled cheese—a sandwich already bordering on perfection? The Grilled Cheese and Pickle Panini seriously raises the bar.

1. Preheat a panini maker.

2. Place a slice of cheese on a slice of bread and cover with a layer of sliced pickles.

3. Place another slice of cheese on top of the pickles and cover with a slice of bread.

4. Repeat to make the second panini.

5. Place the sammies in the panini maker and cook for 2 to 3 minutes, or until the cheese is melted. (You can also just grill them in a skillet.)

6. Slice each panini in half or on a diagonal to make triangles and serve.

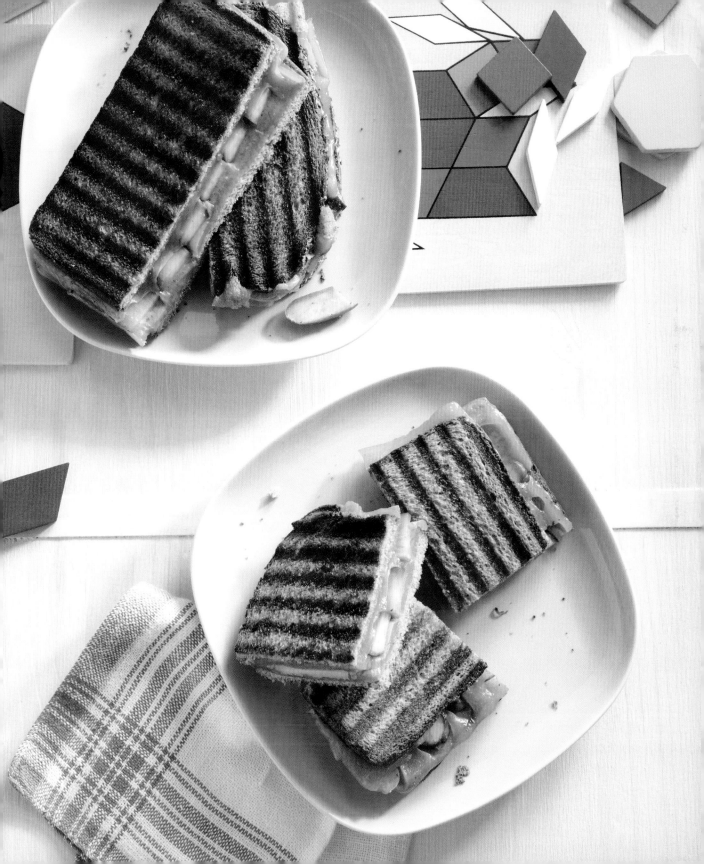

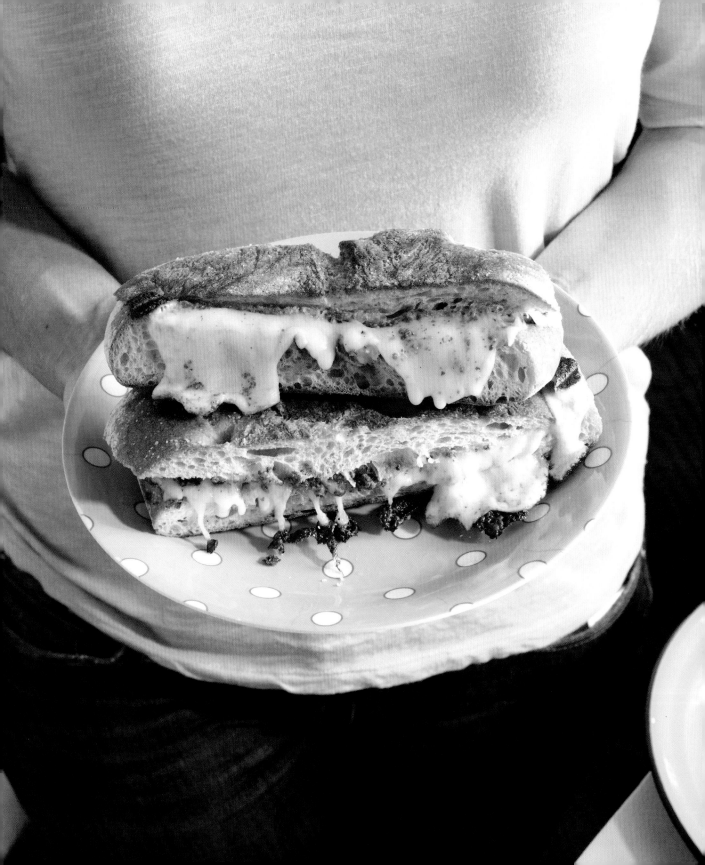

ooey-gooey mozzarella pesto melt

This mozzarella pesto melt feels more like a sandwich you would enjoy at a restaurant than something you'd find in your home kitchen. But if you've got a panini maker, some zesty pesto, and good-quality mozzarella, you too can make this ooey-gooey, crusty Italian sammie worthy of your corner bistro.

1. Preheat a panini maker.

2. Spread 1½ tablespoons of pesto onto 2 bread slices. Top each with 1 slice of mozzarella and sandwich together with the remaining bread slices.

3. Place the sandwiches in the panini maker and cook until the cheese is melted and the bread is golden brown.

Makes 2 servings

3 tablespoons Everyday Basil Pesto (page 211) or Kale Pesto (225)

4 slices focaccia

2 slices fresh mozzarella cheese

egg pickle salad sandwich

Makes 4 sandwiches (1½ cups egg salad)

4 hard-boiled eggs, diced (see page 262)

¼ cup diced dill pickle

1 tablespoon mayonnaise or Vegenaise

2 teaspoons Dijon mustard

8 slices whole-wheat or multigrain sandwich bread

Even if you rarely cook, you probably have one or two recipes up your sleeve that your grandmother taught you. I originally learned to make a classic egg salad from mine. Over the years, I've started adding one of my preferred ingredients to take the recipe up a notch: dill pickles! While it may not seem like an obvious idea, the addition of some diced, crisp pickle adds texture and tang and may have people referring to your egg salad as a new classic.

1. Place the eggs, pickle, mayonnaise, and mustard in a bowl and gently stir to combine.

2. Spread the mixture on 4 slices of bread, sandwich together with the remaining bread, and serve.

NOTE: You can also mash the mixture if you prefer a creamier egg salad.

Kale Chips (page 199)

my childhood favorite pimiento cheese sandwich

One of my most treasured food memories (I bet my brother and cousins can back me up on this one) was making and eating pimiento cheese sandwiches with my grandmother. Stuffed with slices of sharp Cheddar cheese, bits of roasted bell peppers, and a spoonful of mayo, my grandmother's version of this sandwich was not the epitome of healthful eating—but I absolutely adored it. Hard as it is to lighten up this sandwich without sacrificing the taste that makes it so special, I did my best by reducing a half cup of mayo to two tablespoons! This sandwich is a Southern tradition that shouldn't be missed.

1. Place the cheese, pimientos, and mayonnaise in a bowl and stir to combine.

2. Spread half the mixture on 2 slices of bread and sandwich together with the remaining slices of bread.

TIP: You can use low-fat mayonnaise to make this sandwich even lighter.

Makes 2 sandwiches

1 cup finely grated Cheddar cheese (I like to use a hand grater, but you can also use a box grater and then chop it into smaller pieces)

2½ tablespoons or one 2-ounce jar diced pimientos, drained

2 tablespoons mayonnaise or Vegenaise

4 slices whole-wheat sandwich bread

mediterranean pita sammie

Makes 2 servings

1 cup thinly sliced cucumbers

½ cup roughly chopped sun-dried tomatoes

½ cup roughly chopped kalamata olives

2 tablespoons crumbled goat cheese

4 basil leaves, roughly chopped or torn

2 pita pockets, sliced in half

My olive-obsessed daughter could eat this sammie day in and day out. Pita pockets filled with thinly sliced cucumbers, tangy goat cheese, fresh basil, and, of course, tons of kalamata olives will make you feel like you've been transported to Greece.

1. In a bowl, combine the cucumbers, sun-dried tomatoes, kalamata olives, goat cheese, and basil.

2. Stuff the pita pocket halves with filling and serve.

prosciutto and butter sandwich

I endeavor to make lunches that are plenty nutritious and wholesome, but every once in a while I give in to my kids' worship of butter. "Worship" is hardly a strong enough word. Many are the times I've caught Kenya and Chloe at a restaurant eating whole pats of butter!

On those occasions when my willpower is at its lowest, I treat them to a hunky pretzel roll slathered with good-quality butter and thick slices of prosciutto. Not the healthiest of recipes, but it's delectable and makes my kids endlessly happy.

1. Spread 1 teaspoon butter on each piece of bread.

2. Top the bottoms of the rolls with 2 slices of prosciutto and add the roll tops.

3. Cut each sandwich in half diagonally and serve.

Makes 2 servings

4 teaspoons softened butter (I like Kerrygold or Horizon)

2 pretzel rolls, cut in half (available at Trader Joe's or specialty German bakeries)

4 slices prosciutto

pumpernickel tuna melt

Makes 2 servings or 4 mini sandwiches

One 5-ounce can tuna (I prefer light or chunk white tuna packed in water), drained

1 celery stalk, chopped fine

1 teaspoon Dijon mustard

1 teaspoon mayonnaise or Vegenaise

8 slices mini pumpernickel bread (or cocktail pumpernickel bread)

4 slices Cheddar cheese

It's no secret that I spend *way* too much time in the grocery, but it wasn't until one day this year when I realized that for too long I had been walking by the cutest-looking, tastiest, and most kid-friendly bread. Mini pumpernickel can be found in the bread section of your grocery, and since the slices are small in size, they're perfect for little hands and lunch boxes (and great for parents trying to control their portion size).

The other great thing about pumpernickel is that it keeps fresh in the refrigerator longer than most other breads, so once you have it on hand you can make this sandwich anytime. The rest of the ingredients are probably already in your pantry, so throwing these together for lunch should be a breeze.

1. Preheat a panini press.

2. To make the tuna salad, combine the tuna, celery, mustard, and mayonnaise in a bowl.

3. Place a quarter of the tuna salad on each of 4 slices of bread.

4. Top each chunk of tuna salad with a slice of Cheddar cheese and close the sandwich with another slice of bread.

5. Cook the sandwiches in the panini press for 3 minutes on medium heat (or in a sauté pan for 2 minutes on each side), until toasted and golden.

strawberry–cream cheese "sushi rolls"

For kids who prefer sandwiches that are more sweet than savory, these "sushi rolls" are a real treat. They also look really appealing in your little one's lunch box. Filled with a smear of tangy cream cheese and a dollop of fresh strawberry preserves, they're so lip-smacking, they could almost pass for dessert. Hey, that's actually not a bad idea.

1. Using a rolling pin, roll the bread to ¼ inch thick.

2. Spread 2 teaspoons of cream cheese on each slice.

3. Spread 2 teaspoons of strawberry preserves on top of the cream cheese.

4. Roll up the bread and cut each roll into five 1-inch "sushi" pieces.

See a photograph of the recipe on page 4.

Makes 2 servings

4 slices whole-wheat sandwich bread

8 teaspoons whipped cream cheese

8 teaspoons strawberry preserves

i ♥ grilled cheese

Makes 4 servings

8 slices whole-wheat sandwich bread

Unsalted butter

4 slices Cheddar cheese

Being the annoying type of mom I am, I try to put something different in my kids' lunches daily, so that they don't get fixated on always eating the same thing. Little good that's done—both of my kids are still grilled cheese obsessed.

If *your* little one loves grilled cheese every day, try making him or her one of these cut-out sammies, which puts a fun spin on the classic. I let the kids help me make this before school in the morning, giving them cookie cutters to make various shapes in the bread, which they love doing. Letting your kid put her initial in the middle of her sandwich is about as awesome as it gets, or give her a big heart cutter for extra love. Lunch doesn't get more personalized than this.

1. Using a heart-shaped cookie cutter, cut the centers out of 4 slices of bread.

2. Heat a pat of butter in a large griddle or skillet over medium heat.

3. Place both a cutout bread slice and a whole slice on the griddle and cook for 3 minutes.

4. Flip the whole piece of bread, cover with a slice of cheese, and top with the piece of cutout bread. Cook 3 minutes, or until the cheese is melted.

5. Repeat with the rest of the bread and cheese to make 3 more sandwiches.

swiss avocado turkey quesadilla

Makes 2 servings

½ cup grated Swiss cheese

2 whole-wheat tortillas

4 slices deli turkey

1 avocado, sliced

From the time my kids were babies they've been totally addicted to avocado. That's been a big bonus for me, as avocados provide all eighteen essential amino acids for the body to form a complete protein as well as the healthy kind of fats everybody needs. They're so versatile that they could be added to almost any recipe in this chapter, but they're especially tasty in this killer quesadilla with tangy Swiss cheese and sliced turkey.

1. Heat a sauté pan over medium heat.

2. Sprinkle 2 tablespoons of cheese on half of each tortilla.

3. Layer the turkey and avocado on top of the cheese and top with remaining cheese.

4. Fold the tortillas in half and place in the sauté pan. Cook for 1 minute on each side, or until the cheese is melted and tortilla is golden.

5. Cut into triangles and serve.

tapenade–cream cheese pinwheels

This recipe calls for only three ingredients, all of which stay fresh in your fridge for weeks, and it takes just a minute or so to make, so when you have to get something awesome in your kid's lunch box in a hurry, these are a total no brainer. I asked Kenya what he liked best about these tasty rolled-up sandwiches, and he said, "They're easy to eat, really creamy, and salty."

1. Using a rolling pin, flatten the bread to ¼ inch thick.

2. Spread each slice of bread with 1½ tablespoons cream cheese and top with 1½ tablespoons tapenade.

3. Roll the bread into pinwheels. The cream cheese will act as a glue to hold the rolls together. Cut into bite-size pieces and serve.

Makes 2 servings

2 slices whole-wheat sandwich bread

3 tablespoons cream cheese

3 tablespoons Cheesy Olive Tapenade (page 220)

turkey blta wraps

Makes 2 servings

4 teaspoons mayonnaise or Vegenaise

2 whole-wheat tortillas

½ cup chopped romaine lettuce

¼ cup diced tomato

½ avocado, diced or sliced

2 slices bacon, cooked and chopped

4 slices roast turkey

As my kids get older, I find they want to eat salads more and more. It's not what you'd expect from a six- and four-year-old, but I found that once I started adding more lettuce and tomato to their sandwiches and wraps, they started to request them.

But even with veggie-loving kids, adding a hit of smoky bacon can only make their smiles wider. To keep these Turkey BLTA Wraps on the leaner side, I use light mayo and turkey bacon, but feel free to use whatever you prefer. With the addition of avocado, this is my twenty-first-century version of the classic BLT, only better!

1. Spread 2 teaspoons mayonnaise on each tortilla, making sure to cover the edges of the tortilla, since the mayonnaise will act as a glue to hold the wraps together.

2. Layer the lettuce, tomatoes, avocado, bacon, and turkey on the edge of the tortilla closest to you.

3. Wrap up like a burrito and serve.

turkey-cheddar panini

I requested a lot of turkey and cheese sandwiches when I was a kid. I remember throwing a fit if my mom didn't have sliced turkey or Cracker Barrel Cheddar on hand (heavens, was I demanding). Even today when I want something übercomforting, it is my go-to sandwich.

It was only a few years ago that I thought about turning this timeworn favorite of mine into a warm pressed sandwich. It totally takes it to another level, and my kids are always psyched to find it in their lunch boxes. I wish I'd known about paninis when *I* was a kid!

1. Preheat a panini press on a medium setting.

2. Place 1 slice of bread on a flat surface.

3. Layer 1 slice of cheese, 2 slices of turkey, 1 slice of cheese, and 1 slice of bread. Repeat to make the second sandwich.

4. Cook the sandwiches in the panini press for 3 minutes, or until the cheese is melted.

5. Slice into quarters and serve.

Makes 2 servings

4 slices whole-wheat sandwich bread

4 slices thin deli turkey

4 slices Cheddar cheese

turkey-cheese rolls

Makes 2 servings

8 slices deli turkey

8 tablespoons grated Cheddar cheese

This recipe idea comes courtesy of my cousin Raleigh, one of the best moms east of the Mississippi, who's always coming up with healthful (and simple) recipes for her boys. Coincidentally, my father-in-law has always loved a similar version, layering a slice of turkey on top of a slice of Swiss cheese, rolling them up into a tube, and then dipping it in Dijon mustard. For this recipe, I just replaced Raleigh's cheese slices with grated cheese and voilà, they disappeared right out of Kenya's and Chloe's lunch boxes.

With only two ingredients, these rolls offer a protein-packed meal that's straightforward and yummy. Toss some sliced cucumbers, an apple, and a handful of crackers alongside them in the lunch box and you're all set!

1. Layer 2 slices of turkey and top with 2 tablespoons of cheese.

2. Roll up, slice, and serve.

3. Repeat to make the rest of the rolls.

NOTE: This can also be made with ham or roast beef.

turkey cranber-wee bagel sandwich

In the period between Thanksgiving and Christmas, *a lot* of turkey is roasted and eaten under our roof. If that sounds familiar and you have a bunch of holiday leftovers, this sandwich is a perfect way to change things up for lunch using ingredients you most likely already have and make sure your leftovers are not *left over* for long!

1. Spread the mayonnaise on the cut sides of the bagel.

2. Layer the turkey, cranberry sauce, and sprouts on the bottom half of the bagel.

3. Add the bagel top to make a sandwich.

Makes 1 sandwich

1 teaspoon mayonnaise or Vegenaise

1 whole-wheat bagel (or mini bagel), sliced in half*

1 or 2 slices roast turkey breast

2 tablespoons of your favorite cranberry sauce, or one of my two recipes on weelicious.com

1 small handful sprouts, microgreens, or lettuce

*I adore the mini whole-wheat bagels from Whole Foods because they're inexpensive, nutritious, the perfect lunch box size for little hands, and Kenya craves them. But you can use any kind of mini bagel you find and love.

veggie burgers

**Makes 4 burgers
or 8 mini burgers**

½ cup bulgur wheat

One 15-ounce can pinto
beans, drained and
rinsed

½ cup grated Monterey
Jack cheese

½ cup grated carrots

½ teaspoon salt

½ teaspoon garlic
powder

½ teaspoon onion
powder

1 tablespoon canola,
vegetable, or olive oil

OPTIONAL
ACCOMPANIMENTS

whole-wheat buns,
lettuce, tomato,
ketchup, mustard,
mayonnaise, pickles

For many of my mom friends, frozen veggie burgers are a mealtime staple. I informally polled some moms on the weelicious Facebook page to find out why they like frozen veggie burgers so much. The most common answers I got were, "My kids love them," "They're easy to prepare," and, most frequently, "They're healthy."

That last answer is almost true. Compared to so many other packaged foods you can buy at the grocery, frozen veggie burgers seem really healthy (some brands are certainly better than others). The problem is that many are packed with sodium, additives, and fillers. They also can be pretty expensive, with the more "healthful" brands charging *well over a dollar per burger*. Paying that kind of money for something you can make so much better and for half the cost at home is beyond me.

This veggie burger recipe is nutritious, easy to make, and freezes beautifully, so you get all the convenience and great taste of store-bought brands, only considerably cheaper (approximately forty cents per burger)—and you know exactly what's in them. And on those days when you're in a hurry (doesn't that seem like every day?), you'll be glad to have a few of these stored in the freezer, ready to heat up and pop in the lunch box.

1. Place the bulgur wheat and 1 cup water in a pot. Bring to a boil over medium heat, then reduce to a simmer, cover, and cook for 13 minutes, or until most of the liquid has been absorbed.

2. Place the bulgur in a large bowl and set aside to cool.

3. Place the pinto beans in a food processor and puree until smooth.

4. Add the pureed beans, cheese, carrots, salt, garlic powder, and onion powder to the bowl with the cooked bulgur and mix thoroughly.

5. Divide the mixture to make 4 regular-size burgers or 8 mini burgers and form into patties (see Note below for freezing instructions).

6. Heat the oil in a large sauté pan over medium heat. Add the patties and cook for 3 minutes on each side, or until the burgers are golden.

7. Serve with the desired accompaniments.

NOTE: The patties can be frozen before being cooked on a baking sheet for 1 hour and placed in a large ziplock bag or individually wrapped and frozen. When ready, defrost and continue with step 6.

veggie tortilla roll-ups

Makes 4 servings

½ cup Supereasy Hummus (see page 210)

4 whole-wheat tortillas

2 medium carrots, peeled and grated (about 1 cup)

1 avocado, sliced

Whenever I make homemade hummus, the kids can predict what will be in their lunch boxes the next day: veggie rolls made with scoopfuls of this creamy spread. With one of my kids already leaning toward becoming vegetarian, these tortilla roll-ups are a protein-packed, tasty lunchtime lifesaver.

1. Spread 2 tablespoons hummus on each tortilla, taking care to cover the edges, since the hummus will act as a glue to hold the wrap together.

2. Sprinkle ¼ cup of the grated carrots along the closest edge of each tortilla, and lay a quarter of the avocado slices on top of the carrots.

3. Roll up, slice in half diagonally, and serve.

Vibrant Chopped Veggie Salad (page 51)

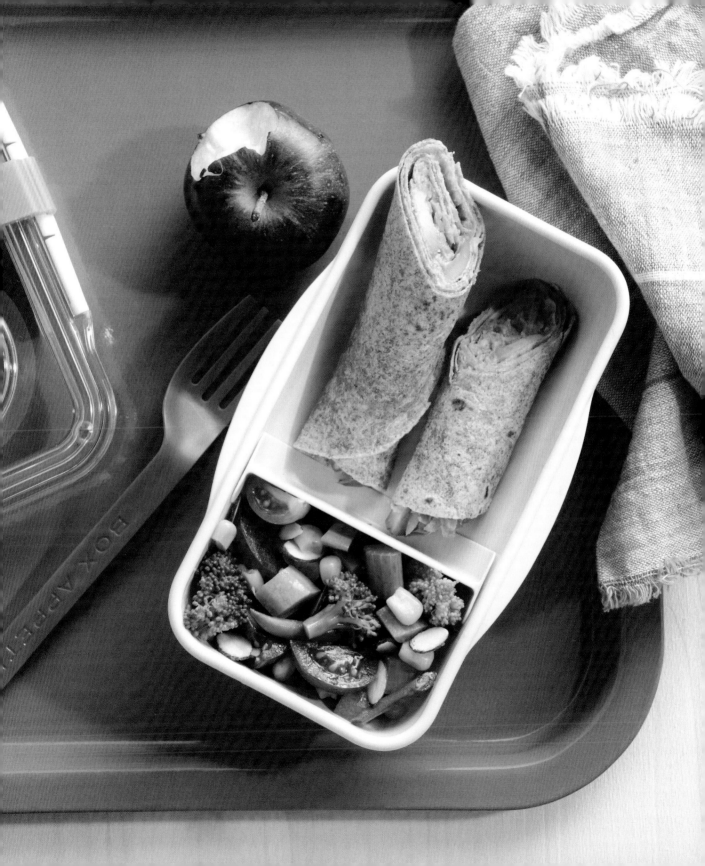

whole-wheat pancake mix

Makes 6 batches of pancake mix serving 4 each

6 cups white whole-wheat flour (see page 132)

⅓ cup sugar

2 tablespoons baking powder

1 tablespoon baking soda

2 teaspoons salt

As much as I love making pancakes from scratch, the convenience of having a good premade mix is essential for time-challenged moms. There have been plenty of sleep-deprived mornings when I've had to get the whole family out the door and wearily reached for my beloved box of Kodiak Cakes pancake mix. Easy to make, and made from wholesome ingredients, they turn out awesome pancakes every time. But with a price tag of almost $6 a box, I resolved one day to create my own simple mix.

It took me a bit of experimentation, but I finally was over the moon—I mean really over the moon—with this outcome. It actually may be one of my favorite weelicious recipes because of its versatility. I use this mix to make waffles, too, and my kids say they're the best they've ever had!

This recipe makes a bit more mix than what you'd normally find in a box of the premade stuff, but I find that to be a plus, especially if you have a house full of pancake or waffle lovers.

1. Whisk together all the ingredients until well combined.

2. Store in an airtight container in a cool, dry place.

pancake sandwiches

1. Whisk the egg, buttermilk, and oil in a large bowl.

2. Whisk in the pancake mix until just combined (do not overmix—lumps are fine).

3. Heat a large pan or griddle over medium heat and grease with butter or oil.

4. Pour about 1 tablespoon of the pancake mixture onto the griddle, making as many pancakes as will fit.

5. Cook for 2 minutes, flip the pancakes, and cook for 1 minute more.

6. Use 2 pancakes to create a sandwich.

TIP: If you do not have buttermilk, you can make it by adding 1 tablespoon vinegar or lemon juice to 1 cup of milk. This mix also works beautifully with any type of milk you prefer!

TIP: To make waffles, place ¼ cup batter in a preheated waffle iron and follow manufacturer's directions.

Makes 4 servings

1 large egg, whisked

1 cup buttermilk (see Tip)

1 tablespoon vegetable or canola oil

1 cup Whole-Wheat Pancake Mix (page 124)

Butter or oil, for the pan

SUGGESTED FILLINGS:

Chocolate-Hazelnut Spread (page 218), peanut butter and Pure Strawberry Preserves (page 226), or apple or pumpkin butter and cream cheese

raspberry-mascarpone heart sandwiches

Makes 4 servings

One 8-ounce package mascarpone cheese or cream cheese

2 tablespoons raspberry preserves

8 slices whole-wheat sandwich bread

1 pint fresh raspberries

I know fresh raspberries and mascarpone cheese aren't two things people usually have on hand, but Valentine's Day comes around only once a year and just imagine how loved your little one will feel when he opens his lunch box on February fourteenth and finds this special Valentine's Day sammie waiting for him.

Filled with fresh raspberries, creamy mascarpone (a soft spreadable Italian cheese sold in most supermarkets), and just a touch of raspberry preserves for added sweetness, this is a scrumptious school lunch surprise your little one won't soon forget.

In fact, your kids may start asking you if every day can be Valentine's Day—and who would say no to that!?

1. Mix the mascarpone cheese and raspberry preserves in a bowl until smooth and creamy.

2. Using a 4-inch heart-shaped cookie cutter, cut a heart out of each piece of bread.

3. Spread 1 tablespoon of the mascarpone mixture onto each heart.

4. Flatten the raspberries by opening them up with your fingers.

5. Place 4 or 5 of the flattened raspberries on half of the bread hearts, then top with the remaining bread hearts to make sandwiches.

smoked salmon and cream cheese bites

One of our favorite vendors at our local farmers' market is Marilyn, or "the fish lady" as we affectionately call her. Marilyn and her sister Eileen sell the most amazing, fresh seafood and she loves showering our kids with special gifts from the sea. One item she always gives them is a slice or two of her home-smoked salmon. My husband grew up eating a lot of smoked fish and he swears Marilyn's is the best he's ever eaten.

Since Chloe can't seem to get enough of the "smokey," as she calls it, I decided to make these beautiful little Smoked Salmon and Cream Cheese Bites to add to her lunch rotation. They're ideal because they're easy for her to pick up and eat—and they look just like little sushi rolls!

1. Spread 2 tablespoons cream cheese evenly on each tortilla.

2. Place smoked salmon in a layer covering the cream cheese.

3. Roll up the tortillas into cylinders and cut them into rolls.

Makes 2 servings

4 tablespoons cream cheese (I use whipped cream cheese because it's easier to spread)

2 whole-wheat or multigrain tortillas

4 to 6 slices smoked salmon

the amazing veggie-packed sandwich

Makes 2 servings

2 tablespoons Everyday Basil Pesto (Page 211) or Supereasy Hummus (page 210)

4 slices whole-wheat sandwich bread

1 small avocado, pitted, peeled, and sliced

1 tomato, sliced

1 Persian cucumber, thinly sliced lengthwise

2 tablespoons sprouts

2 slices cheese (Cheddar, mozzarella, Swiss, or Monterey Jack)

I'm sure there are plenty of parents with selective eaters who could never imagine their culinarily challenged kids eating a veggie sandwich overflowing with crunchy cucumbers and carrots and slathered with luscious hummus and pesto, but I've got two kids who consistently surprise me when they make short work of this sandwich, which is practically a salad on bread. It's full of nutritious foods you want your kids eating and perfect for all those budding vegetarians in your life, since they can get protein, carbohydrates, and vegetables all in one place. Whether you're a vegetarian or not, this sandwich is plain old good eatin'.

1. Spread ½ tablespoon pesto on each slice of bread.

2. Layer the avocado, tomato, cucumber, sprouts, and cheese on 2 slices of bread and top with the remaining bread slices.

sandwich on a stick

Isn't everything better when it comes on a stick?

My kids definitely thought so when they saw me packing these unique kabobs in their lunch boxes. While it seemed a little silly to them at first, as soon as they started munching and sliding off the ingredients one after the other, they totally got into it.

Now Kenya and Chloe often ask me for their meals on a stick. As long as they're eating whatever good stuff I make for them, who am I to argue?

1. Skewer 1 cube of bread, 1 cube of Cheddar cheese, 1 piece of ham, 1 cherry tomato, another piece of ham, 1 cube of mozzarella cheese, and 1 cube of bread.

2. Repeat with the remaining skewers and ingredients.

3. Serve with mustard for dipping or other optional accompaniments.

TIP: Other foods that work great on a stick would be sliced or cubed turkey or roast beef, cucumber, Swiss cheese, and bell pepper.

Makes 10 skewers

10 skewers

2 cups cubed bread (ciabatta, French, or other hearty bread works)

1½ cups cubed Cheddar and mozzarella cheese

1 slice thick-cut deli ham, cut into strips or cubes

10 cherry tomatoes

OPTIONAL
ACCOMPANIMENTS

mustard, mayonnaise, Vegenaise, or Veg-Wee Dip (page 222)

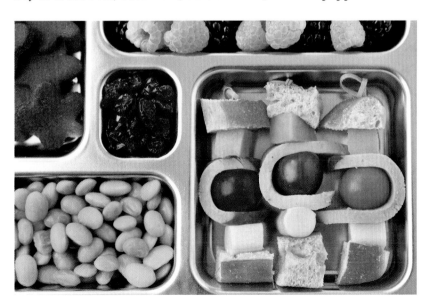

Chocolate Graham Crackers (page 277)

pizza

white wheat pizza dough

Makes four 9-inch pizzas or 1½ pounds dough

One ¼-ounce package active dry yeast

1⅓ cups lukewarm water

1 tablespoon olive oil, plus more for greasing the bowl and brushing on the pizza crust

1 tablespoon honey

3 to 4 cups white whole-wheat flour

1½ teaspoons salt

Have you ever tried making homemade pizza dough? After doing it once you'll realize just how easy it is. You need only a few basic ingredients to produce a simple, delicious dough that bakes up into bubbly, crispy perfection (and is also a ton of fun to prepare).

When I first heard about white wheat, I thought it was the same thing as white flour, but, in fact, it's made from naturally colorless whole wheat, which has virtually the same nutritional benefits of the traditional whole wheat you're used to. It also has a milder flavor than whole wheat, making it more appealing to people who usually eat refined white flour. (Hmm, who could some of those people be . . . kids, perhaps?!)

You can use this nutritious dough to make everything from Pizza Balls (page 138) to Pizza Muffins (page 140) to Stuffed Pizza Rolls (page 147) and more. *Mamma mia!*

1. Combine the yeast and water in a small bowl and let stand until foamy, about 5 minutes. (If the yeast doesn't foam, make sure to check the expiration date—you may need to buy a fresh package.) Add the olive oil and honey and stir to combine.

2. Combine 3 cups of the flour and the salt in a large bowl (or the bowl of a standing mixer, using a dough hook attachment).

3. Add the liquid mixture to the dry mixture and mix to combine. Knead the dough either by hand on a clean surface for 10 minutes or on the low setting of your standing mixer for 3 minutes, until smooth and elastic. You want the dough to bounce back when you press it. If your dough is too wet and sticky, add more flour, ¼ cup at a time, until you reach a soft and elastic consistency.

4. Transfer the ball of dough to an oiled bowl, cover the top of the bowl with a dish towel, and set it aside in a warm place to rise for 30 minutes. The dough will double in size.

5. Preheat the oven to 500°F.

6. Turn the dough out onto a lightly floured surface and knead for 15 seconds. Cut into 4 equal balls, form each into rounds, and flatten each into a disk. Let the disks rest for 5 minutes. If using the dough for Pizza Muffins divide the dough into 3 disks and freeze one for another day.

7. Proceed with your desired recipe that uses pizza dough, or freeze some or all of the disks: place 1 round disk on a parchment-lined plate or cookie sheet and layer the rest of the disks on top, with parchment between each disk. Freeze for 1 hour, then transfer the stack of frozen pizza disks to a freezer bag. The disks can be stored in the freezer for up to 3 months. When you're ready to use them, remove the disk(s) from the freezer and let them defrost in the refrigerator for 24 hours. Then, let them come to room temperature and proceed with steps 5 and 6.

TIP: White whole-wheat flour can be found at most grocery and health food stores. If you can't find white whole-wheat flour you can use equal amounts white and wheat flour.

veggie-heavy pizza sauce

Makes 4 cups

1 tablespoon olive oil

1 red, orange, or yellow bell pepper, diced

1 medium carrot, peeled and chopped

1 celery stalk, chopped

1 small onion, diced

2 garlic cloves, minced

1 tablespoon tomato paste

Two 28-ounce cans diced tomatoes, drained

One of the reasons you won't find vegetables masqueraded in my meatloaf or disguised in my dinners is that I want my kids knowing that vegetables *rock* and will help their bodies grow every day.

If you're the parent of a challenging eater, this Veggie-Heavy Pizza Sauce is for you. It's basically a variety of pureed vegetables, but it tastes just like the sauce you get at your favorite pizzeria. While it's right at home on top of crisp pizza dough, it's also perfect on pasta, rice, or even quinoa.

There's no need to sneak with this pizza sauce. Instead, tell your kids that not only is this the most tangy, tasty sauce ever, but it also happens to be made entirely from veggies! Knowledge is power, and I say that it also happens to be delicious!

1. Heat the oil in a saucepan over medium heat. Add the pepper, carrot, celery, onion, and garlic and sauté until the veggies are soft, about 5 minutes. Add the tomato paste and cook for 1 minute, stirring constantly.

CRYSTAL: I've been searching high and low for an easy but delicious wheat pizza crust recipe. Your white wheat pizza crust fit the bill. It's the best we've ever had! The Veggie-Heavy Pizza Sauce to go with it . . . yum . . . I could eat it with a spoon! Thank you for sharing your recipes. They have seriously changed my life.

NICOLE: I absolutely love the pizza sauce! It's so easy to make and I freeze portions, which come in handy during the week. We love homemade pizza, and it's wonderful to have this healthy sauce on hand!

2. Add the tomatoes, turn the heat to low, and simmer for 10 minutes.

3. Remove the pan from the heat and puree the mixture with an immersion hand blender (or in a regular blender) until almost smooth.

4. Return the sauce to the heat and simmer 10 to 20 minutes, until thick. The longer you simmer this sauce, the thicker and more flavorful it will become. You can simmer it for up to 2 hours—just be careful to stir it often to make sure it doesn't scorch.

5. Serve the sauce on Homemade Pizza Your Way (page 136), Pizza Bagel Bites (page 137), pasta, rice, or anything you like!

White Wheat Pizza Dough (page 132)

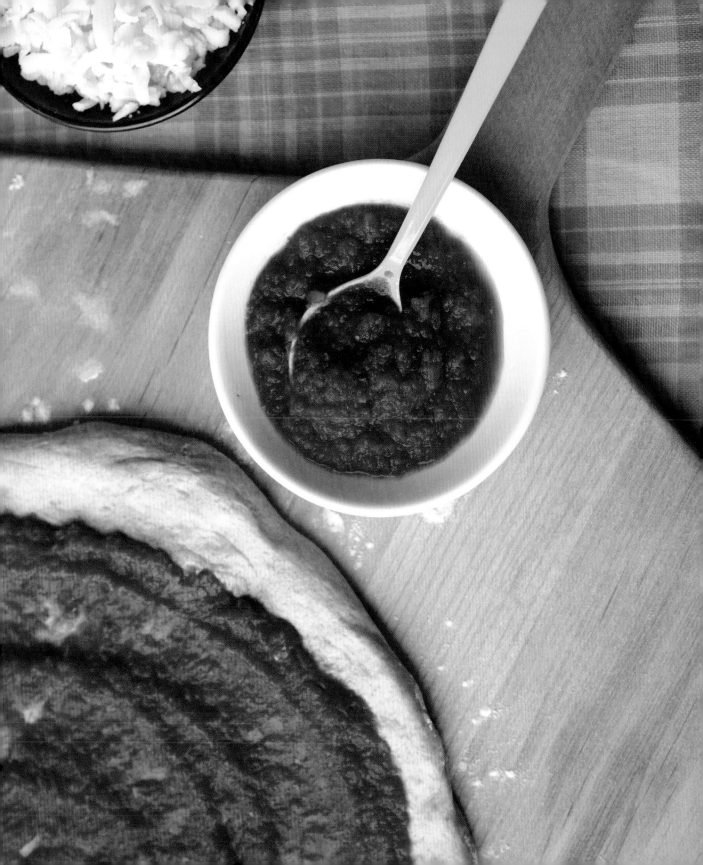

homemade pizza your way

**1 disk White Wheat
Pizza Dough (page 132)
or prepared dough**

**½ cup Veggie-Heavy
Pizza Sauce (page 134)
or other sauce**

**½ cup shredded
mozzarella**

**Optional desired
toppings (see Note)**

**Olive oil, for brushing
the crust**

TOPPING IDEAS:

**ham, pineapple, cherry
tomatoes, mushrooms,
olives, peppers,
pepperoni, steamed
kale, onions, fresh
basil, corn kernels,
sun-dried tomatoes,
scallions, grilled
chicken, artichoke
hearts, shrimp,
steamed broccoli,
prosciutto, anchovies,
bacon, and sausage**

A fun Sunday night tradition of ours is making homemade pizzas together as a family. One of our kids' favorite parts is getting to choose the toppings for their sections of the pie. We've actually found that foods they normally won't eat on their own become totally appealing to them when tossed on their pizza. I guess pizza truly is a magic food.

1. Preheat the oven to 500°F.

2. Holding it at the edges, pinch and pull the disk of dough until it forms a 9-inch circle. Periodically switch from pulling and pinching the dough to stretching it out using your knuckles. If you're feeling adventurous, rest the dough on top of your fist and stretch it outward. Don't be scared to throw the dough up in the air! According to my friend who used to work at Spago, this actually helps form an even circle.

3. Place the dough on a baking sheet. Spread the sauce over the dough and top with mozzarella and your desired toppings. Brush the outside of the crust with a bit of olive oil and bake 10 to 15 minutes, or until the crust is golden brown.

pizza bagel bites

I'm convinced that most kids (and most parents, too) could subsist on Pizza Bagel Bites. What's not to like about them? Toasty whole-wheat mini bagels topped with a rich veggie-laden tomato sauce and gooey mozzarella cheese . . . I'd better stop, just the thought of it is making me hungry!

1. Preheat the oven to 400°F.

2. Split each mini bagel in half crosswise. Place them cut-side up on a baking sheet and bake for 5 minutes.

3. Spread 1 tablespoon of the pizza sauce on each half of the mini bagels and sprinkle with 1 tablespoon of cheese.

4. Bake for another 5 minutes, or until the cheese is melted and golden.

Makes 2 servings

2 mini whole-wheat bagels

¼ cup Veggie-Heavy Pizza Sauce (page 134)

¼ cup shredded mozzarella cheese

📺 pizza balls

Makes 16 balls

Olive oil

1 recipe White Wheat Pizza Dough (page 132) or two 1-pound prepared pizza dough balls, at room temperature

¾ cup chopped broccoli florets (see Note)

1 cup shredded mozzarella cheese

½ cup Veggie-Heavy Pizza Sauce (page 134)

Grated Parmesan cheese, for garnish

MICHELLE: So easy to make! My children help me put them together and then wait, not so patiently, next to the oven door until they're ready. They are gobbled up in minutes.

CARRIE: It's hard to tell who loves them more—the kids or the adults!

I dig these Pizza Balls. When they're piping hot, the little spheres pull apart to reveal gooey melted cheese and whatever other toppings you can think of to put inside. The portion size is smaller than a big slice of pizza, making them easy and fun for little hands to hold. I also find them a bit less messy than slices, which can drip cheese and sauce everywhere. Great to go from dinner to the lunchbox.

1. Preheat the oven to 425°F and grease a 9-inch pie plate with olive oil.

2. Divide the dough into 16 even pieces.

3. In a bowl, combine the broccoli (or whatever addition you choose), mozzarella, and pizza sauce.

4. Roll out a piece of dough into a 3-inch round, and place 1 tablespoon of the cheese mixture in the center.

5. Bring the edges of the dough to the center, pinching to make sure they stick together, then roll the dough into a ball.

6. Place the ball, seam side down, in the pie plate. Repeat to form the rest of the balls.

7. Brush each ball with olive oil and sprinkle with a bit of Parmesan cheese.

8. Bake for 25 minutes, or until golden.

NOTE: You can replace the broccoli with a mixture of any of the following: cooked chicken, mushrooms, onions, bell peppers, tomatoes, olives, pepperoni, pineapple, ham—the sky's the limit.

TIP: To freeze, spread the unbaked balls on a baking sheet and freeze; when frozen, you can move them to a ziplock freezer bag. Just add 5 minutes to the baking time when ready to cook.

pizza muffins

Makes 12 muffins

Olive oil or cooking spray

2 disks White Wheat Pizza Dough (page 132)

¾ cup Veggie-Heavy Pizza Sauce (page 134)

¾ cup shredded mozzarella cheese

OPTIONAL TOPPINGS

sliced mushrooms, diced cooked chicken or ham, diced red pepper, sliced olives, or whatever you and your kids love. The possibilities are endless.

One Sunday when we were attempting some pizza creations, Chloe was on the kitchen floor playing "chef" with my muffin tins. It gave me an idea: Pizza muffins! Pizza is already totally kid-friendly, but when it's cooked in the shape of a muffin, it adds an insanely cool and appealing twist to that same old slice you're used to.

When I told my husband about my inspiration for this recipe, the first thing he said was, "Thank goodness Chloe wasn't playing with a Jell-O mold."

1. Preheat the oven to 450°F and grease a muffin pan with olive oil or cooking spray.

2. Roll out the dough into a thin 16 x 12-inch rectangle. Cut it into 12 squares of about 4 x 4 inches. You can also do rounds with a 4" cookie cutter.

3. Place 1 dough square/round in each cup, making sure that the corners of the dough are sticking out and gently press the edges of the dough onto the pan.

4. Brush the edges of the dough with olive oil.

5. Bake the dough for 8 minutes, or until the dough feels dry to the touch.

6. Pour 1 tablespoon of sauce into each cup and evenly distribute the cheese among the cups. If you're adding more toppings, now's the time!

7. Bake for 5 to 6 minutes, until the cheese is golden and bubbling.

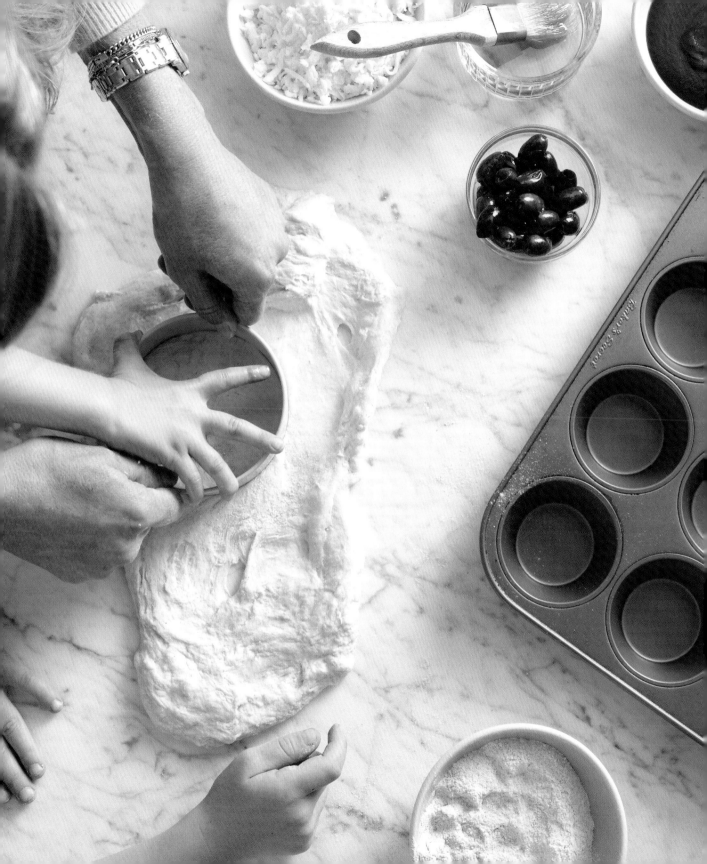

pizza panini

Makes 2 servings

¼ cup Veggie-Heavy Pizza Sauce (page 134)

4 slices panini or ciabatta bread

4 mozzarella cheese slices

8 pepperoni slices

It's amazing how a run-of-the-mill sandwich can be turned into something extraordinary simply by putting it in a panini press. And when you don't have pizza dough in the fridge, you can even make a pizza of sorts in minutes. Just try this mac daddy Pizza Panini and see for yourself. I'd wager you think it tastes as good as a slice from the local pizzeria.

1. Preheat a panini maker, grill pan, or griddle.

2. Spread 1 tablespoon of the pizza sauce on each slice of bread.

3. Layer cheese and pepperoni on 2 of the slices and top with remaining slices.

4. Place each sandwich in the panini maker for 3 minutes, or until the cheese is melted and the bread is golden brown and crisp.

two-cheese pesto pizza

I hope you add this supersimple recipe to your lunch repertoire. By using *naan*—an oven-baked flatbread typical to Indian cuisine that can be found at most large grocery stores—instead of pizza dough, the crust is all set to go and simply awaiting the toppings.

1. Preheat the oven to 450°F.

2. Combine the mozzarella and Parmesan in a bowl.

3. Spread 1 tablespoon of the pesto over each piece of naan and top with ¼ cup of the cheese blend.

4. Place the pizzas on a baking sheet and bake for 10 to 12 minutes, or until bubbling and golden.

Makes 4 servings

1 cup shredded mozzarella cheese

2 tablespoons grated Parmesan cheese

¼ cup Everyday Basil Pesto (page 211)

4 pieces whole-wheat naan

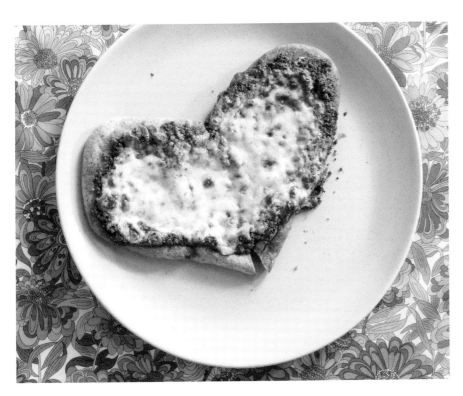

pizza quesadillas

4 tortillas (I use spelt tortillas because I like the nutty flavor, but flour tortillas work great)

¼ cup Veggie-Heavy Pizza Sauce (page 134)

½ cup chicken breast, cooked and chopped fine (see Tip)

½ cup dinosaur kale, cooked and diced (see Tip)

1 cup grated mozzarella

OPTIONAL FILLINGS

pepperoni, diced cooked ham, diced pineapple, sliced mushrooms, diced bell pepper, chopped onion, sliced olives

My husband occasionally gives me flack for writing that so many foods are Kenya's favorite, but what can I say? The kid requests a wide variety of things to eat and he tends to say, "This is my favorite" about a lot of them. Still, quesadillas and pizza are both undoubtedly *way* up on Kenya's favorites list (my husband's, too). They both make him beeline to the kitchen table and turn into a human vacuum whenever I make either. The first time I asked Kenya if he wanted to help me make Pizza Quesadillas, his face was a mixture of pure elation and total confusion. Whatever I was talking about, he knew it sounded awesome.

This is one of those recipes you can totally improvise on, depending on what you've got lying around your kitchen. As long as you have tomato sauce, cheese, and tortillas, you're good to go. And this is a great recipe to get kids in on the action. It's a fun recipe, doesn't make much of a mess, and is the perfect opportunity to use whatever veggies, meats, olives, cheeses, or anything else you may have in the fridge. Kenya has a thing for dinosaur kale (probably because of its cool name), so it's an easy sell for me and a healthy addition to this dish.

And who knows, just maybe it will be your new favorite, too!

1. Place 2 tortillas flat in front of you and spread each with 2 tablespoons of the sauce.

2. Top one of the tortillas with ¼ cup chicken, ¼ cup dinosaur kale (or any of your favorite fillings), and ½ cup of the cheese.

3. Place the other tortilla on top to cover (sauce side down) and press down lightly.

4. Slide the tortilla into a dry pan on medium heat and cook on each side for 3 minutes, or until the cheese is melted through.

5. Repeat to make the second quesadilla.

6. Cut the quesadillas into wedges and serve.

TIP: You can use a precooked roast chicken from the grocery or place a boneless, skinless chicken breast in a baking dish and cook for 20 minutes in a 350°F oven.

TIP: To cook kale, place chopped kale in a steamer pot and cook for 6 to 8 minutes, or until tender.

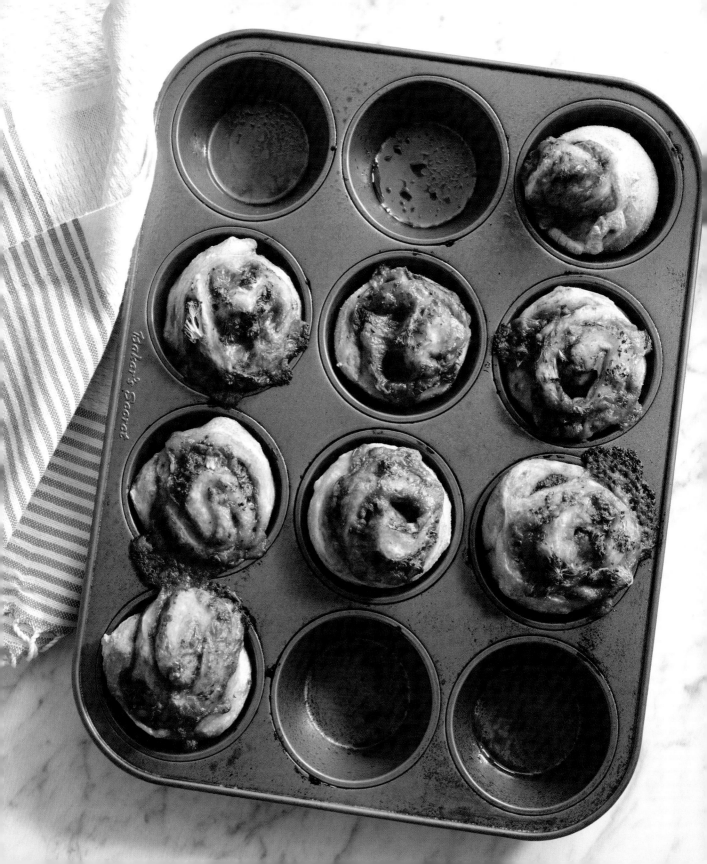

stuffed pizza rolls

This is my savory version of a sweet roll—instead of being filled with cinnamon and sugar, they're stuffed with mozzarella cheese, marinara sauce, and broccoli (or your family's favorite pizza topping). Pizza flavors swirled together and baked as snug as a bug in a rug (or roll) forms an unexpected lunchtime treat that is sure to keep everyone smiling.

1. Preheat the oven to 400°F and grease 10 muffin cups with olive oil.

2. Roll out the pizza dough to ¼ inch thick, making a 10 x 20-inch rectangle.

3. Spread the marinara sauce in a thin layer across the surface of the dough. Sprinkle with the cheese and broccoli (or your favorite topping).

4. Roll up the dough lengthwise to form a 20-inch log and pinch the seam together.

5. Slice the log into 2-inch pieces.

6. Place the pizza rolls in the muffins cups and pat down slightly. (You can also place the rolls directly on a baking sheet—they'll hold together.)

7. Bake for 25 minutes (20 minutes if using a baking sheet), or until golden and bubbly and the center of the dough is cooked through.

8. Immediately remove to a cooling rack to cool, and serve.

Makes 10 rolls

Olive oil

2 disks White Wheat Pizza Dough (page 132) or 1 pound prepared pizza dough, at room temperature

¾ cup Veggie-Heavy Pizza Sauce (page 134)

1 cup grated mozzarella cheese

½ cup chopped broccoli (or your favorite topping)

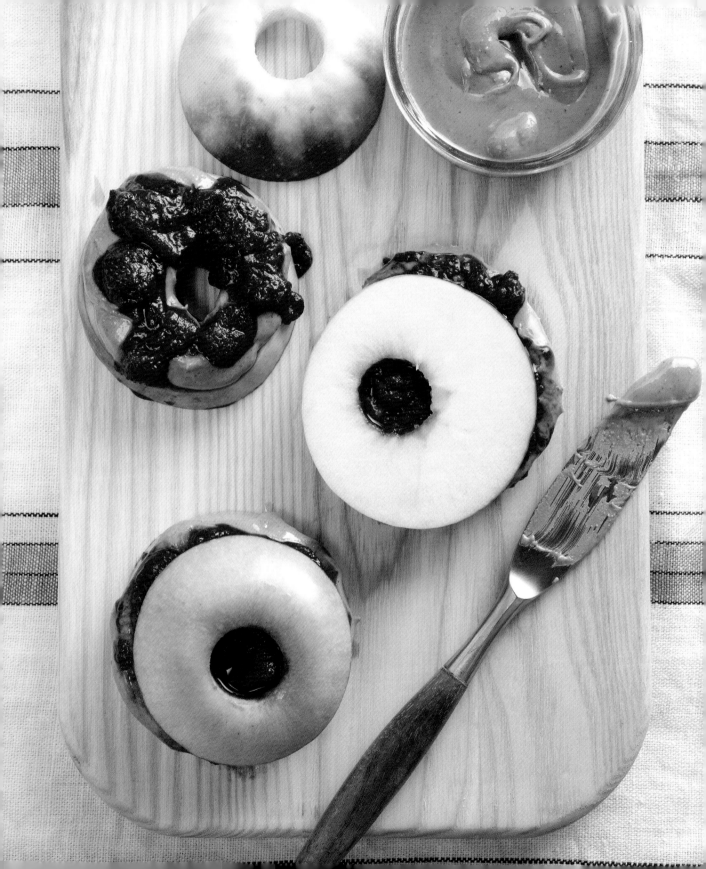

apple ring pb&j

The first time I made and tasted one of these Apple Ring PB&Js I think my eyes crossed with utter glee. Take one bite and you'll understand why.

Low-carb or gluten-free peeps who want to enjoy a PB&J without the bread—this one's for you!

1. Slice the apple crosswise into ¼-inch-thick slices. You should be able to get 8 apple slices.

2. Spread 2 teaspoons of the peanut butter on each of 4 apple slices. Top each with 2 teaspoons of the preserves and the remaining 4 apple slices to form 4 sandwiches.

NOTE: To prevent the apple from browning, you can rub a cut lemon on each exposed apple surface.

TIP: I love using Granny Smith apples, but any variety will work.

Makes 4 sammies

1 large apple, cored

8 teaspoons peanut, almond, or sunflower butter

8 teaspoons Pure Strawberry Preserves (page 226) or apricot or raspberry preserves

▣ chocolate pb&j cups

Makes 20 cups

½ cup smooth peanut butter

3 tablespoons powdered sugar, sifted

One 10-ounce bag dark chocolate chips (or semisweet or milk chocolate, as desired)

¼ cup Pure Strawberry Preserves (page 226)

1 tablespoon fleur de sel

RUTH:
These easy and delicious homemade chocolate peanut butter cups are the perfect way to share the love with family and friends!

I have an absolute weakness for Reese's peanut butter cups. One day I finally thought, what about making them homemade?

It turns out that it's really easy. I add a dollop of fruit preserves to give the classic chocolate–peanut butter combo an extra dimension and top each cup with a flake or two of fleur de sel for an extra salty-sweet note. The kids and I make these every time we go to cookie exchanges, parties, or other special holiday events. They're truly irresistible!

1. Place the peanut butter and powdered sugar in a bowl and stir to combine.

2. Place the chocolate chips in a microwave-safe bowl and melt in the microwave for 60 to 90 seconds, stirring halfway through, until smooth.

3. Fill the wells of a paper-lined mini-muffin pan with 1 heaping teaspoon of the melted chocolate. Refrigerate the pan for at least 10 minutes.

4. Meanwhile, roll 1 teaspoon of the peanut butter mixture into a ball and flatten it into a disk the size of a mini-muffin well. Repeat with the rest of the peanut butter to make about 20 disks.

5. When the chocolate has cooled, place a peanut butter disk in each cup. Top each disk with ½ teaspoon of the preserves.

6. Top the cups with about 1 teaspoon melted chocolate to cover and finish with a few flakes of fleur de sel. Refrigerate until set, about 20 minutes.

7. Peel the papers off and eat!

NOTE: The cups can be kept refrigerated or at room temperature. They're also crazy good frozen and then eaten whenever you want just one!

TIP: You can also fill the cups with apricot, blackberry, or raspberry preserves.

peanut butter pancake sandwiches

Makes 4 servings

1¼ cups all-purpose flour

2 teaspoons baking powder

½ teaspoon salt

¼ cup smooth peanut butter

1 large egg

1 tablespoon sugar

1¼ cups milk

Vegetable or canola oil

Jelly, jam, or preserves

As I discovered shortly after having kids, you don't always need traditional bread to make a sandwich. After all, what could be better than substituting pancakes for the bread, especially if they're peanut butter pancakes?

1. In a medium bowl, whisk together the flour, baking powder, and salt.

2. In a separate medium bowl, whisk the peanut butter, egg, and sugar until combined, then whisk in the milk until incorporated.

3. Whisk the wet ingredients into the dry ingredients until just combined (it's okay if there are a few lumps).

4. Heat a large sauté pan or griddle over medium heat and grease with oil.

5. For each pancake, drop about ¼ cup of the pancake mixture onto the griddle and cook for 2 to 3 minutes on each side, or until lightly golden. Set aside to cool.

6. Spread 1 to 2 tablespoons of jam on one side of each cooled pancake and top with another pancake to make a sandwich. Continue with the remaining pancakes and serve.

TIP: If you have leftovers from this recipe, warm a few up for breakfast the next morning with a drizzle of maple syrup and no one will remember that they ate them for lunch the day before.

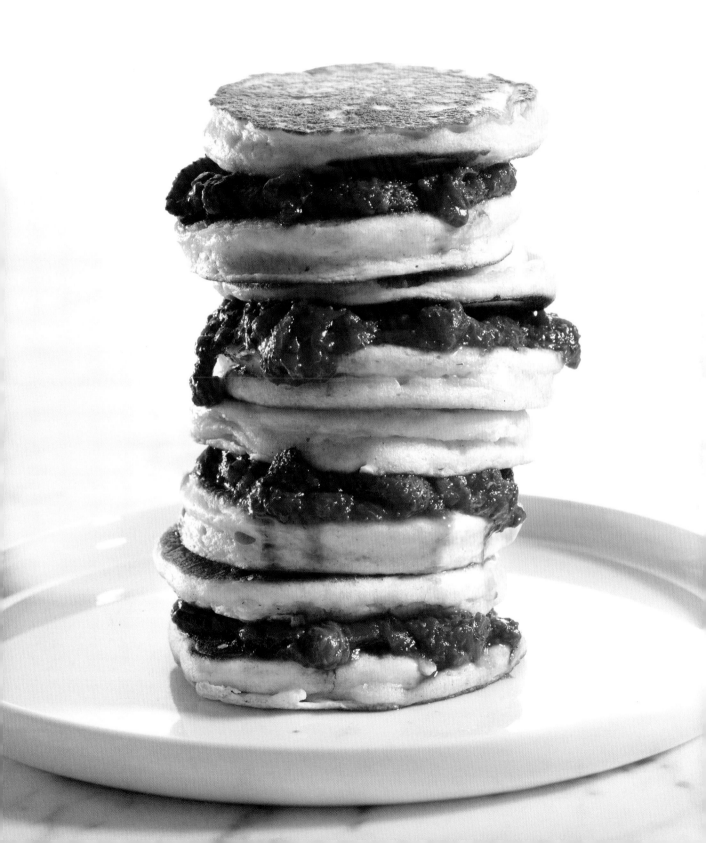

pb&ab pancake sammie

Makes 2 servings

2 tablespoons apple butter

4 pancakes (see Whole-Wheat Pancake Mix, page 124)

2 tablespoons your favorite nut or seed butter

When my kids were younger and had smaller appetites, I would always make way too many pancakes for breakfast and wind up having a major surplus. So what do you do with two dozen leftover pancakes? You freeze them!

Frozen pancakes are great for popping in the toaster when you're rushed to get everyone out the door in the morning with something good to eat. However, inspiration struck me one day when I wanted to make the kids a sandwich but didn't have any bread.

There are tons of versatile fillings for pancake sandwiches (see Peanut Butter Pancake Sandwiches, page 154), but I find apple and nut butter together to be crazy good!

1. Spread 1 tablespoon of the apple butter on each of 2 pancakes and 1 tablespoon nut butter on each of the remaining 2 pancakes.

2. Sandwich the pancakes together and serve.

TO FREEZE: Place the pancakes in ziplock bags or containers and freeze for up to 3 months. To defrost, place the pancakes in a toaster oven on a low setting.

pb&j cupcakes

It's clear who's going to be super popular at the lunch table when they open their lunch boxes and find these cupcakes inside—your kids!

I came up with this recipe after making a batch of peanut butter muffins. I offered them to my kids with some preserves on the side for dipping, but before I knew it, we were all cutting them in half, slathering the centers with luscious ruby red preserves and what resulted were these adorable mini PB&J Cupcakes.

Part sandwich, part cupcake, totally delectable!

1. Preheat the oven to 350°F and spray a mini-muffin tin with cooking spray.

2. In a medium bowl, whisk together the all-purpose flour, whole-wheat flour, baking powder, and brown sugar.

3. In a separate medium bowl, whisk together the peanut butter, oil, vanilla, eggs, and milk.

4. Add the dry ingredients to the wet ingredients and mix until just combined.

5. Fill the mini-muffin cups ⅔ full and bake for 18 to 22 minutes, or until they are golden and the tops spring back when lightly pressed.

6. Move the cupcakes to a wire rack to cool.

7. When the cupcakes are completely cool, slice the top off each cupcake, spread about 1 teaspoon of the preserves on the bottom half, and replace the top to form a cupcake sandwich. Repeat with the rest of the cupcakes and serve.

TIP: For a decadent treat, fill with Chocolate-Hazelnut Spread (page 218).

Makes 4 dozen

Cooking spray

1 cup all-purpose flour

¾ cup whole-wheat flour

2 teaspoons baking powder

½ cup brown sugar

¾ cup smooth peanut butter

¼ cup canola or vegetable oil

2 teaspoons pure vanilla extract

2 large eggs

1 cup milk

½ cup Pure Strawberry Preserves (page 226)

pb&j pinwheels

Makes 4 servings

¼ cup regular or whipped cream cheese

2 tablespoons jam, jelly, or preserves

⅓ cup smooth peanut butter

2 pieces lavash or tortillas, preferably whole wheat

It's amazing how positively kids react when you do something as simple as changing the shape of one of their favorite foods. There's obviously nothing that needs improving when it comes to a delicious peanut butter and jelly sandwich, *but* try mixing in a bit of cream cheese, rolling it up in lavash instead of bread, and cutting it into wheels. It becomes a completely new take on a lunchtime classic that's even more fun to look at and eat!

1. Place the cream cheese and jam in a bowl and combine until smooth.

2. Spread half of the peanut butter on a piece of lavash and top with half of the cream cheese/jam mixture.

3. Roll the lavash lengthwise into a log and slice it into bite-size (about 1-inch) wheels.

4. Repeat to make the second pinwheel sandwich and serve.

pb&j yogurt swirls

Plain yogurt is packed with calcium and protein, and it's easier to digest than milk, but to kids, plain yogurt can be as ordinary as its name. In order to get most kids to eat yogurt, you have to entice them with the flavored varieties sold at the grocery store. But many popular brands are full of additives, so I thought it would be fun to see how plain Greek yogurt (which I prefer because it's twice as high in protein as regular yogurt and has half the sugar) tasted when swirled together with creamy, nutritious peanut butter and natural sweeteners that are lower in sugar. I'm happy to report that not only is this recipe beautiful to look at—it's mind-blowingly delicious too!

Makes 4 servings

2 cups plain yogurt (I like using Greek yogurt)

¼ cup natural or low-sugar jelly, jam, or preserves

¼ cup smooth peanut butter (see Note)

1. Divide the yogurt among 4 bowls.

2. In a small saucepan, heat the jelly or preserves over low heat for 1 minute, or until liquefied. Set aside to cool. (You can also zap it for 30 seconds in a bowl in the microwave.)

3. Drizzle the jelly and peanut butter equally among the bowls of yogurt and swirl the contents together.

NOTE: If using traditional peanut butter brands such as Jif or Skippy, melt it in the microwave for about 15 seconds to soften. You can also use natural peanut butter, which tends to already be a bit more liquefied.

STEPHANIE: This peanut butter and jelly yogurt is a favorite in our house. We are yogurt lovers (I mean we eat it for every meal!), and adding PB and J is a great way to make it filling. We're obsessed!

pb&j "pop-tarts"

Makes 12 tarts

1 Double Pie Crust (page 162) or store-bought double-crust pie crust, such as Pillsbury

Flour, for dusting

¼ cup smooth natural peanut butter

¼ cup preserves, jam, or jelly

One afternoon I discovered four (yes, four) half-eaten jars of peanut butter in my refrigerator and was determined to not let any of it go to waste. There are plenty of great uses for peanut butter, but when I also realized that I had a considerable amount of frozen pie dough in the freezer, my solution was inspired by nostalgia: homemade "Pop-Tarts" filled with peanut butter and blackberry preserves.

Totally decadent and they got my runaway peanut butter supply under control!

1. Preheat the oven to 400°F and line a baking sheet with a Silpat or parchment paper.

2. Roll out the pie crust on a lightly floured surface to ¼ inch thick and cut it into about twenty-four 2 x 3-inch rectangles.

3. Place 1 rectangle on a lightly floured work surface and drop 1 teaspoon each of the peanut butter and preserves in the very center.

LAURA: PB&J "Pop-Tarts" are the perfect go-to snack/meal. I make them and toss them in my bag for the kids when we go out to the museum or zoo.

4. Lightly dip your index finger into a cup of water and "brush" a bit of water along the edge of the dough (this will allow the two sides of the rectangle to adhere to one another).

5. Top with another rectangle of pie dough. Gently press down along the edges of the tart with the tines of a fork to seal it (making sure the mixture stays inside the tart).

6. Place the tarts on the prepared baking sheet and bake for 18 minutes, or until golden.

7. Cool on a wire rack and serve.

TO FREEZE: Place the unbaked tarts on a baking sheet and freeze for 1 hour. Remove, place in a ziplock bag, label, and freeze for up to 3 months. Add an extra 2 minutes to the baking time.

double pie crust

Makes 1 double crust

½ cup (1 stick) butter, chilled and cubed

8 tablespoons vegetable shortening or lard, chilled and cubed

2½ cups all-purpose flour

1 tablespoon sugar

1 teaspoon salt

5 or 6 tablespoons ice water

1. Place the butter, shortening, flour, sugar, and salt in a food processor and pulse until the mixture resembles coarse cornmeal.

2. Sprinkle 1 tablespoon of the ice water in the food processor at a time and pulse a few times, until the dough starts to come together.

3. Place the dough on a piece of parchment paper or plastic wrap, gather it into a ball, and flatten it into a disk.

4. Refrigerate the dough for 30 minutes, or until chilled.

5. Proceed with the PB&J "Pop-Tart" recipe (page 160). The dough will keep for 1 week in the refrigerator or up to 2 months in the freezer.

pb&j croutons

This is my version of a deconstructed PB&J. I can't stand it when bread goes stale, so I started turning it into toasted bread cubes to be used in salads, to munch on as a healthy snack, or for dipping into peanut butter and jelly, as in this simple idea.

1. Preheat the oven to 450°F.

2. Place the bread on a baking sheet, drizzle with the oil, and toss to coat.

3. Bake for 15 to 20 minutes, or until golden brown.

4. Place the peanut butter and jelly in a dip container side by side, or mix them together.

5. Serve the croutons with the peanut butter and jelly for dipping.

TIP: The toasted bread cubes can also be used to dip into Roasted Carrot Hummus (215), Black Bean Hummus (212) or Veggie Cream Cheese Spread (224).

Makes 2 servings

½ cup cubed bread

½ teaspoon canola or vegetable oil

1 tablespoon smooth peanut butter

1 tablespoon preserves

the world's greatest pb&j

Makes 2 servings

4 tablespoons smooth or chunky natural peanut butter

4 slices whole-wheat sandwich bread

4 tablespoons preserves of choice

Butter (optional)

The night I gave birth to Chloe, all I wanted afterward was a peanut butter and jelly sandwich. Call me a girl with simple tastes, but it's true—I craved thick-sliced sandwich bread, toasted and slathered with tons of smooth peanut butter and fresh strawberry preserves.

I actually dreamed about having this "push" sandwich for weeks before Chloe arrived, and hours after she was born and resting in my arms, I gobbled up not one, but two. After all, I'd more than earned it!

If only I knew then what I know now. The secret to making the world's greatest PB&J is finishing it in a waffle iron. The bread gets supercrispy and the peanut butter and jelly melt together in an indescribably delicious way. When you want to impress someone with your incredible culinary skills, whip up one of these ooey-gooey, delectable treats. I promise you that they'll declare it "the world's greatest PB&J."

1. Preheat a waffle iron.

2. For each sandwich, spread 2 tablespoons peanut butter on one slice of bread, 2 tablespoons preserves on another, and sandwich the pieces together.

STEFANY: *Love* the World's Greatest PB&J . . . purely decadent!

3. Lightly grease the waffle iron with butter, if desired, and cook the sandwiches in the iron for 3 to 4 minutes, or until the bread shows golden waffle marks.

4. Serve with a tall glass of milk for an ideal waffle sandwich experience!

AMBER: The World's Greatest PB&J: so good you don't want to share with the kids!

main
events

mixture

My girlfriend Diane has three young kids, which means three lunches every day, five days a week. No easy feat. She's a stickler about providing nutritious meals and has always offered her kids an impressively balanced diet since they were babies.

When her son Beckett was just two and a half years old, he came over to our house for lunch one day with something Diane calls *mixture*. It's basically just a mix of vegetable, protein, and carbohydrate all in one. Not only is mixture visually appealing, but it's an easy, all-in-one balanced meal that gets you out of the everyday sandwich-making grind. Brilliant!

The possibilities for mixture are endless, but just to get you rolling with the idea, here are four of my favorite versions: Mexican, Italian, Greek, and Asian.

mexican mixture

1 cup cooked brown rice

½ cup Pressure Cooker Black Beans (page 190) or drained and rinsed canned black beans

½ avocado, diced

¼ cup diced tomato

3 tablespoons grated Cheddar cheese

Salt, to taste (optional)

In a bowl, mix together all the ingredients.

asian mixture

In a bowl, mix together all the ingredients.

Makes 2 servings

1 cup cooked quinoa

½ cup shelled edamame

6 large wild shrimp, cooked and roughly chopped

1 tablespoon sesame seeds

2 teaspoons Bragg's Liquid Aminos or soy sauce

greek mixture

Makes 2 servings

1 cup crushed pita chips

½ cup chopped cucumbers

¼ cup chopped kalamata olives

¼ cup diced tomatoes

3 tablespoons crumbled feta cheese

1 tablespoon freshly squeezed lemon juice

1 tablespoon extra-virgin olive oil

¼ teaspoon salt, or to taste

In a bowl, mix together all the ingredients.

NOTE: To make pita chips, slice pita bread into wedges and bake in a 350°F oven for 10 to 15 minutes, or until crisp.

italian mixture

In a bowl, mix together all the ingredients.

1 cup cooked pasta, such as farfalle, ziti, or campanelle

¼ cup chopped cherry tomatoes

2 tablespoons grated mozzarella cheese

1 tablespoon grated Parmesan cheese

2 basil leaves, roughly chopped or torn

¼ teaspoon salt, or to taste

1 teaspoon olive oil (optional)

beany cheesy burritos

Makes 2 servings

1 cup Healthy Refried Beans (see the recipe opposite)

2 whole-wheat tortillas

½ cup grated Cheddar cheese

OPTIONAL
ACCOMPANIMENTS

chopped tomatoes, guacamole, sour cream, shredded lettuce

Oh how happy my kids would be if I put a burrito in their lunch boxes every day. While I'm at it, I shouldn't exclude my hubby, who loves taking them to work.

Simply stuffed with a lighter version of traditional refried beans and lots of grated, melted cheese, they're easy to hold for little ones and filling enough for the bigger kids and adults.

1. Spread half the refried beans on each tortilla and sprinkle with Cheddar cheese.

2. Roll into burritos.

3. Microwave for a few seconds to melt the cheese, if desired.

healthy refried beans

1. Heat the olive oil in a small heavy-bottomed pot.

2. Add the onions and sauté for 5 minutes, or until translucent. Add the garlic and cook for 1 minute.

3. Add the pinto beans and salt and mash with a potato masher or fork. The mixture should be smooth.

4. Add 2 to 4 tablespoons of hot water, depending on your desired consistency. Stir and cook until heated through.

TO FREEZE: Allow the beans to cool, place in a glass container or zip-lock freezer bag and freeze for up to 4 months. When ready, defrost in the fridge for 24 hours.

Makes 1¼ cups

2 tablespoons olive oil

1 small onion, diced

1 garlic clove, diced

One 15-ounce can pinto beans, drained and rinsed

1 teaspoon salt

mexican muffins

Makes 4 servings
or 8 muffins

Cooking spray

⅓ cup whole-wheat flour

⅓ cup all-purpose flour

2 teaspoons baking powder

¼ teaspoon garlic powder

¼ teaspoon onion powder

¼ teaspoon ground cumin

¼ teaspoon salt

1 large egg, whisked

⅓ cup milk

1 tablespoon tomato paste

½ teaspoon honey

⅓ cup shredded Mexican blend cheese (Cheddar and Monterey Jack)

¼ cup fresh or frozen corn kernels

½ cup diced cooked chicken

You've got about a half cup of cooked chicken left over from last night's dinner. Not enough to feed a family for leftovers. Or is it?

Why not try using your leftovers to make something totally new? These unique savory muffins are packed with aromatic Mexican spices, sweet corn, and a touch of cheese that come together to make an all-in-one, savory handheld treat. Perfect for the lunchbox.

Who said good things don't come in small packages?

1. Heat the oven to 375°F and spray a muffin tin with cooking spray.

2. In a large bowl, whisk together the whole-wheat flour, all-purpose flour, baking powder, garlic powder, onion powder, cumin, and salt.

3. In a separate bowl, whisk together the egg, milk, tomato paste, honey, cheese, and corn.

4. Mix the wet ingredients into the dry ingredients until just combined.

5. Gently fold in the chicken.

6. Fill each muffin cup ⅔ full of batter.

7. Bake for 15 minutes, or until lightly brown.

8. Serve warm or at room temperature.

CHRISTY: I make my nineteen-month-old your Mexican Muffins on a regular basis. He loves them so much, and I love that he's getting loads of nutrients packed into one little muffin!

RISA: My three-year-old loves the Mexican Muffins with guacamole and salsa to spread on them. It's the meal he asks for any time he has a friend over for lunch.

Jicama Sticks (page 196)

ᴛ�v easy chicken nuggets

Makes 24 nuggets

1 pound boneless, skinless chicken breasts, chopped

½ cup mashed potatoes

¼ teaspoon dried parsley

½ teaspoon garlic powder

¼ teaspoon onion powder

½ teaspoon salt

¾ cup panko bread crumbs

1 tablespoon grated Parmesan cheese

Cooking spray

The golden arches of McDonald's were a magical place for me as a kid. But I wasn't a hamburger girl; for me it was all about the chicken nuggets, especially the variety of sauces to choose from.

What I wish I knew back then is what fast food restaurants put into their nuggets. If you've never seen the brilliant Jamie Oliver's *Food Revolution* episode where he shows school kids how fast food chicken nuggets are made, you might want to check it out to educate yourself. It's a scary fact if there ever was one.

These homemade chicken nuggets trump the classic fast food variety in every way—extra crispy on the outside and moist, tender, and juicy on the inside. Plus, they're baked instead of fried and you can feel good about feeding your kids all these ingredients! They're what you always dreamed a nugget *should* taste like. (For a more home-style nugget, try the Crispy Chicken Bites on page 182.)

1. Preheat the oven to 375°F.

2. Place the chicken, mashed potatoes, parsley, garlic powder, onion powder, and salt in a food processor and pulse until smooth and combined.

3. In a shallow bowl or plate, combine the bread crumbs and Parmesan.

4. With moistened hands, roll 1 tablespoon of the chicken mixture between your palms and flatten into a "nugget" shape.

5. Gently press the nugget into the bread crumb mixture to coat.

6. Transfer to a lightly sprayed or greased cooling rack on a baking sheet lined with foil.

7. Lightly spray the nuggets with cooking spray.

8. Bake for 20 minutes, or until crispy outside and cooked throughout.

9. Serve hot with honey mustard, ketchup, or Veg-Wee Dip (page 222).

NOTE: If you want the nuggets to be golden brown, place them under the broiler for an additional 2 minutes after cooking.

TO FREEZE: After step 5, place the chicken nuggets on a sheet tray and freeze for 30 minutes. Transfer to a ziplock bag, label, and freeze for up to 4 months. To bake, do not defrost; just add 3 to 5 minutes to the baking time.

RUTH: I make Easy Chicken Nuggets by the five-pound batch! My whole family loves them for lunches or dinner, and they freeze perfectly.

ERIN: The Easy Chicken Nuggets are a lifesaver. Not only are they easy, but they're great out of the freezer—I always have some on hand for my toddler.

BROOKE: What I was most surprised about from the Easy Chicken Nuggets recipe was that they actually look just like store/restaurant bought chicken nuggets. I thought they would be distinguishable as homemade chicken nuggets, but the only thing giving them away is how good they taste!

KRISTINE: I could never figure out the secret to getting nuggets the right texture to make them more like the soft fast food ones. This recipe *nails* it! Seemed like a lot of work, but it was actually easy once you get going. And oh the shape possibilities—my little guy gobbled them up. Just the right spice. They also froze beautifully!

AMBER: Easy Chicken Nuggets is the perfect name for this recipe. They take minutes to prepare and you can make enough to freeze for weeks to come. They're perfect right out of the freezer and *so* much better than the processed ones found in the grocery stores!

SARA: I was buying nuggets at the store every week until I found your Easy Chicken Nuggets. Everyone likes them. I like to keep a batch in the freezer for last-minute dinners.

chicken satay bites

Makes 4 servings

1 tablespoon nut butter (almond, peanut, or sunflower butter)

1 garlic clove, minced

1 teaspoon grated ginger

1 tablespoon soy sauce

1 tablespoon honey

½ teaspoon sesame oil

2 boneless, skinless chicken breasts, cut into 1-inch cubes

Tender morsels of marinated and baked white-meat chicken in a rich sauce made from nut butter mixed with the Asian flavors of sesame, ginger, and soy? You'd better double up on this recipe, because when you send your kids to school with these Chicken Satay Bites, they may come home craving more!

1. Preheat the oven to 400°F.

2. In a medium bowl, combine the nut butter, garlic, ginger, soy sauce, honey, and sesame oil.

3. Add the chicken to the marinade, cover the bowl, and marinate for 20 minutes to overnight in the refrigerator.

4. Place the chicken on a baking sheet and bake for 14 minutes, or until golden and cooked through.

chicken teriyaki on a stick

The first time I made this sweet, tasty teriyaki sauce for dinner, I ladled it into little bowls for my kids to dip their baked chicken in. To make this recipe a little more lunch-box friendly, I marinate the chicken first so it absorbs some of that irresistible sauce, then skewer it with ice-pop sticks and bake it up.

1. Preheat the oven to 400°F.

2. In a medium bowl, place the soy sauce, honey, ginger, and garlic and whisk to combine.

3. Place the chicken in a bowl (or a ziplock bag for easy clean up), mix with half the marinade, cover the bowl, and refrigerate for 20 minutes to overnight.

4. Skewer each piece of chicken lengthwise on an ice-pop stick, place on a greased baking sheet, and bake for 14 minutes, or until golden.

5. Remove the chicken from the oven and set aside to cool slightly.

6. Serve with the remaining teriyaki sauce for dipping.

NOTE: Soak the ice-pop sticks in water before skewering or cover the exposed portion with foil to prevent sticks from browning.

Makes 8 sticks

⅓ cup soy sauce or Bragg's Liquid Aminos

3 tablespoons honey

1 teaspoon grated ginger

1 garlic clove, minced

2 boneless, skinless chicken breasts, each cut into 4 long strips

8 ice-pop sticks (see Note)

crispy chicken bites

Makes 35 bites

Vegetable or canola oil spray

2½ cups corn flakes, whole-wheat flakes, or other flaky cereal

1 teaspoon kosher salt

1 cup buttermilk (or 1 scant cup milk plus 1 teaspoon white vinegar or lemon juice)

1 pound boneless, skinless chicken breasts, cut into 1-inch cubes

OPTIONAL ACCOMPANIMENTS

ketchup, honey, Dijon or yellow mustard, Veg-Wee Dip (page 222), Zippy Yogurt Tahini Sauce (page 221), or your favorite BBQ sauce

Most kids I know could subsist on chicken nuggets alone. Not such an encouraging idea when most boxed and fast food varieties are packed with fillers and deep-fried in oil. But when the chicken is coated in a nutritious and wholesome crispy cereal and baked until golden with a good dipping sauce on the side . . . it's a total winner.

You'll never buy boxed or hit the drive-thru again!

1. Preheat the oven to 400°F and spray a large baking sheet with cooking spray.

2. Place the cereal and salt in a ziplock bag and crush the flakes with a rolling pin. Or use a food processor and pulse until the mixture resembles bread crumbs.

3. Pour the buttermilk in a large bowl and the cereal coating in another large bowl.

4. Dip the chicken pieces in the buttermilk, then roll them in the cereal, making sure to coat the chicken completely.

5. Place the chicken bites on the baking sheet and lightly spray them with oil.

6. Bake for 12 to 14 minutes, or until cooked through.

7. Serve with the sauce or sauces of your choice.

TO FREEZE: After step 4, place the chicken tenders on a sheet tray and freeze for 30 minutes. Transfer to a ziplock bag, label, and freeze for up to 4 months. To bake, do not defrost; just coat with spray and add 3 to 5 minutes to the baking time.

Crispy Chicken Bites with corn flakes on the left and Heritage flakes on the right.

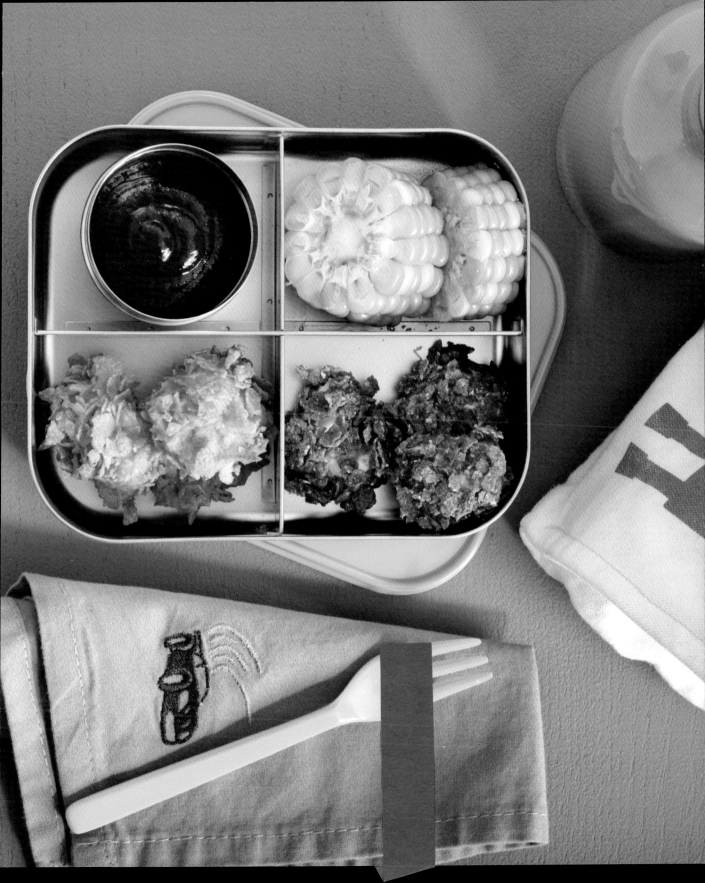

falafel bean patties

**Makes 14
mini falafel**

**One 15-ounce can
chickpeas (garbanzo
beans), rinsed and
drained**

1 garlic clove

¼ cup chopped onion

¼ cup chopped cilantro

¼ cup chopped parsley

½ cup bread crumbs

**1 teaspoon ground
cumin**

½ teaspoon salt

**Olive, vegetable, or
canola oil, for pan
searing**

**Zippy Yogurt Tahini
Sauce, for serving
(page 221)**

In my never-ending quest to find foods that are both healthful and easy for kids to hold on to (so they don't have to always rely on a fork and knife in their lunch box), I started making falafel. The healthy trick to this recipe is pan searing the falafel instead of frying them, as most falafel recipes call for.

Falafel is made from a base of chickpeas. By the way, have you ever looked closely at a chickpea? It has a little nub that looks a bit like a chick's beak—hence the name. But beak or no beak, chickpeas are a powerhouse of fiber as well as a terrific vegetarian protein source. Fiber is an important part of kids' diets because it fills them up longer than other foods, giving them the needed energy to run around and play.

Serve these at home or in the lunch box with a little Zippy Yogurt Tahini Sauce (page 221) on the side, which boosts the nutritional content of the meal even more and adds a little fun factor for the kids.

1. Place all the ingredients except the oil and tahini in a food processor and process until combined thoroughly. Scrape down the sides of the processor as needed.

2. With moist hands, form patties using about 1 tablespoon of the mixture. Place them on a plate while you form the remaining patties.

TANYA: The Falafel Bean Patties are a staple at our house. My three-year-old loves dipping them in tzatziki, and I love how easy the recipe is. Sometimes we make falafel sandwiches by putting them in pita pockets. A bonus is how easy they are to freeze and reheat. The perfect side dish for these are the Roasted Carrot Coins (page 201)!

3. In a medium sauté pan over medium heat, heat about 2 tablespoons of oil, or enough for a thin coating of oil.

4. Add half the patties to the pan and saute for 4 minutes on each side, or until golden (you may have to add a little more oil if your pan gets too dry).

5. Remove the patties to a paper towel–lined plate to absorb any extra oil.

6. Cook the second batch of falafel.

7. Cool and serve with Zippy Yogurt Tahini Sauce.

TO FREEZE: After step 2, place patties on a sheet tray and freeze for 30 minutes or until frozen, then transfer to a ziplock bag, label, and freeze for up to 4 months. When ready to cook them, defrost in the fridge overnight and follow steps 3 through 7.

tex-mex rice cakes

Makes 14 to 16 cakes

1 cup cooked brown rice

½ cup whole-wheat bread crumbs

½ cup grated Cheddar cheese

¾ cup frozen corn, defrosted

2 tablespoons chopped cilantro

½ teaspoon salt

2 large eggs

2 tablespoons vegetable or canola oil for cooking

OPTIONAL ACCOMPANIMENTS

salsa, guacamole, Veg-Wee Dip (page 222), or sour cream

Our family loves eating brown rice, so I always try to keep a big bowl of it in the refrigerator. It's a nutritious, wholesome, and versatile base for so many dishes.

On many nights when I'm stumped about what to make for dinner, I make these Tex-Mex Rice Cakes. I always have the ingredients on hand, and it takes me only minutes to prepare. Of course, I make a few extra each time to freeze or go in the kids' lunch boxes the next day!

1. Combine the brown rice, bread crumbs, Cheddar cheese, corn, cilantro, and salt in a large bowl and mix to combine.

2. In a separate bowl, whisk the eggs.

3. Add the eggs to the rice mixture and mix to combine.

4. Shape about ¼ cup of the mixture into a patty and set aside. Repeat with the rest of the mixture.

5. Heat the oil in a large skillet over medium heat. Add the patties and cook for 2 minutes on each side, until golden brown.

TO FREEZE: Shape the mixture into patties, place them on a baking sheet, and freeze for 30 minutes, then place them in a ziplock bag and freeze for up to 4 months. Thaw before cooking.

NICOLE: The Tex-Mex Rice Cakes are so versatile and freezer friendly—they're a great way to get veggies into my toddler!

MICHELLE: We love the Tex-Mex Rice Cakes! My toddler takes them to preschool for lunch and devours them every time. A great way to use leftover rice!

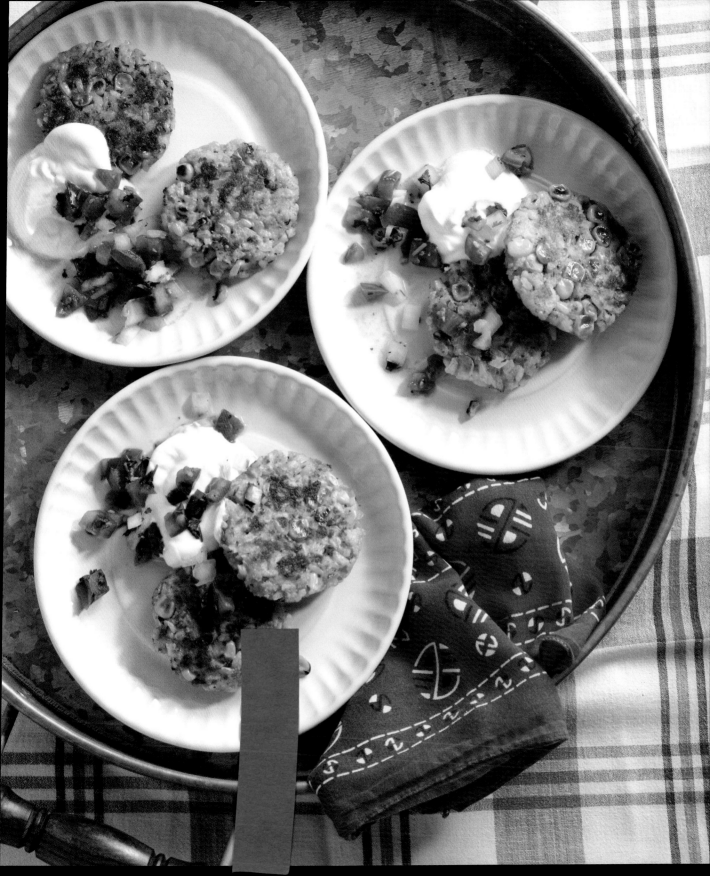

veggie meatballs

Makes about
56 meatballs

1 tablespoon olive oil

1 small onion, diced

1 carrot, peeled and cut into small dice

1 garlic clove, minced

2 tablespoons tomato paste

One 15-ounce can white beans, rinsed and drained

1 teaspoon Italian herbs

2 large eggs

½ cup grated Parmesan cheese

½ cup bread crumbs

½ teaspoon salt

OPTIONAL
ACCOMPANIMENTS

Veg-Wee Dip (page 222), ketchup, mustard, or sour cream

More and more these days I come across kids who are vegetarian. Even one of my own children tends to prefer an all-veggie diet, so I like to have as many simple recipes as possible at my fingertips. You can bake these Veggie Meatballs on a baking dish or even in a mini muffin tin. A huge bonus, as with a lot of the recipes in this book, is that they're really easy for kids to hold and they pack great in a lunch box. However, it's their soft texture and incredible flavor—from the creamy white beans and bold tomato, herbs, and cheese—that make them irresistible.

1. Preheat the oven to 350°F.

2. Heat the olive oil in a medium sauté pan over medium heat. Add the onions, carrots, and garlic and sauté for 8 minutes, or until tender and cooked through.

3. Cool the mixture slightly, then place it and the rest of the ingredients in the bowl of a food processor. Pulse until finely chopped and combined.

4. Using about 1 tablespoon per meatball, roll the mixture into balls.

5. Place them in a baking dish and bake for 25 minutes, or until cooked through. (If using a muffin tin, mold 2 tablespoons of the mixture into each mini muffin cup, pat down, and bake for 20 minutes.)

TIP: Buy tomato paste in a squeeze tube. It will last longer than canned tomato paste.

pressure cooker black beans

Makes 8 servings

1 pound dry black beans

1 small onion, finely chopped

1 bunch cilantro stems and/or leaves, tied together with kitchen twine

1½ teaspoons salt

2 tablespoons balsamic vinegar

Cooked brown rice, for serving

If there's one food that Chloe eats every day—and I mean every day—it's beans. Thank goodness for my pressure cooker, because it makes the most flavorful, tender, and tasty beans you've ever tried. No soaking or cooking for hours. No BPA-lined cans, either. Just dump all the ingredients into the pressure cooker and in *well under an hour* you're in business. Spoon on top of brown rice and you have an inexpensive lunchtime meal that forms a complete protein. It doesn't get simpler, cheaper, or more delicious than this.

1. Combine the beans, onions, cilantro, and salt in a pressure cooker with 8 cups of water. Following the manufacturer's directions, cover the pressure cooker and lock the lid.

2. Cook on high pressure for 40 minutes.

3. Allow the steam to release completely (again, follow the manufacturer's directions) before opening the pressure cooker. Stir in the balsamic vinegar.

4. Serve the beans with cooked brown rice.

mexican-spiced rice balls

Okay, you've got a batch of sticky, overcooked rice and don't know what to do with it. Say hello to your new best friend, Mexican-Spiced Rice Balls. With a chunk of gooey cheese in the center, it's like getting a surprise in every bite.

Don't worry if you don't have overcooked rice. This recipe overcooks it for you!

1. In a medium saucepan over medium-high heat, combine the rice, cumin, paprika, oregano, garlic powder, salt, and 2¼ cups water. Bring the mixture to a boil, turn the heat to low, cover, and cook for 45 minutes, or until the rice has absorbed the water and is cooked through. Turn off the heat, leave the pot covered, and let it sit on the stove for 10 minutes.

2. When the rice is cool enough to handle, scoop about 2 tablespoons and use moist hands to roll into a ball. Squeeze a cheese cube into the center and press the rice around it. Continue with the remaining rice and cheese.

3. Place the rice balls on a plate in the microwave for 10 to 15 seconds to melt the cheese. Alternatively, place the rice balls in a steamer pot over boiling water for 1 to 2 minutes.

Makes 22 balls

1 cup short-grain rice

1 teaspoon ground cumin

1 teaspoon paprika

1 teaspoon dried oregano

½ teaspoon garlic powder

¼ teaspoon salt

¾ cup Cheddar cheese cubes (I use 4 cheese sticks cut into 6 pieces each)

veggies

corn wheels

Often the simplest foods are the most popular. Take these corn wheels, for instance. Simply slicing an ear of corn into rounds makes it fun and even easier for small hands to hold. Roll the rounds in some grated Parmesan cheese and you've just added a bit of protein that your kids will love.

1. Bring a large pot of water to a boil. Add the corn and boil for 4 minutes.

2. Remove the cobs from the water and slice them into 1-inch coins.

3. Pour the Parmesan into a shallow dish and roll the wheels in the cheese until evenly covered. Serve.

NOTE: You can also slice the corn off the cob after cooking and sprinkle with the cheese, which my kids call corn sheets.

Makes 2 servings

2 ears fresh corn on the cob, shucked

2 tablespoons grated Parmesan cheese

jicama sticks

Makes 1½ cups

1 medium jicama, peeled

Juice of a lime

¼ teaspoon mild paprika

¼ teaspoon salt

Jicama? What in the world is jicama? That was my reaction when I saw this veggie for the first time. Talk about intimidating. There are certain fruits and vegetables you see and immediately give up on before even *trying* to figure out what to do with them. Shockingly, jicama is a lot easier to work with than it may appear, and this simple recipe is a perfect example.

Simply peel off the brownish outer skin and cut the jicama into your favorite shape (sticks, in this case). The crunchy jicama is complemented by lime juice, a bit of salt, and a sprinkling of mild paprika. The simple flavors of this dish are a perfect addition to the lunch box or as an after-school snack.

1. Cut the jicama into 3-inch sticks.

2. Place all the ingredients in a bowl, toss to combine, and serve.

TIP: When looking for jicama at your local grocery or Latin market, you'll see a large root with a light brown outer skin. Some people even say it looks like an overgrown potato.

See the photograph for this recipe on page 177.

radish salad

I've never really enjoyed the taste of radishes. Although they're crunchy and gorgeous in color, I just couldn't get over their spicy flavor. So of course, like many parents, I assumed my kids would be just like me and never used to serve them radishes. Thank goodness I'm not the only decision maker living under our roof, because my husband adores them.

But when Kenya and Chloe bit into whole radishes for the first time, they responded exactly as I thought they would—"too spicy!" My husband took this as a challenge. He chopped the radishes up, drizzled them with a bit of olive oil, gave them a squeeze of lemon and just a dash of salt, and put them back in front of the kids. With just that little bit of magical preparation, the kids *and I* went from radish haters to radish lovers.

Give this inexpensive veggie a try and become a believer, too!

Place all the ingredients in a bowl and toss to coat.

Makes 3 to 4 servings

1 bunch (or 1½ cups) radishes, quartered or sliced

Juice of a lemon

1 tablespoon olive oil

¼ teaspoon kosher salt

kale chips

When you're trying to inspire kids to eat healthy, my experience has proved that anything in the form of a chip, muffin, pancake, or on-a-stick is usually bound to be a hit.

These super-crispy kale chips disappear instantly when we make them. When I served them to my friends' kids—several of whom normally turn their noses up at anything green—they devoured the entire bowlful. They are truly addictive.

Another plus is that kale is among the most nutrient rich of all foods. Loaded with vitamins A and C and calcium, this vegetable gets an A-plus for nutrition, and it's one that you definitely want your kids to be eating!

1. Preheat the oven to 350°F.

2. Wash the kale, cut out the stems, and cut the leaves into 2-inch pieces.

3. Divide the kale between 2 baking sheets lined with a Silpat or parchment paper, drizzle or spray with oil and toss to coat (make sure there is a bit of space between the pieces of kale so they don't steam).

4. Bake for 18 to 20 minutes (keep an eye on them during the last few minutes of cooking so they don't burn), or until crispy.

See the photograph for this recipe on page 106.

Makes 4 servings

1 bunch kale

1 tablespoon olive oil or canola oil spray

crunchy potato chips

**Makes 2 to 3 cups
of chips**

**2 russet, Idaho, or
sweet potatoes,
unpeeled**

**1 tablespoon vegetable
oil**

Salt, to taste

Cooking spray

Okay, seriously, who doesn't like potato chips? Left to my own devices, I could inhale an entire bagful in one sitting. However, your average store-bought bag of chips is laden with saturated fat and calories, and while I don't want to deprive my kids of this classic treat, I certainly want to keep them away from bad fats and mega-doses of sodium. Sure, most chip makers offer "healthy" versions, but why spend the extra money on store-bought chips when you can make even better ones for a mere fraction of the price?

I've been making these baked "potato chips" for my husband and me for years. You can use almost any kind of potato (the sweet potato version is *amazing* and loaded with vitamins and minerals). They take only minutes to prepare and are a healthful and fantastic snack for your kids' lunch boxes.

1. Preheat the oven to 400°F.

2. Slice the potatoes into ⅛-inch-thick "chips" using a knife or a mandoline.

3. Combine the potatoes, oil, and salt in a bowl or re-sealable bag and toss to coat.

4. Spray 2 baking sheets with a thin coating of cooking spray and spread the potatoes in a single layer.

5. Bake for 15 to 20 minutes, or until the chips start to turn golden. Flip the chips and bake for 15 minutes more (some of the chips may turn golden before others, so keep an eye on them and remove them as they crisp).

See the photograph for this recipe on page 85.

roasted carrot coins

Whenever I take the kids to my friend's house for a play date, she usually serves steamed carrot coins for dinner. They're tender and sweet, and all our kids love them. I think the coin shape and name makes them extra appealing to little ones.

I used to avoid making cooked carrots because I have such vivid memories of the waterlogged ones from my middle school cafeteria tray which always went untouched. Remember those? Limp, bland, and quite sad looking—it's easy to see why kids often reject foods at a young age. First impressions can mean everything which is why I focus so much on presentation.

Just by giving them a little extra lovin' by roasting them with a bit of seasoning, these carrots are nothing like the ones I grew up on. They turn out sweet, bright orange, and scrumptious. It's nice to know that you can re-discover foods you grew up on (even the ones you may not have fond recollections of) and see them in a whole new light!

1. Preheat the oven to 400°F.

2. Place the carrots on a baking sheet and toss with the paprika, oil, and salt to combine.

3. Roast for 30 minutes, or until caramelized.

See the photograph for this recipe on page 8.

Makes 4 servings

4 medium carrots, peeled and cut into ¼-inch coins (about 2 cups)

¼ teaspoon mild paprika

1 teaspoon olive oil

¼ teaspoon salt

roasted vegetables

Most Sundays the kids go to the farmers' market with me and I let them pick out whichever veggies they want to eat that week. Once we get home I give them child-safe knives and cutting boards to cut up everything with me before plopping the vegetables on big baking sheets and roasting them to golden perfection.

The best part about this recipe is that you can enjoy these veggies for dinner or put them in the lunch box with a drizzle of lemon or maple syrup the next day, or even chop them into a veggie quesadilla the day after that. Food is all about getting the most mileage out of everything you make and having everyone excited to eat it. This dish lives up to that promise.

1. Preheat the oven to 400°F.

2. Place the chopped vegetables on a baking sheet, drizzle with the oil and salt, and toss to ensure everything is well coated.

3. Bake for 30 to 40 minutes, or until the vegetables are soft and beginning to caramelize. (If you're using broccoli, you may want to hold it back and put it on the tray after the rest of the veggies have been roasting for 10 minutes. It tends to cook a bit more quickly.)

TIP: Drizzle a bit of lemon juice or maple syrup on the veggies after they come out of the oven to brighten the flavors even more.

Makes 4 servings

4 cups chopped vegetables (broccoli, cauliflower, carrots, sweet potatoes, sweet bell peppers, onions, butternut squash, zucchini, parsnips, mushrooms, and so on)

2 tablespoons olive oil

1 teaspoon salt

dips and spreads

avocado honey dip

There's nothing worse than sending your child to school with a lunch box packed full of fresh veggies only to have them come back home exactly the way you sent them: uneaten. My advice? Add a dip like this one and see if it convinces your kid to munch and crunch on the good stuff.

As many weelicious readers know, we're big on dips in our house. I find that whenever I put out a big platter of veggies and accompany it with a yummy dip, the variety of vegetables I can get into my kids' little bodies increases by . . . well, a lot! Case in point was the day I made this Avocado Honey Dip. Chloe was sitting at the kitchen counter next to me while I was concocting it and asked if she could try some, so I made up a little plate for her with baby carrots, sugar snap peas, and pretzels. Chloe dug in and in a matter of seconds, she had finished what I gave her and had her little arms wrapped around the mixing bowl possessively. In her mouth was the spatula I had used to stir it. You can't ask for a better review than that!

Makes 1 cup

1 ripe avocado, peeled and pitted

¼ cup whipped cream cheese

1 tablespoon lemon juice

1 tablespoon honey

1. Place all the ingredients in a bowl and mash together until smooth.

2. Serve with cut-up veggies, crackers, pretzels, or even as a spread on toast.

TIP: A ripe avocado should be soft to the touch but not mushy.

NOTE: This dip also works great as a sandwich spread.

TRICIA: My son dips his crackers, veggies, and fruits in the Avocado Honey Dip . . . and it's so delicious he cannot resist dipping his fingers in it too!

STEACY: The Avocado Honey Dip is a sweet treat that packs a healthy punch. My kids love it!

avocado hummus

Makes 2 cups

One 15-ounce can chickpeas (garbanzo beans), drained and rinsed

1 medium avocado, peeled and pitted

1 garlic clove

2 tablespoons lemon juice

½ teaspoon kosher salt

¼ cup olive oil

1 tablespoon tahini

OPTIONAL ACCOMPANIMENTS

pita bread, pita chips, carrot sticks, radishes

There's a vendor at our farmers' market who sells the most delectable Middle Eastern food, and his personality is just as distinctive as the goods he sells. Before you can say that you've already eaten he'll tear off a big hunk of fresh whole-wheat pita and personally prepare for you a tasting of unbelievable flavor combinations from among his twenty different kinds of dips, yogurts, sun-dried tomatoes, olives, and hummus. This is the man who first persuaded Kenya to try Manchego cheese, and now, if I don't keep a hunk of it in our fridge at all times, I have a very unhappy little guy on my hands.

I had never thought of putting avocado in hummus, but one Sunday I was convinced to buy some from my friendly purveyor, and Chloe loved it. True to form, she ate the entire container in one sitting and demanded more. Obviously I didn't have any, and so necessity being the mother of invention, I tried making my own. It was a big hit.

Now if I could just figure out how to make Manchego cheese . . .

1. Place all the ingredients in a food processor and pulse until smooth.

2. Serve with the desired accompaniments. The dip will keep for 4 days in the fridge.

TIP: In a pinch you can substitute peanut, almond, or sunflower butter for the tahini.

SARA: Avocados and chickpeas, two things we *love* in my house. Combined, it makes the best dip or condiment to eat with just about anything!

JUNIPER: My three-year-old has a dairy and nut allergy and will not touch a vegetable! The avocado hummus is our go-to with lunch. She

loves it (and I can't say that about too many things), and I know she's getting protein and vitamins she really needs!

📺 supereasy hummus

Makes 1½ cups

One 15-ounce can chickpeas (garbanzo beans), drained and rinsed

1 garlic clove

2 tablespoons tahini

3 tablespoons lemon juice

1 teaspoon salt

⅓ cup olive oil

One of the first foods I gave my kids after they journeyed through a rainbow of fruit and veggie purees was hummus. Its creamy texture and vibrant flavor were an eye-opening pleasure for them both, especially after the simplicity of their first foods.

You can *always* find hummus in my fridge. For starters, it's easy to make and stays fresh for more than a week, so I never have to worry about having a healthful protein that I know my kids love on hand (that being said, it's usually all gone before the week is up).

1. Place the chickpeas, garlic, tahini, lemon juice, and salt in a food processor and pulse to combine.

2. Add the olive oil and continue to pulse until smooth and creamy.

TIP: Tahini is a sesame seed paste that can be found at your local grocery, usually near the peanut butter or in the kosher aisle.

everyday basil pesto

This pesto is easy to make, you can store it for weeks in the fridge, and my kids hoover it up no matter what I put it on—from fish to pasta to sandwiches.

1. Place all the ingredients in a food processor and pulse until smooth.

2. Toss with fresh pasta and serve, or store in the refrigerator for up to 2 weeks or in the freezer up to 3 months.

TIP: Place pesto in ice cube trays and freeze so you always have a single serving whenever you need it!

Makes 1 cup

2 cups fresh basil leaves

¼ cup grated Parmesan cheese

¼ cup pine nuts (raw or toasted briefly in a dry skillet)

1 garlic clove

½ teaspoon salt

¼ cup olive oil

REBEKKA: A must-have staple in my home at all times! We eat it with pasta and paninis, and it's the secret ingredient in all my tomato-based sauces.

SHANNON: My eighteen-month-old will eat just about anything if it has pesto on it. It's not just for pasta! I toss it with steamed veggies and smear it on wraps and pita bread, and it's great on chicken or fish! I always try to keep some basil pesto in the fridge.

KEREN: Your basil pesto has become a staple in our house. I even know the recipe by heart! It takes less than 5 minutes to make and we use it on pasta, in omelets, as a sandwich/panini spread, and in your delicious turkey pesto meatballs!

DIANNE: My son loves the basil pesto; this was my go-to "food" served over star pasta when he was sick, teething, or even just being a bit picky and didn't want to eat anything else.

black bean hummus

⅓ cup pepitas

1 small garlic clove

One 15-ounce can black beans, drained and rinsed

3 tablespoons olive oil

2 tablespoons water

Juice of ½ lemon

½ teaspoon cumin

¼ teaspoon salt

¼ cup chopped cilantro (you can use the stems—they have tons of flavor)

OPTIONAL ACCOMPANIMENTS

tortilla or pita chips, carrots, cucumber, celery, or jicama sticks

Traditional hummus is made from garbanzo beans, tahini, olive oil, and lemon juice, but there's no reason you can't get creative and come up with an array of new hummus flavors using different types of beans, vegetables, or nuts. When I find a food my kids like, I try to build on it to help introduce them to new flavors.

This is a Mexican-inspired hummus using pepitas (pumpkin seeds), black beans, cumin, and cilantro. In the spirit of keeping everything homemade, I make my own healthful and crispy tortilla chips (see the Tip below) instead of buying fried ones at the store. It's easy to do, and my kids love getting to break up the tortillas into chips themselves.

Whether you're inviting friends over for a party, want a protein-packed school lunch-box snack for your little one, or just need something nutritious and delicious to nibble on throughout the day, this hummus delivers. *Olé!*

1. Place the pepitas in a dry sauté pan and toast over low heat for 5 minutes, or until the pepitas start to turn golden, stirring halfway through.

2. Place the pepitas and garlic in a food processor and pulse for 1 minute.

3. Add the remaining ingredients and pulse until smooth.

TIP: Make your own tortilla chips! Using scissors or a knife, cut corn or flour tortillas into chips. Bake at 350°F on a baking sheet for 12 to 15 minutes, or until nice and crispy.

caramelized onion dip

If I was going to make a top ten list of Foods I Think Kids Will Avoid, onions would be at the top. However, I no longer assume what kids will and won't like, as they continually surprise me at every turn.

The ingredient list for this dip features a big, juicy onion that caramelizes to perfection during cooking and becomes sweet—not at all what you might expect—mellowing out any strong onion flavor. When pureed with the Greek yogurt, it results in mouthwatering creamy perfection!

1. Heat the oil in a sauté pan over low to medium heat. Add the onions and garlic, and cook for 15 minutes, stirring occasionally, until the onions are soft, golden, and slightly mellowed. Set the onions aside to cool.

2. Place all the ingredients in the bowl of a food processor and pulse to finely chop and combine.

3. Chill and serve.

Makes 1 cup

2 tablespoons olive oil

1 large white onion, chopped

1 large garlic clove, chopped

½ cup plain Greek yogurt

½ teaspoon salt

OPTIONAL ACCOMPANIMENTS

celery, radishes, sugar snap peas, carrots, crackers, or pita chips

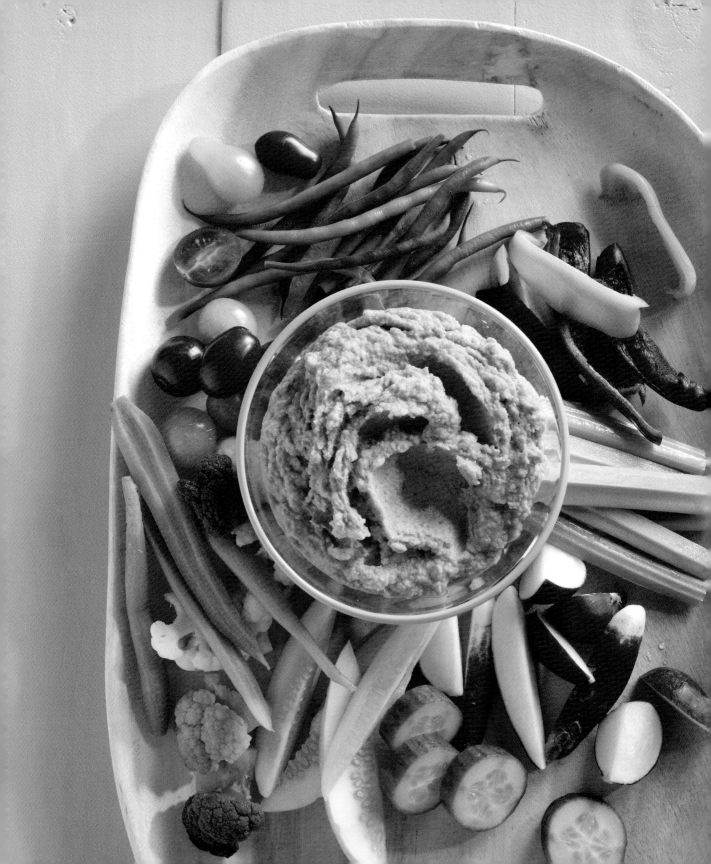

📺 roasted carrot hummus

Hummus is a godsend for many parents, especially for those whose kids have a vegetarian or vegan bent. It's one of those foods that holds up well unrefrigerated (making it perfect for the lunch box), is high in protein, and is an ideal accompaniment to crackers and raw vegetables or even as a sandwich spread.

Simply roasting a few carrots, which offer a caramelly sweetness, and adding in a few other flavorful ingredients, such as peanut butter—yes, peanut butter—results in a yummy hummus with a unique depth of flavor.

1. Preheat the oven to 400°F.

2. Place the carrots and whole garlic clove on a baking sheet. Drizzle with the olive oil, sprinkle with the salt, and toss to coat.

3. Roast for 45 minutes, or until the carrots are fork tender and starting to caramelize.

4. Place all the ingredients in a food processor and puree until smooth.

NOTE: You can thin this hummus by adding olive oil or hot water, 1 tablespoon at a time, until desired consistency is reached.

Makes 2 cups

3 large carrots, peeled and cut into 1-inch pieces

1 garlic clove

2 teaspoons olive oil

½ teaspoon kosher salt

One 15-ounce can chickpeas (garbanzo beans), drained and rinsed

2 tablespoons lemon juice

2 tablespoons peanut butter (or almond butter, sunflower butter, or tahini)

OPTIONAL ACCOMPANIMENTS

cauliflower, broccoli, cucumbers, pretzel sticks, or rice cakes

carrot ginger miso dip

Makes ½ cup

1 large carrot, peeled
and finely grated
(about ½ cup)

1 tablespoon minced or
grated ginger

1 tablespoon rice wine
vinegar

1 tablespoon yellow or
white miso

3 tablespoons canola
or vegetable oil

OPTIONAL
ACCOMPANIMENTS

sugar snap peas, celery
sticks, endive spears, or
cucumber sticks

I constantly get e-mails from parents saying that their little ones won't eat vegetables. Kids can present parents with all kinds of eating challenges, but in my experience if you give them something to dip their vegetables in, chances are pretty good that they'll want to give it a try. It transforms eating into an active and fun event. I'm not saying this strategy will work with every child, but it's worked for me and many readers to whom I've suggested it.

One of my readers once suggested giving little names to the veggies, like "trees" for broccoli, "logs" for carrots, and "sticks" for green beans, allowing little ones to use their imaginations at the table. Simply eating veggies with your child is a good modeling tool. Even better when you do it with this savory Japanese inspired dip alongside.

1. Place the carrot, ginger, vinegar, and miso in a food processor or blender and puree.

2. Drizzle in the oil while the machine is running, mixing until the puree is thick and creamy.

CRYSTAL: It reminds me of the ginger dressing you get at Asian restaurants—only better. And it makes a terrific dip for raw veggies, too!

TIP: This dip also makes a delicious salad dressing!

cucumber yogurt dip (raita)

I love to make this yogurt-based Indian dip called *raita,* which pairs beautifully with tandoori kebabs. At dinnertime the kids literally slurp it right out of the bowl. I'm normally programmed to eat Greek yogurt with a drizzle of honey or sprinkle of granola on top, but yogurt is used in savory cooking all over the world. One taste of this dip/sauce and you'll understand why. Cool, tart, and creamy, with added crunch from the cucumber, this dip is a lunch box must.

P.S. I bet you'll be asked for thirds and fourths of this one, so I highly recommend doubling or tripling the recipe!

1. In a bowl, mix together all the ingredients.

2. Serve chilled with the desired accompaniments.

TIP: I love using Persian cucumbers with the skin on, but you can also use peeled English or hothouse cucumbers.

Makes 1 cup

½ cup plain Greek yogurt

½ cup diced cucumbers (see Tip)

2 teaspoons lemon juice

¼ teaspoon salt

OPTIONAL ACCOMPANIMENTS

pita chips, carrot sticks, tandoori kebabs

chocolate-hazelnut spread

Makes 1¼ cups

1 cup hazelnuts

¼ cup agave nectar or honey

2 tablespoons unsweetened cocoa powder

3 tablespoons hot water

Every night, my husband and I take turns telling our kids bedtime stories. While hubby comes up with supercreative, elaborate, entertaining tales that feature a lesson or moral woven in, my stories are generally straightforward travelogues along the lines of "Mommy and Kenya Go to Paris" (think I've been reading too much *Madeleine?*). In my story, Kenya and I roam around looking at the Eiffel Tower, touring Notre Dame, and eating everything from croissants to crepes. Kenya usually asks if we can make the food I talk about so fondly and one story resulted in us preparing crepes three mornings in a row!

Crepes are easy to make (see page 302), and my kids love being surprised by different fillings. In one of my stories, I talked about eating banana-filled crepes with Nutella, but instead of buying a jar of the famous hazelnut-chocolate spread they use in France, we decided to make our own homemade version.

Whether you decide to slather this insanely delicious and addictive treat on graham crackers, strawberries, crepes, or eat it right off the spoon, this version of Homemade Nutella will make you feel like you're on your own Paris vacation.

NICOLE: With my family coming from Germany, I was raised on Nutella—but Nutella has got nothing on this delicious recipe!

1. Preheat the oven to 350°F.

2. Place the hazelnuts on a baking sheet and toast for 15 minutes.

3. Remove the hazelnuts to a kitchen towel (not one of your nice ones) and rub to remove the skins.

4. Place the hazelnuts in a food processor and chop for 30 seconds.

5. Add the remaining ingredients and pulse until smooth.

6. Serve with Whole-Wheat Crepes, as a sandwich spread, or as a dip for fruit.

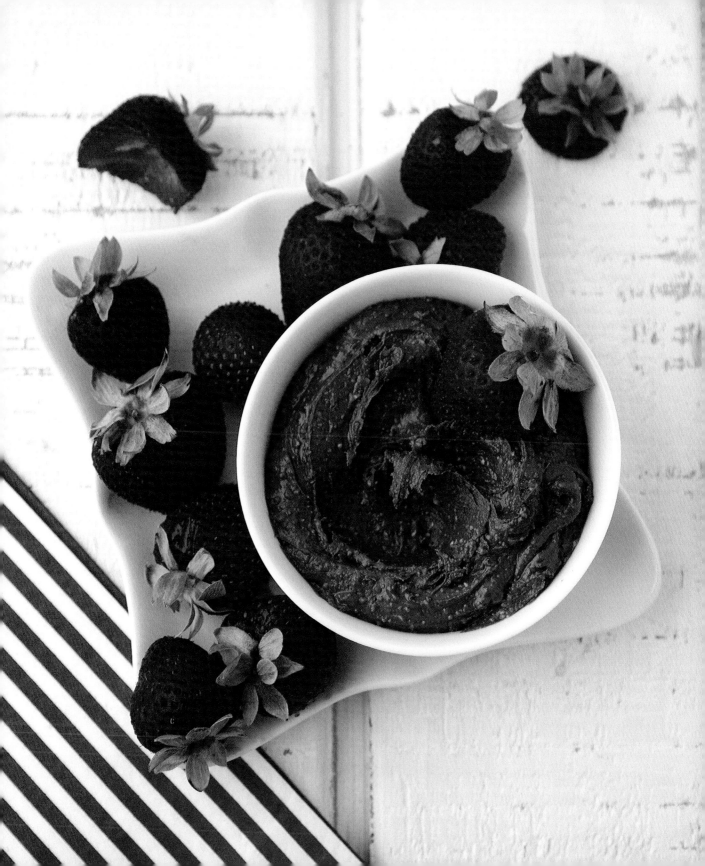

cheesy olive tapenade

Makes 1½ cups

1½ cups pitted kalamata olives (or one 12-ounce jar, drained)

½ cup grated Parmesan cheese

2 tablespoons olive oil

1 garlic clove

6 fresh basil leaves

1 tablespoon lemon juice

I'm always a bit shocked when I encounter kids who love olives, but when you think about it, what's not to love? Their light briny flavor can be addictive for some people, and when the pits are removed, they're perfect for packing into a school lunch or making into a spread (or tapenade) like this one. There are tons of variations on tapenade that I've tried throughout the years. I added some grated Parmesan to this one, knowing that the addition of cheese can sell almost anything edible to my kids.

As per usual, I let them help me measure out the ingredients, whiz them together in the blender, and then spread the final result on bread with cream cheese for their school lunch. They love it.

1. Place all the ingredients in a food processor and puree until smooth.

2. Spread on toast points, crackers, or on a sandwich.

zippy yogurt tahini sauce

Zippy, zingy, and full of flavor! This sauce is full of protein and a great accompaniment to Falafel Bean Patties, Chicken Nuggets, or your favorite veggies to dip away!

Place all the ingredients in a bowl and stir to combine.

Makes a little over ½ cup

½ cup plain yogurt

1 tablespoon lemon juice

1 tablespoon tahini (if your little one has a sesame seed allergy, you could leave this out)

veg-wee dip

Makes ½ cup

½ cup plain yogurt
(I use Greek yogurt)

1 teaspoon Spike
or other salt-free
seasoning

1 teaspoon lemon juice

I actually started making this versatile dip for myself years before I had kids. I still eat it with steamed artichokes and even on grilled fish. With just a quick shake, squeeze, and stir, you can turn plain ol' yogurt into something that tastes just like ranch dressing (only this one is *much* better for you).

Whether you put a small serving of this alongside slices of red bell pepper in a lunch box or serve it on a platter with an assortment of carrots, cucumbers, cherry tomatoes, and green beans at dinnertime, this dip will help inspire the veggie lover in everyone!

1. Place all the ingredients in a bowl and stir to combine.

2. Serve with raw or steamed veggies such as baby carrots, celery, cucumber, fennel, cauliflower, cherry tomatoes, broccoli, and jicama.

BECKY: I couldn't get my kids to eat any vegetables until I started giving them this dip, which, thank goodness, changed everything!

Whole-Wheat Cheddar Crackers (page 266)

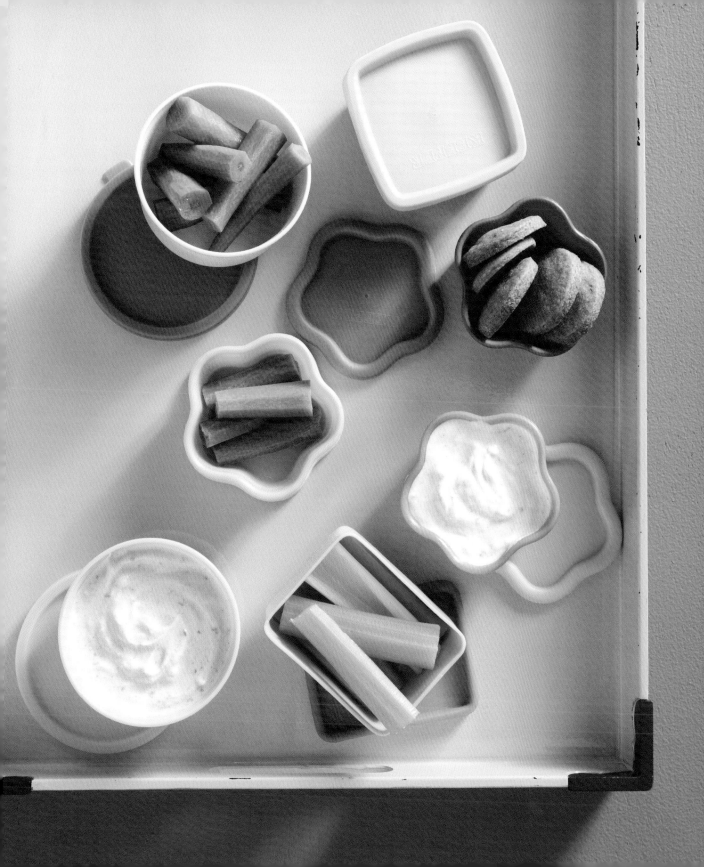

veggie cream cheese spread

Makes 2¼ cups

2 carrots, peeled and roughly chopped

1 cup chopped broccoli florets

One 12-ounce container whipped cream cheese or one 8-ounce package regular cream cheese, softened

½ teaspoon garlic powder

½ teaspoon onion powder

½ teaspoon salt

Having a tough time getting enough vegetables into your or your child's diet? Then this dish is for you! For best results, I suggest you let your kids make it *with* you. Since all you have to do is dump the ingredients in the food processor and pulse it up, it's the ideal thing to make with even the tiniest of chefs.

My favorite part about this spread is the variety of ways you can serve it. You can schmear it on a bagel, roll it up in a lavash or whole-wheat wrap and cut it into pinwheels, or even use it as a dip for *more* veggies. Did you even think that was possible?

1. Place the carrots in the bowl of a food processor and pulse until finely chopped.

2. Add the broccoli and continue to pulse until finely chopped.

3. Add the remaining ingredients and pulse until the mixture is smooth and well incorporated.

kale pesto

If there's one food item I suggest every mom always keep in her fridge for a quick dinner fix, it's pesto. Pesto can be your best friend when it's late in the day and you're officially too fried to make dinner—let alone think about what it should be. I should know, because I feel that way constantly.

I've rarely met a kid who doesn't enjoy pesto. Maybe it's the unmistakable taste of Parmesan cheese that makes it so addictive for them. Mixed into rice or pasta, as part of an Egg Pesto Melt (page 96), whipped up in an omelet, or spread on chicken or fish before baking, pesto is a miracle food that makes almost anything taste better.

1. Place all the ingredients in a food processor and puree until smooth.

2. Serve over rice, pasta, or as a sandwich spread.

NOTE: To toast walnuts, spread roughly chopped walnuts on a baking sheet and pop in a 400°F oven for 5 minutes.

Makes 1 cup

2 cups packed kale leaves, stems removed

½ cup toasted walnuts (see Note)

2 tablespoons grated Parmesan cheese

1 garlic clove, roughly chopped

2 tablespoons lemon juice

½ teaspoon kosher salt

¼ cup olive oil

pure strawberry preserves

2 pints strawberries (about 5 cups), stemmed and halved

1 to 2 tablespoons freshly squeezed lemon juice

¼ cup agave nectar or honey (optional, depending on the sweetness of the berries)

For years we've been buying preserves from a vendor called Harry's Berries at the Hollywood Farmers' Market. Harry's sells the most incredible strawberries I've ever tasted, but my husband thinks that there's too much sugar in their preserves. As a means of comparison I sampled several different brands of strawberry jam and preserves from our local grocery, and I thought that they, too, all had a really sugary aftertaste.

The preserves I love are the ones that taste like pure strawberries with a bare hint of added sweetness, so I came up with my own recipe, substituting honey for sugar. The real trick, though, is using the best strawberries you can find. As with most recipes, the quality of your ingredients is everything. Whether you spread them on a rice cake with a little cream cheese, place a dollop on top of plain yogurt, or spoon them on oatmeal or pancakes, these vitamin C–packed chunky preserves are pure heaven in every bite.

1. Place all the ingredients in a saucepan and bring to a simmer over low to medium heat.

VALERIE: I made it at least once a month last summer and my daughter loves it with peanut butter, cream cheese, mixed into yogurt, or just on toast. Love giving her (and this summer her little brother) such a fresh and yummy treat!

CRISTY: We have always loved making the Pure Strawberry Preserves! It's challenging to find preserves that don't have a ton of sugar without sacrificing taste, but this recipe is wonderful!

2. Cook, uncovered, for 50 to 60 minutes, stirring occasionally, until most of the liquid has evaporated (you want the preserves to have little chunks of strawberries).

3. Cool and serve on top of plain yogurt or spread on toast.

TIP: Store in a jar in the refrigerator for up to 2 weeks (although I've kept mine up to 3 weeks).

snacks

🐹 animal crackers

Makes a *lot*, depending on the shape and size you cut them in

1½ cups all-purpose flour

½ cup old-fashioned rolled oats

1 teaspoon baking powder

½ teaspoon salt

½ teaspoon ground allspice or mace

½ cup sugar

½ cup (1 stick) unsalted butter, chilled and cut into pieces

1 teaspoon pure vanilla or lemon extract

1 large egg

EMILEE: **We *love* the Animal Crackers at our house! They're definitely not just for the little kids—Mommy and Daddy love them as well! I love knowing what is in them and I can pronounce all the ingredients!**

Animal crackers are synonymous with kids. All little ones seem to love these imaginative treats, and I'd bet you have your own fond childhood memories of eating them as well . . . with good reason. Animal crackers make everyone happy, which is why many moms keep them on hand.

In coming up with this recipe, I bought a bunch of boxed brands to investigate the ingredient lists and try to replicate the texture and flavor of the tastiest ones. I think I got pretty close.

Whether you're making these for a birthday party, school snack, or midday treat, these Animal Crackers are sure to bring out the kid in everyone.

1. Place the flour, oats, baking powder, salt, allspice, and sugar in a food processor and pulse to combine.

2. Add the butter and pulse to combine.

3. Add the vanilla and egg and pulse until the dough forms a ball.

4. Wrap the dough in plastic wrap and chill in the refrigerator for 30 minutes.

5. Preheat the oven to 350°F.

6. Roll out the dough on a floured surface to ¼ inch thick and cut out animal shapes.

7. Place the cutouts on a Silpat- or parchment-lined baking sheet.

8. Bake for 15 minutes and remove to a cooling rack.

TIP: The cookies can be covered and stored at room temperature up to 5 days.

TO FREEZE: After step 6, place the cutout cookies on a baking sheet and freeze for 20 minutes. Remove, place in a ziplock bag, label, and freeze for up to 4 months. When ready to bake, follow cooking directions, adding 2 minutes to the baking time.

chocolate chip granola bars

Do you have any idea how much money you spend on granola and/or nutritional bars for your kids each year?

Take a minute and add it up. I would bet it's more than you think. They may be convenient—on those busy mornings when you don't have time to make breakfast, there's nothing easier than tossing one bar into your child's lunch box and another into your purse—but at what cost?

About eight years ago, I got so fed up with spending money on granola and nutritional bars that I decided to figure out how to make them myself. I worked so hard at it that I seriously flirted with the idea of starting my own bar business! These Chocolate Chip Granola Bars are unbelievably delicious and, if you wrap and store them individually, just as easy to grab when you're on the go as the ones you buy at the market (plus, you'll have no problem pronouncing any of the ingredients in these). The best part? This recipe makes thirty bars and will cost you less than $4.00 to make.

If you can't bear the thought of giving your kids chocolate chips first thing in the morning (my husband always gets tweaked when he sees our kids eating chocolate at 8 a.m.), you can easily replace them with naturally sweet dried fruit, such as cranberries, cherries, or raisins. Still, if my kids are going to have chocolate, I'd rather it be in the morning than right before they go to bed.

Chewy and crunchy with toasted oats and a sweet surprise in every bite, these Chocolate Chip Granola Bars are a must for your lunch box rotation!

1. Preheat the oven to 325°F and line a baking sheet with parchment paper.

2. Combine the oats, flour, coconut, brown sugar, chocolate chips, and salt in a large bowl.

3. In a separate bowl, whisk together the canola oil, vanilla, and honey.

4. Pour the wet ingredients over the oat mixture and stir to combine.

Makes about 30 bars

4 cups old-fashioned rolled oats

¼ cup whole-wheat flour

½ cup shredded unsweetened coconut

⅓ cup packed brown sugar

1 cup chocolate chips (or raisins or other dried fruit)

½ teaspoon kosher salt

½ cup canola oil

1 teaspoon pure vanilla extract

½ cup honey

5. Spread the granola mixture on the baking sheet and shape it into a 9 x 13-inch rectangle that's about 1 inch thick.

6. Bake for 40 minutes, or until golden and dry to the touch.

7. Cool on the baking sheet for 10 minutes, then cut into 3 x 1-inch bars using a serrated knife. These bars will remain fresh for several weeks if wrapped individually in parchment or wax paper.

CHRISTA AND TRAVIS: **The Chocolate Chip Granola Bars, Whole-Wheat Cheese Crackers, and Animal Crackers are absolutely delicious and a staple in our house . . . my daughter loves to help in the kitchen, I like the fact I know exactly what is in them and that they are safe for my daughter, who has peanut and tree nut allergies.**

SARAH: **My son has severe nut allergies. So there really aren't any good granola bars from the store that he can eat. So we tried the Chocolate Chip Granola Bar recipe and it's amazing! We've been making it for over a year now and there is no end to the different ways you can make them! So many moms have asked me where I got my recipe and I'm happy to tell them! We love weelicious!**

STEFANY: **Your Chocolate Chip Granola Bars are *to die for*! My three-year-old daughter could eat the entire batch in one sitting if I let her. I have to hide them in the pantry (yet she still seems to find them). Great recipe, thank you!**

LINDSAY: My whole family LOVES and I mean loves your Chocolate Chip Granola Bars! I had never even given a thought to all of the ingredients in store-bought bars until I came across your recipe! I'm so glad I did! They are the hit of play dates and a go-to snack I can feel good about feeding my family!

KIM: I make a double-batch of your Chocolate Chip Granola Bars every other week. There is a one-per-day rule, or else they disappear way too quickly! When I talked about buying granola bars at the store during a busy month, there was a resounding protest from my family! I recently shared the recipe on Facebook and now a friend is making them regularly too!

CRYSTAL: The whole family *loves* these bars— including my husband! I freeze them in individual bags so they are handy when I'm making lunches, or packing snacks for a car trip. The best part is, they're so easy to make!

RUTH: Be warned—the Chocolate Chip Granola Bars are highly addictive. We go through a batch every week and haven't purchased commercial granola bars in years.

banana upside down mini muffins

Makes 2 dozen

5 medium ripe bananas

¾ cup buttermilk

1 large egg

3 tablespoons canola or vegetable oil

1 teaspoon pure vanilla extract

2 cups white whole-wheat flour

⅓ cup packed brown sugar

1 teaspoon baking powder

½ teaspoon baking soda

½ teaspoon salt

Of the top ten foods I keep on hand at all times, bananas are way up there. They're inexpensive, come in their own wrapper, and are naturally filling. If those reasons weren't enough, the fact that bananas make the most tender, sweet muffins is an added bonus.

These muffins have a coin-size piece of banana on the bottom that caramelizes when baked. When you flip them over you're greeted by that sweet sight, resulting in a two-bite treat you can't resist.

1. Preheat the oven to 375°F.

2. Slice 2 of the bananas into ¼-inch coins and place the coins in the bottom of 24 greased mini-muffin cups.

3. In a large bowl, mash the remaining 3 bananas (you should end up with a heaping cup of mashed banana). Whisk in the buttermilk, egg, oil, and vanilla.

4. In a medium bowl, whisk together the flour, brown sugar, baking powder, baking soda, and salt.

5. Mix the dry ingredients into the wet ingredients until just combined.

6. Pour the batter on top of the banana coins, filling the muffin cups about ¾ full.

7. Bake for 12 minutes, or until a toothpick inserted in the center comes out clean.

8. Allow muffins to cool for a few minutes, then remove from the muffin cups and turn upside down to serve.

cinnamon pita chips

I detest waste and try hard to use every bit of food that I buy, but inevitably a loaf of bread or a bag of bagels or pita will go stale. I fight back and give baked goods a second life by turning them into bread crumbs, croutons, or chips. These Cinnamon Pita Chips are a perfect example. Just cut stale or fresh pita into wedges and sprinkle them with cinnamon and sugar before baking. Your whole house smell like heaven as they toast up. As a result, they vanish almost instantly, and you'll be chuffed by your own thriftiness.

1. Preheat the oven to 350°F.

2. Slice each pita in half and cut each half into 3 wedges.

3. Combine the sugar and cinnamon in a small bowl.

4. Place the pita triangles on a baking sheet and spray lightly with oil (or brush a bit of oil on each chip). Sprinkle with the cinnamon and sugar mixture and toss to coat.

5. Bake for 10 minutes, or until crisp.

Makes 18 chips

Three 6-inch whole-wheat pitas

2 teaspoons sugar

1 teaspoon ground cinnamon

Canola oil spray or canola oil

cranberry cheese balls

Makes 1 dozen

2 tablespoons dried cranberries

1 cup grated Cheddar cheese

These Cranberry Cheese Balls came about on a day when I had grated way too much Cheddar for another recipe. Chloe and I started rolling the excess into balls and then popping them in our mouths, one after another. We decided to take different dried fruits and roll them into the balls as well, and surprise, surprise—they turned out to be pretty good. Not bad as a vegetarian snack, and perfect for the lunch box.

1. Chop the cranberries into small pieces.

2. In a bowl, combine the cranberries and cheese.

3. Using a small ice cream scoop or a tablespoon, roll the mixture into 12 small balls. Press and shape them to hold them together. Serve immediately or refrigerate until ready.

TIP: You can substitute dried cherries, blueberries, or apricots for the cranberries.

hubby's "better than ice cream"

When it comes to food, sometimes my husband is just as creative as my kids. Take, for instance, this Greek yogurt loaded with cinnamon, honey, and walnuts. The first time hubby made it was one Sunday night after dinner. I had offered the kids ice cream for dessert, and because they hadn't really eaten a lot of their dinner, he jumped in and said, "I've got something much better than ice cream." Coming from me these words might not have had the same powerful effect on Kenya and Chloe, but Daddy is known for some of the culinary tricks he has up his sleeve, and they went for it.

Minutes later my mixologist husband was ladling this light golden mixture into colorful bowls and the kids were *devouring* it. When they asked for seconds, it was confirmed this recipe was a hit, and a genius one at that. While it's an inspired dessert, it's also a healthful and protein-rich treat I feel extra good about serving for breakfast, in the lunch box, and on those *we didn't eat all our dinner but demand dessert* nights like the one that inspired this recipe. Plus, how many things can you offer your kids that trump ice cream?

1. Place all the ingredients in a bowl and stir to combine.

2. Serve with the optional accompaniments as desired.

Makes 2 servings

1½ cups plain Greek yogurt (0% or 2%)

1 teaspoon ground cinnamon (or more to taste)

3 tablespoons honey

⅓ cup walnuts, chopped

OPTIONAL ACCOMPANIMENTS

fresh or dried berries, diced bananas, kiwis, mango, or granola (page 233)

fruit and seed bars

Makes 15 bars

1 cup old-fashioned rolled oats

½ cup raw pumpkin seeds (also known as pepitas)

½ cup raw sunflower seeds

2 tablespoons flax seeds

1 cup dried fruit (blueberries, raisins, currants, cranberries, and/or cherries)

½ cup unsweetened coconut flakes

⅓ cup honey

½ cup sunflower butter

These Fruit and Seed Bars deliver the goods: sunflower seeds are packed with protein and vitamin E, pumpkin seeds with magnesium, and flax seeds with an off-the-charts amount of omega-3 fatty acids. Consider all the other healthful ingredients in this recipe and these bars are just as sweet, crunchy, healthy, and delicious as any nut-filled protein bar you'll find in stores. My kids can't seem to get enough of them, and they're a treat that most schools will happily welcome.

1. Preheat the oven to 325°F. Grease an 11 x 7- or 9 x 9-inch baking pan, then line it with parchment, allowing the parchment to come up two sides of the pan.

2. In a food processor, pulse the oats, pumpkin seeds, sunflower seeds, flax, dried fruit, and coconut until finely chopped (it's okay if there are a few coarsely chopped pieces).

3. Add the honey and sunflower butter and pulse until the mixture is combined.

4. Pour the mixture into the pan and spread it out evenly.

MAIJA: I have made the Fruit and Seed Bars for my boys and they are the perfect, healthy version of the typical sugar-laden granola bar. My boys love them for an afterschool snack or on the go to a sports activity.

JENNIFER: The Fruit and Seed Bars are a staple in our house. I make a double batch and freeze half so that we always have these bars on hand! My son will ask for them by name and loves to help make them! Thank you so much for this recipe!

5. Bake for 25 minutes, or until firm to the touch.

6. Let cool completely, then use a serrated knife to cut into fifteen 2-inch bars.

TO FREEZE: Cool, place in ziplock bags, label, and freeze. Defrost to room temperature and enjoy!

mini bagel chips

Makes 12 chips

3 mini or regular bagels, any flavor

The only thing that rivals our local deli's delectable matzo ball soup is the homemade bagel chips they serve with it. We always take the leftovers with us and my kids love it when I put them in their lunch boxes.

Whenever you've got a few extra bagels lying around—especially if they're starting to get stale—slice and bake them up to make these crispy, crunchy chips that are great with soup or dipped into creamy Supereasy Hummus (page 210) or Veggie Cream Cheese Spread (page 224).

1. Preheat the oven to 350°F.

2. Slice the bagels into ¼-inch-thick disks.

3. Place the bagel slices on a baking sheet and bake for 15 minutes, or until golden brown and crisp.

savory chex mix

When I was growing up, one of my neighbors was a charming woman named Mrs. Wolf. In her seventies, she was sweet, wise, and very good to me. Many days after school I would make a beeline over to her house for long conversations while she refilled a bowl over and over with homemade Chex mix. Even now, whenever I see a row of Chex cereal boxes at the supermarket I can't help but think of Mrs. Wolf, our sweet chats, and one of my favorite savory nibbles.

1. Preheat the oven to 300°F.

2. Place all the ingredients in a bowl and toss to combine.

3. Spread the mixture in an even layer on a rimmed baking sheet and bake for 30 minutes.

NOTE: You can use any mixture of unsweetened cereal you prefer—choose what you love to eat!

Makes 7 cups

2 cups Rice Chex cereal

2 cups Wheat Chex cereal

2 cups O's cereal, or Cheerios

1 cup slivered almonds

½ cup grated Parmesan cheese

½ teaspoon paprika

½ teaspoon onion powder

½ teaspoon garlic powder

½ teaspoon salt

3 tablespoons olive oil

roasted honey cinnamon chickpeas

Makes about 2 cups

One 15-ounce can chickpeas (garbanzo beans), drained and rinsed, or 2 cups cooked chickpeas

½ teaspoon ground cinnamon

1 tablespoon canola or vegetable oil

1 tablespoon honey

The shelves of most supermarkets are overflowing with a seemingly endless amount of snack food choices, but how many of them are actually nutritious? The majority, at best, contain a good deal of salt, sugar, hydrogenated oils, and more.

These amazing Roasted Honey Cinnamon Chickpeas are my version of healthful junk food. They're supercrunchy and sweetened with a light coating of cinnamon and honey, making them even more addictive than those junky snacks you can't pry out of your child's hands. In fact, with only four wholesome ingredients, including protein-packed chickpeas, you'd be hard pressed to find another snack food that's this good for you.

1. Preheat the oven to 400°F.

2. Place the chickpeas between two paper towels and pat them dry, loosening and removing the outer skins (this takes a few minutes, but it's a great way to get the kids involved). Pat the chickpeas completely dry.

3. Whisk the cinnamon and oil in a bowl to combine. Add the chickpeas and stir to coat. Spread the chickpeas on a baking sheet.

AMANDA: **Roasted Honey Cinnamon Chickpeas are amazing! They taste great and are so good on the go. Make a game out of "shelling" the chickpeas by popping them out of the skin and letting them hit different targets on the cookie sheet!**

ERIN: **My three-year-old twins *adore* the Roasted Honey Cinnamon Chickpeas! Even when I double the recipe, it's completely gone within a couple of days.**

4. Roast for 40 minutes, or until dried out and crunchy.

5. Place the chickpeas in a bowl and toss with the honey.

6. Spread the chickpeas on the baking sheet and roast for 7 minutes more.

7. Cool completely and serve.

NOTE: Store in a covered container on your counter for up to 2 weeks.

kenya's favorite pickles

Makes two 16-ounce jars

1 pound mixed vegetables (I use carrots, cucumbers, green beans, and pickling cucumbers, but you can also use cauliflower, celery, green tomatoes, jalapeños, or okra)

¼ cup kosher salt

1 tablespoon agave nectar or sugar

1 cup distilled white vinegar (you can also use champagne vinegar or white wine vinegar)

4 garlic cloves

6 dill sprigs

2 bay leaves

I think Kenya gets his love of pickles from my side of the family. My mother and I have both always been obsessive pickle eaters, but my husband argues that Kenya's love comes from him; he fondly recalls time spent as a kid on Essex Street on the Lower East Side of New York City, choosing pickles from the wooden barrels at his father's favorite pickle place, Guss' Pickles. Suffice it to say Kenya comes by his passion for pickles honestly.

I'm all for buying jarred pickles, but one day four years ago I spotted lemon and pickling cucumbers at the farmers' market, and they motivated me to make my own. There are tons of different herbs and spices you can use to make pickles, but I prefer the classic and simple approach. This mix of fresh ingredients produces a pickle with the perfect amount of flavor and zip that kids seem to love.

1. Divide the vegetables between two 16-ounce mason jars.

2. Combine the salt, agave, vinegar, and 1 cup water in a small bowl and whisk to combine.

3. Divide the garlic, dill, and bay leaves between the jars.

4. Pour the vinegar mixture over the vegetables and cover the jars.

5. Refrigerate and start enjoying after 2 to 3 days. You can eat them for up to 1 month.

MAYA: My boys, eight and four, love Kenya's Favorite Pickles. We use cucumbers and dill from our garden when we can and we also pickle carrots, green beans, wax beans, and cauliflower. They are so tasty and so much better than pickles from the store, which are either floppy or full of artificial colors and preservatives.

TIP: I always keep glass mustard, pasta sauce, and other kinds of jars to make these pickles.

TIP: When the first batch of pickles is gone, add more veggies to the same brine.

whole grain fruit-filled bars

When I started coming up with recipe ideas for this book I asked the exceptional weelicious Facebook community about which recipe they would most want to see. Whole Grain Fruit-FIlled Bars were one of the most requested, and I totally agree with the consensus.

My kids adore those popular soft grain- and fruit-filled store-bought bars, and they're certainly great for the lunch box or a quick breakfast in the car. But when you're buying box after box, the price can really add up—almost double the cost making them on your own. When you taste this homemade version, I hope you'll agree it's totally worth the effort.

1. Preheat the oven to 350°F.

2. In the bowl of a food processor, combine the flour, oats, brown sugar, and salt. Pulse for 30 seconds.

3. Add the butter and cold water and pulse until the dough holds together when pressed.

4. Grease a 9 x 13-inch baking dish, line it with parchment paper, and grease the parchment paper.

5. Divide the dough mixture in half and press half into the prepared baking dish, using the back of a spatula to press down evenly.

6. Spread the preserves evenly on top of the dough. Sprinkle the remaining dough evenly on top of the preserves and gently press down using the back of a spatula.

7. Bake for 45 minutes golden brown.

8. Cool, cut into 1½ x rs, and serve.

TIP: Bars can be sto m temperature up to 3 days or refrigerated up to a week.

Makes 16 bars

1½ cups whole-wheat flour

1½ cups quick cooking or old-fashioned rolled oats

½ cup packed brown sugar

½ teaspoon salt

¾ cup (1½ sticks) cold, unsalted butter, chopped into ½-inch cubes

2 tablespoons cold water

¾ cup fruit preserves

peach fruit leather

**Makes 7
long strips**

**4 cups chopped
peaches, skin on
(about 4 ripe peaches)**

1 tablespoon honey

One of the great sights and smells of summer for me is a big basket of fresh peaches. Our family is so fond of eating them that I tend to go a bit over-board at the farmers' market every Sunday and buy *way* more than we could possibly consume in a week. Unless we want to eat peaches for every meal, there's nothing really to be done except . . . make fruit leather!

You should just see how excited my kids get for this homemade fruit leather. They go through it so quickly that I tend to make about three batches a week, but one of the best things about this recipe is that it stays good for weeks, if not months.

1. Preheat the oven to its lowest setting, around 175°F (135°F if using a dehydrator).

2. Place the peaches and honey in a blender and puree until smooth.

3. Pour the mixture onto a Silpat- or parchment-lined baking sheet and use the back of a spoon or spatula to spread it *very evenly* into a large rectangle, about 11 x 15 inches.

4. Bake for 3 to 4 hours, or until the fruit leather is dry and not sticky to the touch. Remember, baking times will vary depending on how thick you spread your mixture and how much water (juice) is naturally in the fruit. The leather should be dry to the touch, not burned, if you're using an oven. The time could be as little as 2 hours if your oven runs hot. (If you're using a dehydrator, cook for 5 hours or until dry to the touch.)

5. Cool at room temperature; it takes several hours for the fruit to soften up. When you first take the fruit leather out of the oven, the edges will be a bit dry and crispy, but if you allow it to sit overnight it softens up nicely.

6. Using a knife, pizza cutter, or scissors, cut the leather into seven 2-inch-wide-by-14-inch-long strips, keeping the paper on, if desired. Roll the leather into fruit roll-ups.

TIP: If you have a dehydrator, this is the perfect time to use it!

📺 pineapple fruit leather

**Makes 7
long strips**

**1 pineapple, peeled,
cored, and cut into
chunks**

I've become a bit obsessed with fruit leather and all the different fruits that lend themselves to making this chewy, sweet treat. Whenever I make a sheet my kids will start grabbing at it as soon as it's done. I do my best to make a few sheets at a time, lest they leave me with nothing to roll up and put in their lunches.

When pineapple is a good bargain, buy it up and make a bunch of this leather.

1. Preheat the oven to 175°F (135°F if using a dehydrator).

2. Place the pineapple chunks in a blender and puree until smooth.

3. Pour the pineapple puree onto a Silpat- or parchment-lined baking sheet and use the back of a spoon or spatula to spread it *very evenly* into a large rectangle, about 11 x 15 inches.

4. Bake for 4 to 5 hours, or until the fruit leather is dry and slightly sticky to the touch, but not mushy. Remember, baking times will vary depending on how thick you spread your mixture and how much water (juice) is naturally in the fruit. (If using a dehydrator, count on 5 hours.)

5. Cool at room temperature; it takes several hours for the fruit to soften up (when you first take the leather out of the oven, the edges will be a bit dry and crispy, but if you allow it to sit overnight it softens up nicely).

6. Using a knife, pizza cutter, or scissors, cut the leather into seven 2-inch-wide-by-14-inch-long strips, keeping the paper on, if desired. Roll the leather into roll-ups.

TIP: If you have a dehydrator, this is the perfect time to use it!

NOTE: Fruit leather will stay good for weeks, if not months.

chai-spiced almonds

A handful of almonds is a great source of protein and vitamin E, but jazz the little dudes up with a handful of spices and they become totally addictive. My kids like almonds, but when I make these candylike Chai-Spiced Almonds, they can't stop eating them!

1. Preheat the oven to 400°F.

2. Place the almonds on a rimmed baking sheet and roast for 10 minutes.

3. Remove the almonds from the oven and place them in a bowl. Drizzle with the honey, sprinkle with the spices and salt, and stir to combine, making sure every almond is coated.

4. Lightly spray the baking sheet with canola oil spray and spread the almonds evenly on the sheet. Bake for 8 minutes more.

5. Remove from the oven and set aside to cool completely.

NOTE: These taste delicious warm, right out of the oven, but as they cool, the almonds will harden and have a more satisfying crunch. Store covered at room temperature up to 2 weeks.

Makes 2 cups

2 cups raw almonds

2 tablespoons honey

1 teaspoon ground cinnamon

1 teaspoon ground nutmeg

1 teaspoon ground ginger

½ teaspoon ground cardamom

½ teaspoon salt

Canola oil spray

polenta berry muffins

Makes 10 muffins

1 cup polenta (fine cornmeal)

1 cup all-purpose flour

2 teaspoons baking powder

¼ teaspoon salt

½ cup sugar

½ cup buttermilk (see Tip)

1 large egg

1 teaspoon pure vanilla extract

⅓ cup canola oil

2 teaspoons orange zest

1 cup fresh or frozen blackberries or mixed berries

Coming up with a wholesome snack isn't the easiest challenge, but when it includes a nourishing grain like cornmeal and antioxidant-rich berries, you know you're off to a good start. Whenever my kids need to bring a snack for their whole class, these little gems are always a good bet.

1. Preheat the oven to 400°F and use paper liners or grease 10 cups of a muffin pan.

2. In a bowl, whisk together the polenta, flour, baking powder, salt, and sugar.

3. In a separate bowl, whisk together the buttermilk, egg, vanilla, and oil.

4. Stir the dry ingredients into the wet ingredients and mix until just combined.

5. Fold in the orange zest and berries.

6. Divide the batter into the prepared muffin cups, filling two-thirds of the way. Bake for 15 minutes, or until a wooden pick inserted in the center comes out clean.

7. Transfer to a wire rack to cool.

TIP: If you do not have buttermilk, you can make it: place ½ cup milk less 1½ teaspoons in a measuring cup and fill with less 1½ teaspoons of white vinegar or lemon juice. Allow to sit for 5 minutes, then stir and add to the recipe.

NOTE: This dough is thick—don't worry about how dense it looks before baking!

soft pretzel bites

Makes 80 bites

1 cup warm water
(about 100°F)

½ tablespoon honey

One ¼-ounce packet
active dry yeast

2 cups white whole-
wheat flour

1 teaspoon salt, plus
more for sprinkling

2 teaspoons vegetable
or canola oil

1 cup room-
temperature water

2 teaspoons baking
soda

Sesame seeds
(optional)

There's nothing like the taste (or smell) of freshly baked pretzels. These warm mini nuggets are perfect for popping into little (or big) mouths. They can be served alone or with a side of Supereasy Hummus (page 210) or Caramelized Onion Dip (page 213), making them a great midday snack, and ideal for the lunch box.

1. Preheat the oven to 425°F and line a baking sheet with parchment paper or a Silpat.

2. In a large bowl, stir together the warm water and honey.

3. Sprinkle the yeast over the water mixture and let sit for 10 minutes.

4. In a separate bowl, whisk together the flour and salt.

5. Slowly add the flour to the yeast mixture. Using an electric mixer with a dough hook attachment (or mix by hand using a wooden spoon), mix for 5 minutes, or until the dough is combined and forms a soft ball, adding more flour if the dough is too sticky.

6. Remove the dough from the mixing bowl, rinse the bowl, and grease with the vegetable oil.

7. Return the dough to the greased bowl and turn it to coat it with oil.

8. Cover the bowl with a kitchen towel and let the dough rest at room temperature for 30 minutes.

9. Place the dough on a lightly floured surface and knead two or three times to remove air bubbles.

10. Cut the dough into 8 equal pieces. Roll each piece of dough into a 10-inch-long rope, keeping

JULI: My daughter loves your soft pretzels! Such a fun activity to have her help make them and shape them into letters and shapes; and I love knowing that they are nutritious!

SARAH: I made the soft pretzel dough for my son's preschool class for snack. The kids had a great time rolling out their own little pretzels and sprinkling them with salt. When they came out of the oven all of the kids were so excited to take a bite of something they had a hand in making. Great recipe!

the dough covered with a kitchen towel when you're not working with it. Cut each rope into 10 equal pieces.

11. Place the pretzel bites on the baking sheet, cover with a kitchen towel, and let them rest for 10 minutes.

12. In a small bowl, combine the room-temperature water and baking soda.

13. Dip the pretzel bites in the mixture, then return them to the baking sheet. Sprinkle the pretzel bites with salt or roll them in sesame seeds, if using.

14. Bake for 6 minutes, or until light golden brown.

TO FREEZE: After baking the pretzel bites place on a baking sheet and freeze for 20 minutes. Place in labeled ziplock bags or containers and freeze up to 4 months. To reheat place in a 300°F degree oven for 10 minutes.

ham and cheese muffins

Makes 18 muffins

Cooking spray

1½ cups all-purpose flour

1 cup whole-wheat flour

2 teaspoons baking powder

1 teaspoon baking soda

½ teaspoon salt

2 large eggs

¼ cup vegetable or canola oil

2 tablespoons maple syrup or honey

1¼ cups buttermilk (see Tip)

1 cup shredded Cheddar cheese

1 cup finely chopped cooked ham

I have a hard time describing the anxiety and frustration I feel when I have a million things to do but still need to get something substantial, and relatively healthful, into my kids' tummies. With a family full of busy schedules, I've resorted to pre-preparing an arsenal of foods that are easy to pull out of the freezer and reheat.

Ham and Cheese Muffins are not only delicious and perfect for little hands to hold, but they're a great way for kids to get their protein and carbohydrates all in one, along with a good dose of fiber from the whole-wheat flour. Make a batch of these on a Sunday afternoon and freeze them for later. On those days when you and your kids are racing around, you'll be so relieved to have these muffins handy.

1. Preheat the oven to 350°F and spray two muffin pans with cooking spray.

2. In a large bowl, combine the all-purpose flour, whole-wheat flour, baking powder, baking soda, and salt and stir to combine.

3. In a separate bowl, whisk the eggs, oil, and maple syrup until combined.

4. Add the buttermilk to the egg mixture and whisk.

5. Add the wet ingredients to the dry ingredients and stir until just combined.

6. Fold in the cheese and ham.

7. Fill the muffin cups ⅔ full and bake for 18 to 20 minutes (15 minutes if using mini muffin cups).

8. Transfer to a wire rack to cool.

TO FREEZE: Place the cooked muffins in ziplock bags, label with the date, and freeze for up to 3 months. Reheat to warm through.

TIP: If you don't have buttermilk on hand, you can make it by combining 1¼ cups of milk less 1 tablespoon and 1 tablespoon of white vinegar or lemon juice. Allow to sit for 5 minutes, then add it to the recipe.

KIM: The Ham and Cheese Muffins were so easy to make, and my toddler loved them. They're an easy way to sneak some protein in his diet, since he doesn't generally like meat!

FLOWER: Much to my dismay, my little man is going through a picky phase, and if it's not carby or cheesy, he isn't interested. Thank you for a new way to introduce a protein in a cheesy carby package! He devours these muffins, and I'm satisfied knowing he's getting the body-building protein he needs!

JESS: The Ham and Cheese Muffins are perfect—supereasy to make and delicious. I made them in a mini-muffin tin and the size was just right for my ten-month-old. He loved every bite!

BROOKE: My little man loves the Ham and Cheese Muffins. I make them in mini-muffin tins and he stuffs the whole thing in his mouth, he loves them! So glad there is a healthy snack he can munch on when he is hungry. I freeze the leftovers and just pop them in the microwave for 15 seconds for a quick snack.

spinach cake muffins

**Makes 24
mini muffins**

Cooking spray
(optional)

½ cup unsweetened
applesauce

1 large egg

2 teaspoons pure
vanilla extract

1 cup packed fresh
spinach leaves

⅓ cup sugar

2 tablespoons
vegetable or canola oil

1½ cups all-purpose
flour

1 teaspoon baking
powder

½ teaspoon baking
soda

½ teaspoon salt

I get inspired (and thrilled) when weelicious moms send me their ideas for new recipes. Last year, a reader sent me a recipe she had seen for muffins made with spinach and applesauce combined with a boxed cake mix that she wanted to make healthier. Although a spinach muffin seemed out there, I was won over by this mom's enthusiasm.

After a bunch of trial and error, I came up with a shockingly delicious muffin. They had just the perfect amount of sweetness and an appealing bright green color. Chloe joined me in making a batch and she got so into it I caught her eating spinach leaves directly out of the measuring cup (who says kids don't like their greens?).

Thank you to the weelicious mom who inspired this recipe (you know who you are!).

1. Preheat the oven to 350°F and use paper liners or grease a 24-cup mini muffin pan.

2. Place the applesauce, egg, vanilla, spinach, sugar, and oil in a food processor and puree until smooth.

3. In a separate bowl, combine the flour, baking powder, baking soda, and salt.

4. Pour the spinach puree into the flour mixture and stir until combined. Scoop the batter into the mini muffin pan, filling each cup ⅔ full.

STEPHANIE: **I've made your Spinach Cake Muffins and my kids LOVE them! Green is my son's favorite color and we all love how vibrant the spinach makes these muffins. Both of my boys will eat 4+ of these for breakfast and then come home from school asking if they can have them for snack! Best part is that they know there is spinach in them, yet still devour them.**

5. Bake for 12 minutes, or until a toothpick inserted in the center comes out clean.

6. Transfer to a wire rack to cool.

TERRI: I sent out your spinach muffins recipe to a couple of friends that I thought would be interested. My alley neighbor, Melissa, made them and then shared the recipe with her sons' daycare/preschool class at Children's Hospital (she is a doc there). They read a story about a kid not wanting to eat spinach, then gave the kids the spinach muffins, which they ate. The kids couldn't believe it was spinach. It is now going to be incorporated in their curriculum there!

the perfect hard-boiled egg

**Makes
1 dozen eggs**

**1 dozen large eggs,
white or brown**

Open my refrigerator on any given day and you will almost always find a big bowl of hard-boiled eggs. Many Sundays, when I come home from the farmers' market, I gently place a dozen organic, vegetarian-fed eggs into a pot of water and less than 15 minutes later I've got a delicious, high-protein snack that everyone in the family enjoys.

They always come in handy. Nothing to eat for breakfast? Hard-boiled egg! Lunch? Egg salad sandwich! Dinner got you stumped? Sliced eggs on a chopped salad!

LESLIE: Your Perfect Hard-Boiled Egg recipe is my go to. Perfect every time and great when I'm in a pinch for the kids' lunches. I use it to make a quick egg salad or throw boiled eggs in their lunch boxes for some quick protein!

SHAREE: I always make a batch of the hard-boiled eggs on Sunday for the week ahead. They are great for breakfasts and lunches through the week. Your recipe is easy and a no-fail way to get the perfect egg.

Whether you've got a baby starting on egg yolks as a first food, or you're simply watching your weight and are in need of a protein-packed egg white, eggs will satisfy your tummy and wallet. After all, a twenty-five-cent snack that will last up to two weeks in the refrigerator (if they don't all get eaten before that) is right up my alley.

Just follow these simple steps for making the perfect hard-boiled egg and you won't go wrong.

1. Place the eggs in a large pot and cover with cold water.

2. Bring the water and eggs to a boil, and then turn off the heat.

3. Let the eggs sit in the hot water for 12 minutes.

4. Pour off the hot water and cover the eggs with cold water and a handful of ice (this stops the cooking process).

5. Drain the water and let the eggs cool.

6. Peel the eggs and serve, or refrigerate until ready to eat.

toasted pepitas and sunflower seeds

With so many nut-free schools and lots of kids leaning toward vegetarianism, it can be difficult creating simple recipes that also offer a boost of protein. That's why I'm so fond of this recipe. By adding a drizzle of Bragg's Liquid Aminos, which contains sixteen amino acids, the seeds get a salty soy sauce taste that is hard to resist. Plus they stay fresh in a covered container for weeks!

1. Preheat the oven to 350°F.

2. Combine the pepitas, sunflower seeds, and Bragg's in a bowl and stir to coat.

3. Place the seeds on a baking sheet and roast for 10 minutes.

4. Stir the seeds and roast another 10 to 15 minutes, or until golden and crispy (make sure to keep an eye on them in the last few minutes so they don't burn).

5. Cool and store in a covered container at room temperature for up to 2 weeks.

Makes 2 cups

1 cup raw pepitas (pumpkin seeds)

1 cup raw sunflower seeds

1 tablespoon Bragg's Liquid Aminos or soy sauce

baked whole-wheat raspberry doughnuts

This book wouldn't be complete without a doughnut recipe. However these aren't the sugary, greasy doughnuts we all grew up on; these are baked, made with whole-wheat flour, and full of fresh raspberries just bursting with sweetness. It may seem unusual to put a doughnut inside a lunch box, but I promise you'll get major praise from your kids, and can actually feel good about including it.

1. Preheat the oven to 375°F. Grease a doughnut pan and lightly dust it with flour.

2. In a large bowl, whisk together the flour, baking powder, and salt.

3. In a standing mixer (or in a bowl using a hand mixer), cream the butter and sugar.

4. Add the egg, buttermilk, and vanilla and mix until thoroughly combined.

5. Add the dry ingredients to the wet ingredients and mix until just combined.

6. Gently fold in the raspberries.

7. Spoon the batter into the prepared doughnut pan (filling each well three-quarters full).

8. Bake for 14 minutes, or until the tops spring back when lightly pressed.

TIP: To make them even more dessertlike, you can mix 1 cup of powdered sugar with about 1 tablespoon of milk, whisk, and then glaze the doughnuts.

Makes 10 doughnuts

1¼ cups whole-wheat flour

1 teaspoon baking powder

½ teaspoon salt

2 tablespoons unsalted butter, softened

½ cup white sugar

1 large egg

½ cup buttermilk (see page 254)

1 teaspoon pure vanilla extract

1 cup fresh raspberries

whole-wheat cheddar crackers

Makes a lot,
depending on the
shape and size
you cut them in

2 cups grated Cheddar cheese

1 cup whole-wheat flour

1 tablespoon Spike salt-free seasoning (or any salt-free/herb seasoning will work)

6 tablespoons unsalted butter, chilled

I can't help but cringe when Kenya and Chloe are offered Goldfish as a snack on play dates or at school. They're one of those "easy" foods that most people keep in the pantry for their kids. And why not? They're delicious. But they are also high in sodium, low in fiber, and feature some unnecessary empty ingredients, like sugar.

For such a simple food, making your own homemade version is so much better, especially when you use whole-wheat flour, which ups the fiber content and is far more nutritious than refined white flour. I know what you might be thinking: *It will take longer for me to make goldfish than buy them.* Well, you'll be surprised not only by how quick and easy these Cheddar crackers are to make but also by how much money you'll save. And the best part is that you can use cookie cutters to pop out these crackers in whatever shapes your kids will love. What more could you hope for at lunch or snack time?

1. Preheat the oven to 400°F.

2. Place the Cheddar, flour, and seasoning in a food processor and pulse to combine.

3. Add the butter and pulse until a ball forms.

4. Roll out the dough to ¼ inch thick on a floured or parchment-covered surface. Slice the dough into crackers or cut out your desired shapes with a cookie cutter.

5. Place the crackers on a parchment-lined baking sheet and bake for 12 to 15 minutes, or until they start to turn golden.

6. Cool and serve. Store in a covered container for up to 2 weeks.

TIP: Once cooled, you can freeze the crackers and pop a few as needed in a container to defrost by lunchtime. You can bake and freeze or freeze after step 4.

JESSICA: The Whole-Wheat Cheddar Crackers are a hit with both my two-year-old and my eighty-year-old grandmother! They can go from a tea party for Elmo to a dinner party with adults depending on the shapes you make. We love them in our house. Thank you for all of your recipes!!

RUTH: Whole-Wheat Cheddar Crackers are THE BEST cracker to go along with soups or chili. Make a double batch, because you'll eat half of them straight from the oven.

sunflower butter bran muffins

Makes 12 muffins

2½ cups bran flakes (from the cereal aisle)

1¼ cups milk

1 large egg

⅓ cup oil

½ cup sunflower butter

1 cup all-purpose flour

½ cup brown sugar

1 tablespoon baking powder

½ teaspoon salt

½ cup mini chocolate chips or chopped dried fruit (optional)

These Sunflower Butter Bran Muffins are packed with tons of fiber and are protein-rich to keep kids sated during the day. And since sunflower butter tastes very similar to peanut butter, most kids won't be able to tell the difference. That's good news for everyone in the classroom—especially when they are nut free!

1. Preheat the oven to 400°F, and use paper liners or grease 12 cups of a muffin pan.

2. In a bowl, combine the bran flakes and milk and let sit for 5 minutes. Whisk in the egg, oil, and sunflower butter.

3. In a separate bowl, mix together the flour, sugar, baking powder, and salt.

4. Mix the dry ingredients into the wet ingredients until just combined. Fold in the mini chocolate chips, if desired.

5. Scoop the batter into the muffin cups, filling ⅔ of the way.

6. Bake for 20 minutes, or until a wooden toothpick inserted in the center comes out clean.

7. Transfer to a wire rack to cool.

desserts

apple cinnamon muffins

Makes 12 muffins

Cooking spray
(optional)

1 cup all-purpose flour

½ cup whole-wheat
flour

2 teaspoons baking
powder

¼ teaspoon salt

1 teaspoon ground
cinnamon

½ cup buttermilk (see
page 254)

½ cup honey

2 large eggs

1 teaspoon pure vanilla
extract

¼ cup canola oil

2 cups peeled and
chopped Granny Smith
apples (about 2 large
apples)

What fruit do you grab for most often at the market? I'd bet it's an apple. And why not? They stay fresh longer than many other fruits, and kids tend to love them. Our family dentist told me that our kids should eat apples as often as possible because they're great for their teeth.

In the fall, when I get a smidgen overzealous about apples, I make these muffins. Filled with bite-size pieces of apple and laced with the heart-warming combination of cinnamon and honey, these muffins are simply scrumptious.

1. Preheat the oven to 400°F and line muffins cups or grease the pan with cooking spray.

2. In a medium bowl, whisk together the flours, baking powder, salt, and cinnamon.

3. In a large bowl, whisk together the buttermilk, honey, eggs, vanilla, and oil.

4. Stir the dry ingredients into the wet ingredients and mix until just combined.

5. Fold in the apples.

6. Pour the batter into the prepared muffin cups, filling ⅔ of the way. Bake for 15 to 20 minutes, or until a toothpick inserted in the center comes out clean.

7. Transfer to a wire rack to cool.

blueberry oat muffins

I can't imagine a lunch cookbook that would be complete without a blueberry muffin recipe.

I'm really proud of this one, and it's an awesome addition to any mom's repertoire. Featuring big, fresh blueberries that burst in your mouth and toasty fiber-filled oats in every last bite, it will remind you why blueberry muffins are such an unbeatable classic.

1. Preheat the oven to 400°F and spray a muffin pan with cooking spray.

2. In a medium bowl, whisk together the flour, oats, baking powder, salt, and sugar.

3. In a large bowl, whisk together the buttermilk, egg, vanilla, and oil.

4. Stir the dry ingredients into the wet ingredients and mix until just combined.

5. Gently fold in the blueberries.

6. Pour the batter into the muffin cups, filling ⅔ of the way. Bake for 15 to 20 minutes, or until a toothpick inserted in the center comes out clean.

7. Transfer to a wire rack to cool.

Makes 12 muffins

Cooking spray

1¼ cups all-purpose flour

1¼ cups old-fashioned oats

2 teaspoons baking powder

¼ teaspoon salt

½ cup sugar

½ cup buttermilk (see page 254)

1 large egg

1 teaspoon pure vanilla extract

⅓ cup canola oil

1 cup fresh or frozen (not defrosted) blueberries

whole-wheat chocolate chip cookies

Makes
5 dozen cookies

1 cup all-purpose flour

1¼ cups whole-wheat flour

1 teaspoon baking soda

½ teaspoon salt

1 cup (2 sticks) unsalted butter, softened

1 cup packed brown sugar

½ cup white sugar

2 large eggs, at room temperature

1 tablespoon pure vanilla extract

2 cups semisweet chocolate morsels

Many moms come to weelicious for recipes that are easy to make and on the wholesome side. It's the way I cook at home, too. However, just because my recipes tend to be healthful doesn't mean I'm about deprivation. I'm all for us enjoying our favorite treats every now and then. And seriously, what would life be without chocolate chip cookies?! Still, as much as I always loved making them, I never posted a chocolate chip cookie recipe on weelicious because I didn't think mine were wholesome enough to meet those moms' needs.

There are several ways to make a true chocolate chip cookie, but at the end of the day you can make only so many changes before it ceases to be a classic. Always trying to add a bit of nutrition to my take on classic sweets, I added some whole-wheat flour to this version. At first I was concerned that it might weigh the cookies down, but I couldn't detect a change in the slightest. If anything, kids and adults alike seemed to savor these cookies even more than my usual recipe.

Since you probably don't need the five dozen cookies this recipe produces, I recommend freezing the dough to make individual cookies. Then whenever you have a craving, all you have to do is pop a few of these little gems in the oven and you're set!

1. Preheat the oven to 375°F and line a baking sheet with a Silpat or parchment paper.

2. In a medium bowl, whisk together the flours, baking soda, and salt.

3. In the bowl of a standing mixer, or in a large bowl using an electric mixer, cream together the butter and sugars until light and fluffy, about 3 minutes.

4. Add the eggs one at a time, then the vanilla, mixing for 30 seconds to combine after each addition.

5. Gradually add the dry ingredients and mix until just combined.

6. Stir in the chocolate morsels.

7. Using a mini ice cream scooper or a tablespoon measure, scoop the dough onto the baking sheet, keeping 2 inches between each cookie, and gently press down with the palm of your hand to form cookies.

8. Bake for 12 minutes, or until golden brown. Let the cookies cool on the baking sheet for 2 minutes, then remove them to a cooling rack.

TO FREEZE: Place the scooped raw cookie dough on a baking sheet, flatten with the palm of your hand, and freeze the cookies for an hour or so. Place the cookie dough in ziplock bags, label with the date, and freeze for up to 3 months. Bake as directed, adding an extra minute to the cooking time.

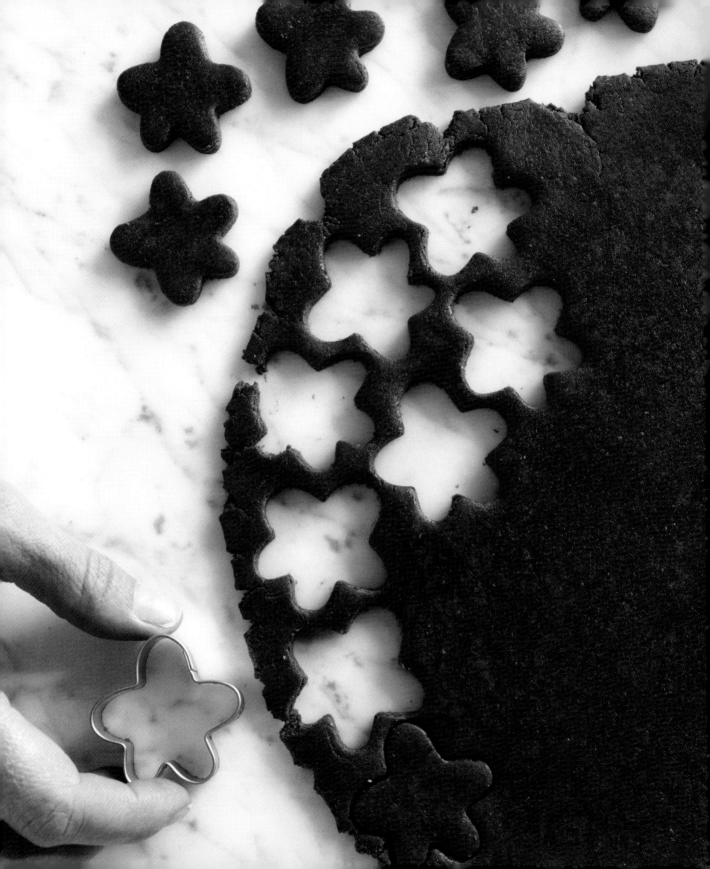

chocolate graham crackers

Whenever the skies turn gray I rejoice. These are the days when our family hunkers down by the fireplace to play board games, read piles of books, and, of course, make s'mores. Whenever the kids see so much as a drop of water falling from the sky, they pull out the (poorly hidden) bag of marshmallows, box of graham crackers, and Chocolate-Hazelnut Spread (page 218).

On one such rainy day, we were sitting by the fire, gently toasting our marshmallows, when Chloe said, "I wish I had a chocolate graham cracker." You can't feel too bad for a four-year-old fantasizing about a chocolate graham cracker while she's got a mouth full of s'mores, but her idea really got me thinking. The next day I went straight to the kitchen and came up with Chloe's dream cookie. It's certainly a graham cracker, but packs a wallop of chocolate in each bite, making them extraordinary delish and the ultimate kid treat. Thanks, Chloe!

1. Preheat the oven to 350°F.

2. Add the flours, cocoa powder, brown sugar, salt, cinnamon, and baking soda to a food processor and pulse to combine.

3. Add the butter and pulse until the mixture resembles a coarse meal.

4. Pour in the honey and ¼ cup water and continue to mix until a dough forms.

5. Remove from the food processor and shape the dough into a flat disk.

6. Roll out the dough between 2 pieces of parchment paper to ¼ inch thick. Cut into rectangular crackers or use cookie cutters to make shapes.

7. Place the cookies on a Silpat or parchment-lined baking sheet and bake for 15 minutes.

See the photograph for this recipe on page 129.

Makes 4 dozen 1-inch crackers

1 cup whole-wheat flour

1 cup all-purpose flour

½ cup unsweetened cocoa powder

½ cup packed dark brown sugar

½ teaspoon salt

1 teaspoon ground cinnamon

1 teaspoon baking soda

½ cup (1 stick) butter, chilled and cubed

¼ cup honey

8. Let the cookies cool on the baking sheet.

9. Serve plain or with Chocolate Hazelnut Spread (page 218) and toasted marshmallows for a chocolaty, hazelnutty s'more.

TO FREEZE: After step 6, place the cutout cookie shapes on a baking sheet and freeze for 20 minutes. Remove, place in a ziplock bag, label, and freeze for up to 4 months. When ready to bake, follow cooking directions, adding 2 minutes to the baking time.

TIP: This dough is extremely forgiving and can be rolled out over and over again.

SONIA: The Chocolate Graham Crackers are so delicious and chocolaty. They're even better than store-bought ones, and more fun because we use cookie cutters in all sorts of shapes. My kids really feel like they're getting a special treat with these, and I feel good about serving them.

JILL: These are a staple in our house! I feel so much better giving my kids treats when I know the ingredients are all things I can pronounce. We love making them together—who doesn't love stamping out shapes?

RUTH: These are so easy to make, and they freeze well. My whole family loves them!

chocolaty vanilla wafers

If I were a betting lady, I'd wager that you have a box of Nilla Wafers in your cupboard. They're one of those time-honored treats kids love and you probably grab a handful yourself every now and then. There's just something irresistible about those sweet cookies, soft throughout with a slightly golden and crispy outside. But do you know what's in them? High fructose corn syrup? Partially hydrogenated cottonseed oil? No thank you.

This recipe makes a ton of *chocolate* (yes, chocolate, how's that for a twist?) vanilla wafers, and I bet you already have all the ingredients in your kitchen. It's also perfect for freezing a bunch for later. If you want to go for a classic vanilla wafer, simply omit the cocoa powder. But why on earth would you want to do that?

1. Preheat the oven to 350°F.

2. In a medium bowl, whisk together the flour, cocoa powder, baking powder, and salt.

3. In the bowl of a standing mixer, or in a large bowl with an electric mixer, cream together the butter and sugar until light and fluffy, about 3 minutes.

4. Add the vanilla and egg and mix for another minute, scraping down the sides of the bowl as you go.

5. Add the dry ingredients to the wet ingredients and mix until combined.

6. Form the dough into a disk and refrigerate for 30 minutes.

7. Using a teaspoon measure, scoop the dough into small balls and place on a parchment- or Silpat-lined baking sheet. Flatten each ball into a disk.

8. Bake for 15 minutes, or until puffed a bit and dry to the touch. Cool on a wire rack.

Makes 4 dozen

1 cup all-purpose flour

¼ cup unsweetened cocoa powder

1 teaspoon baking powder

¼ teaspoon salt

½ cup (1 stick) unsalted butter, at room temperature

⅓ cup sugar

2 teaspoons pure vanilla extract

1 large egg

cocodate cookies

1 large banana, chopped

5 large Medjool dates, pitted and roughly chopped (about ½ cup)

½ cup unsweetened coconut flakes

¼ cup sesame seeds

Years ago I got turned onto Go Raw cookies. With only four ingredients and packed with toasty coconut and supersweet dates, they're free of many of the most common allergy-causing foods. They inspired me to make a (hopefully) allergy-defying cookie of my own that, while not raw, is baked at a very low temperature, making it chewy on the inside and a delectable treat for almost anyone to enjoy. Did I mention that they're also supereasy to make?

Once you taste these Cocodate Cookies I'll bet you'll always want to have a bunch within reach in the cookie jar, your kid's lunch box—and in big bags in the freezer for everyone to enjoy!

1. Preheat the oven to 275°F.

2. Place all the ingredients in the bowl of a food processor and pulse until smooth.

3. Using a small ice cream scoop or a 1 tablespoon measure, form the mixture into balls and place them on a parchment- or Silpat-lined baking sheet. Press down on the balls with the palm of your hand to form cookies.

DANIELLE: I came across the Cocodate Cookies when I was looking for nut-free options to send to my toddler's nut-free school. She loved running the food processor and enjoyed the cookies—but her dad and I had to keep ourselves from devouring them. My husband likes them as a post-workout snack. And we made a big batch to freeze as "toddler food" for a couple expecting a new baby. Figured they would make good "new parent" fuel as well.

4. Bake for 45 to 50 minutes, or until golden and dry to the touch.

5. Cool on a wire rack. They should be dry on the outside, but chewy on the inside.

TO FREEZE: After step 5, place the cookies on a baking sheet and freeze for 20 minutes. Remove, place in a ziplock bag and freeze up to 4 months.

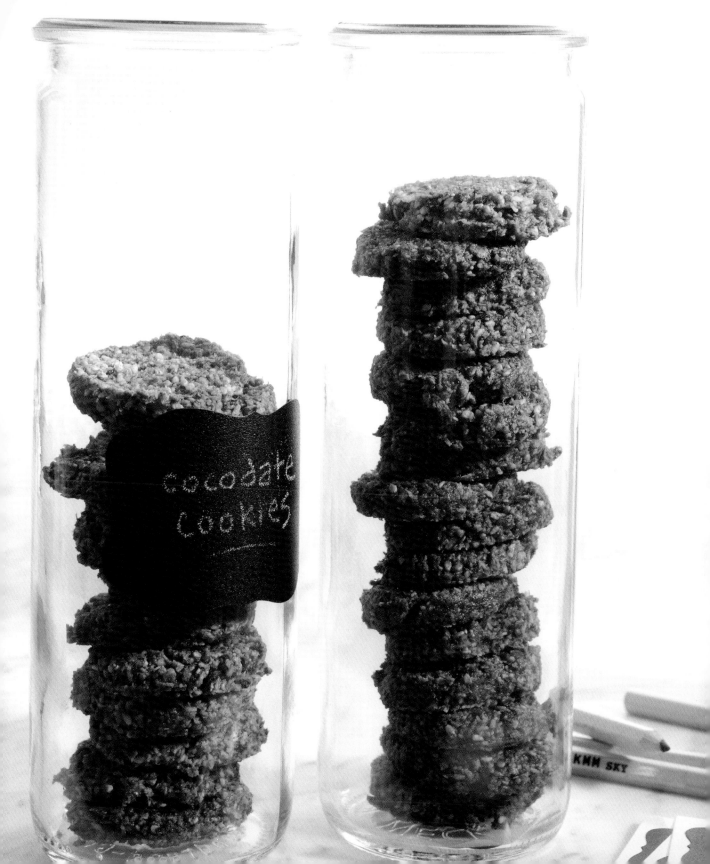

fruity delight

Makes 2 servings

1 nectarine, pitted and diced

2 strawberries, hulled and diced

2 tablespoons sour cream or plain Greek yogurt

2 teaspoons brown sugar

When I started working on this book I asked my friends what they liked eating for lunch as kids. Most of them said PB&J. Period. The end. But my friend Alex's mom must have had a much deeper repertoire with which to tempt her daughter. She told me about one of her favorite treats as a child—one I've dubbed Fruity Delight. It consists of naturally sweet fruit topped with tart sour cream or yogurt and just a sprinkling of crunchy brown sugar. How could four simple ingredients be this unbelievably luscious? Just try it and you'll see.

1. Divide the nectarine and strawberries between two small serving bowls.

2. Top each with a dollop of sour cream or Greek yogurt and sprinkle with brown sugar.

NOTE: This recipe can be made with any type of fruit you like, such as grapes, melon, berries, mango, and more—choose fruit that's in season for the best-tasting results.

creamy chocolate pudding

Makes 5 ½-cup servings

¼ cup sugar

2 tablespoons cornstarch

½ teaspoon salt

2 cups low-fat milk

½ cup chopped semisweet chocolate

1 teaspoon pure vanilla extract

Ever walk by the refrigerator section at the grocery and be inclined to grab those individual chocolate pudding containers that seem to scream *put me in school lunch*? Trust me, I do the same thing. After all, making homemade chocolate pudding takes forever, right?

The good news is no, it takes just minutes to make, and after a brief chill you have and intensely chocolaty pudding that tastes just as it should: silky, creamy, and smooth. Bill Cosby would totally give you the thumbs-up for this one.

1. In a saucepan over medium heat, whisk together the sugar, cornstarch, and salt. Gradually whisk in the milk. Cook for 5 minutes, stirring constantly. The milk will foam and thicken slightly.

2. Add the chocolate and stir until the chocolate is melted. Remove from the heat and stir in the vanilla.

3. Pour into individual serving bowls and chill for at least 30 minutes.

NOTE: To prevent a skin from forming, place parchment paper or plastic wrap directly on top of the pudding so that it's touching the surface, then chill.

birthday lemon cupcakes with blueberry frosting

An interesting thing happened when I took Chloe to her friend's birthday party last year. When the time arrived for cake, all the kids lined up to get some. As the birthday boy's mother passed out slices, Chloe, who had been quietly waiting for her piece, hesitated and asked, "Is there food coloring in that?" During the awkward silence that ensued as the mom processed this inquiry from a three-year-old, I was overcome with equal parts horror and pride.

Although I make my kids aware that food coloring isn't good for their bodies, I'm hardly militant about them consuming it. In fact, I tend to treat birthday parties like Vegas: whatever happens there, stays there. Juice boxes, brightly colored cakes, even cheese puffs are fine by me on special occasions. Yet in spite of my flexibility on the issue, both of my kids tend to avoid artificial food coloring.

Still, I have a fondness for brightly colored desserts, and these cupcakes are one of my new faves. The cake has a bright lemon flavor, while the icing is a vibrant blueish-purple, free of any artificial dyes. When Kenya skeptically asked me how the icing got so blue, I was happy to tell him the color came only from blueberries. He brought some to school soon after, and as he passed the bite-size cakes out to his friends he proudly told them, "There's no food coloring in these!"

Never underestimate how far your kids will go with just a little bit of knowledge!

Makes 3 dozen

Cooking spray, optional

1½ cups all-purpose flour

2 teaspoons baking powder

¼ teaspoon salt

¾ cup (1½ sticks) unsalted butter, softened

¾ cup white sugar

2 large eggs

1 teaspoon pure vanilla extract

⅓ cup whole milk

3 tablespoons lemon juice

Zest of 2 large lemons (about 2 tablespoons)

1½ cups powdered sugar

3 to 4 tablespoons blueberry juice (see Tip)

1. Preheat the oven to 350°F and spray a muffin pan with cooking spray or use liners.

2. In a medium bowl, whisk the flour, baking powder, and salt and set aside.

3. In the bowl of a standing mixer, or in a large bowl using an electric mixer, beat the butter and white sugar on medium-high speed for 2 minutes, or until light and fluffy.

4. Add the eggs one at a time, beating on low speed after each egg, and the vanilla. Beat until combined.

5. Slowly add half the flour mixture to the butter and sugar, beating as you go. Add the milk and the rest of the flour mixture, scraping down the sides of the bowl with a rubber spatula as you beat.

6. Fold in the lemon juice and lemon zest.

7. Pour the batter into the muffin pan, filling the cups ⅔ full, and bake for 22 minutes (15 minutes if you choose to use a mini muffin pan), or until a wooden toothpick inserted into the middle of a cupcake comes out clean. Remove the cupcakes to a wire rack and cool them completely.

8. In a small bowl, lightly whisk the powdered sugar and blueberry juice to form a blueberry glaze.

9. Drizzle the cupcakes with the blueberry glaze.

TIP: To make blueberry juice, defrost frozen blueberries and press through a fine mesh sieve.

my kind of candy

Naming recipes can be challenging at times. I thought about calling this one Date Nut Balls, but that name just doesn't live up to the way I feel about these scrumptious little treats. I debated the moniker Protein Balls, but that didn't seem fitting either. Finally I thought, *If I were going to come up with a nutritious "candy," these bite-size goodies would be it.*

They're packed with wholesome ingredients, like oats, nuts, and dried fruit, but when you add the chocolate chips and mix all the ingredients together, they look and taste much more like bonbons than something that's good for you. I'll let you figure out what you want to call them, but you'd better think fast, because that's how quick they're going to disappear!

1. Place the oats in a food processor and grind to a powder.

2. Add the nuts and pulse until they become small pieces.

3. Place the chocolate morsels and dates in the food processor and pulse until everything comes together. The mixture will be thick and sticky.

4. Using a small ice cream scoop or a teaspoon measure, shape the mixture into small balls.

TIP: The candy can be stored for up to a week, covered, at room temperature, refrigerated for up to a month, or frozen for up to 4 months.

Makes 50 pieces

¼ cup old-fashioned rolled oats

½ cup raw unsalted cashews

½ cup raw unsalted almonds

⅓ cup semisweet or dark chocolate morsels

10 large Medjool dates, pitted and chopped (about 1 cup)

nature cookies

Makes 3 dozen

1 cup whole-wheat flour

2 cups old-fashioned rolled oats

½ teaspoon baking soda

½ teaspoon salt

1 teaspoon ground cinnamon

½ cup (1 stick) unsalted butter, softened

½ cup honey

1 large egg

2 teaspoons pure vanilla extract

½ cup raisins*

¾ cup chopped walnuts*

¼ cup sunflower seeds*

¼ cup semisweet or dark chocolate morsels*

¼ cup dried cherries*

*Or add 2 cups of any mixture you prefer of the following add-ins: coconut, chocolate morsels, nuts, seeds, and dried fruits.

The summer after seventh grade I spent two weeks driving cross country on an Outward Bound–style trip to hike up to the Continental Divide. It was one of the greatest experiences of my life and the first time I was introduced to a hiker's best friend, trail mix.

These cookies are my twist on the classic trail mix combination of dried fruits, nuts, seeds, and chocolate chips that I so adore.

1. Preheat the oven to 350°F.

2. In a medium bowl, whisk together the flour, oats, baking soda, salt, and cinnamon.

3. In the bowl of a standing mixer, or in a large bowl using an electric mixer, cream together the butter and honey until light and fluffy, about 3 minutes.

4. Add the egg and vanilla and mix to combine.

5. Slowly add the dry ingredients into the wet ingredients and mix until just combined.

6. Fold in the raisins, walnuts, sunflower seeds, chocolate morsels, and dried cherries.

7. Using a small ice cream scoop or a tablespoon measure, drop the dough onto Silpat- or parchment-lined baking sheets. Using the back of the ice cream scoop or the palm of your hand, gently press the dough down into disks. (They won't spread during baking.)

8. Bake until golden brown, about 12 minutes.

9. Transfer to a wire rack to cool.

TIP: To make giant nature cookies, you can use a ¼ cup measure and add 5 minutes to the baking time.

mini doughnut muffins

Makes 24 muffins

Cooking spray

1 cup all-purpose flour

¼ cup unsweetened cocoa powder

1 teaspoon baking powder

½ teaspoon salt

½ teaspoon ground cinnamon

2 tablespoons unsalted butter, softened

½ cup sugar

1 large egg

½ cup buttermilk (see page 254)

1 teaspoon pure vanilla extract

If someone was going to offer me a last meal, I think it would be a doughnut from Plehn's Bakery in my hometown of Louisville, Kentucky. Preferably a chocolate one. But as much as I love doughnuts, I hate the idea of having a hot pot of oil on the stove with kids around. Instead, I make these baked Mini Doughnut Muffins to fulfill my cravings.

These bite-size chocolate doughnut muffins with just a touch of cinnamon are the perfect ending to a school lunch, although they might just be the first thing that gets eaten!

1. Preheat the oven to 350°F and spray mini muffin cups with cooking spray.

2. In a medium bowl, whisk together the flour, cocoa powder, baking powder, salt, and cinnamon.

3. In the bowl of a standing mixer, or in a large bowl using an electric mixer, cream together the butter and sugar until light and fluffy, about 3 minutes.

4. Add the egg, buttermilk, and vanilla and stir to combine.

5. Add the dry ingredients to the wet ingredients and mix until just combined.

6. Using a small ice cream scoop or a 1 tablespoon measure, scoop the batter into the mini muffin cups.

7. Bake for 10 minutes, or until the tops spring back when lightly pressed.

oaty muffins

Many parents have confided to me that their kids aren't big on breakfast, so they don't even try anymore to get them to eat in the morning. I understand and sympathize because Kenya, especially when he was younger, could easily do without breakfast most mornings and be fine . . . until 10 a.m., when the blood sugar crash came and he was not only grumpy but low on energy. Still, I make a point of trying to get my kids excited about their first meal of the day. Hopefully it helps them to understand how important eating in the morning is—not only for their bodies, but also their minds and moods.

These easy-to-prepare Oaty Muffins are made with whole-wheat flour, oats, and eggs for some much needed protein. The honey provides a sweet taste for a morning boost and helps prevent the 10 a.m. crash. Good for bellies *and* moods!

1. Preheat the oven to 350°F and line muffin cups or spray a muffin pan with cooking spray.

2. In a medium bowl, combine the oats, flours, baking powder, baking soda, cinnamon, and salt.

3. In a large bowl, whisk the honey, buttermilk, oil, and eggs until combined.

4. Pour the dry ingredients into the wet ingredients and stir until just combined.

5. Fill the muffin cups ⅔ the way up and bake for 20 to 22 minutes (16 to 18 minutes for mini muffins), or until a toothpick inserted in the center comes out clean.

6. Transfer to a wire rack to cool.

Makes 12 muffins

Cooking spray (optional)

¾ cup old-fashioned rolled oats

¾ cup whole-wheat flour

¾ cup all-purpose flour

2 teaspoons baking powder

1½ teaspoons baking soda

1 teaspoon ground cinnamon

1 teaspoon salt

½ cup honey

½ cup buttermilk (see page 254)

½ cup vegetable or canola oil

2 large eggs, whisked

pumpkin muffins with cream cheese icing

Makes 12 muffins

Cooking spray (optional)

1½ cups all-purpose flour

2 teaspoons baking powder

½ teaspoon baking soda

½ teaspoon salt

1½ teaspoons pumpkin pie spice

6 tablespoons unsalted butter, melted

¾ cup packed brown sugar

1 cup pumpkin puree

1 large egg

¼ cup milk

1 teaspoon pure vanilla extract

I was going through my pantry last December and came upon a seemingly endless hidden supply of pumpkin puree. Either canned pumpkin was procreating when I wasn't around or, more likely, those mysterious cans were the product of countless grocery visits when I fantasized implusively about making pumpkin doughnuts, pumpkin bread, pumpkin pie, and so on. Not surprisingly, I never had the time for all those recipes I really wanted to make, but now there I was, days shy of the New Year, with the holidays over, school out, and a little bit of free time on my hands. The kids and I made these yummy pumpkin muffins, topped with a smear of luscious cream cheese icing, and they came out great.

One small suggestion: as long as the expiration date hasn't passed, never toss out food from your pantry. Instead, figure out a recipe based around that ingredient you were once inspired to buy and turn it into something tasty.

1. Preheat the oven to 400°F and line muffin cups or spray a muffin pan with cooking spray.

2. In a medium bowl, whisk the flour, baking powder, baking soda, salt, and pumpkin pie spice.

3. In a large bowl, whisk the butter, brown sugar, pumpkin puree, egg, milk, and vanilla.

4. Add the dry ingredients to the wet ingredients and whisk until just combined.

5. Fill the muffins cups ⅔ full and bake for 20 minutes, or until a toothpick inserted into the middle comes out clean.

6. Transfer to a wire rack to cool, then frost with Cream Cheese Icing.

cream cheese icing

1. Place the cream cheese and butter in a bowl and use a hand mixer to beat for 30 seconds on medium-low speed.

2. Add the powdered sugar and vanilla and beat for 1 minute, or until the frosting is smooth and creamy.

3. Frost the muffins.

Makes 1 cup

4 ounces cream cheese, softened

4 tablespoons (½ stick) unsalted butter, softened

1 cup powdered sugar

1 teaspoon pure vanilla extract

ASHLEY: Your Pumpkin Muffins are the go-to muffin in our house. I stock up on pumpkin when it's in season so we can eat them all year long! My kids love when I put a couple in their snack or lunch, plus they'll sneak a few as we run out the door in the morning!

JD: I made over three hundred bite-size muffins for my son's school, and the kids were sneaking into the teachers' kitchen to steal the very few leftovers . . . you've got the love of 250 kids.

KRYSTIE: Pumpkin Muffins are a big favorite at our house for the kids and my partner and me. Weelicious has helped me find uses for pumpkin year round! Now we always have a can in the pantry.

KRISTIN: Your Pumpkin Muffins were the first recipe I ever made from your site, and they're what motivated me to start cooking better for my little one. He absolutely loves them, and I love that they're supereasy to make!

pumpkin pie "pop-tarts"

Makes 10 tarts

½ cup pumpkin puree

2 tablespoons packed brown sugar

¼ teaspoon pumpkin pie spice

Flour, for rolling out the dough

1 recipe Double Pie Crust (page 162) or 1 package premade pie crust

One halloween when I was five, I ended up in the ER with a buddy after she came close to slicing her finger off carving pumpkins with me. Not wanting to repeat this experience with my kids, I invented these Halloween "pop tart" treats.

They're filled with sweet, creamy pumpkin puree and spiked with a touch of fall spices that will make your kitchen smell divine. While your kids mix the puree and stamp out the pumpkins, you can perform the more delicate design work with a knife so that your little chefs stay out of the ER!

1. Preheat the oven to 400°F.

2. In a bowl, combine the pumpkin puree, brown sugar, and pumpkin pie spice.

3. On a lightly floured surface, roll out the pie crust to ¼ inch thick and, using a pumpkin-shaped cookie cutter, cut out about 20 pumpkin shapes. To make faces on your pumpkins, use a paring knife to cut out triangle eyes and a zigzag mouth on half of the pumpkins.

4. Place one pumpkin (without a face) on a lightly floured work surface and place 2 teaspoons of the filling in the center.

5. Lightly dip your index finger into a cup of water and "brush" the border of the dough with the water. This will allow the 2 sides of the dough to adhere to one another.

6. Top with a cutout pumpkin (with a face) and lightly press the edges together.

7. Repeat to make the rest of the pumpkin tarts.

8. Place the tarts on a parchment- or Silpat-lined baking sheet and bake for 18 minutes, or until golden.

9. Set the tarts aside to cool.

TO FREEZE: After step 7, place the assembled tarts on a baking sheet and freeze for 1 hour. Place the tarts in a ziplock bag, label, and freeze for up to 3 months. To bake, follow step 8, adding an extra 2 minutes to the baking time.

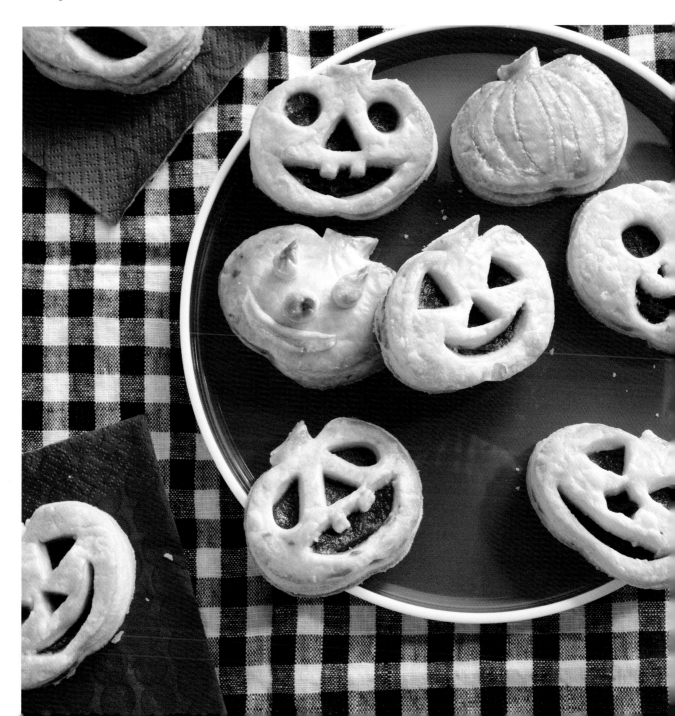

📺 rice crispy treat balls

Makes 70 balls

⅔ cup brown rice syrup

⅔ cup almond, peanut, or sunflower seed butter

4 cups organic crispy brown rice cereal

Like most of us, growing up I was used to homemade Rice Krispies Treats made with plenty of sugary, gooey marshmallows and cut into uneven blocks. Then there were the pre-made ones you could buy in the store, loaded with corn syrup. Not the most nutrtious of treats, but oh, those memories!

This is my healthful and (in my opinion) considerably more fun take on the classic. I use brown crisped rice cereal instead of white and toss out the marshmallows in favor of protein-packed nut butters. Then I roll them into bite-sized balls to give them more eye appeal.

Crispy, crunchy, sweet, and always a simple success!

1. In a small saucepan over low heat, warm the brown rice syrup and nut butter and stir for about 2 minutes, until melted and combined.

2. Place the crispy rice cereal in a large bowl. Pour the syrup over the cereal and mix thoroughly.

3. When the mixture cools a bit, use a small ice cream scoop or a 1 table-spoon measure to form the mixture into small balls. (Moisten your hands with a little water to make rolling the balls easier.)

TIP: Place balls in a sealed container at room temperature for up to 5 days.

LINDSAY: We *love* the Rice Crispy Treat Balls! My kids ask for them all the time. The first time they had the "real" ones at a birthday party, they told me ours were better.

EMILY: These are the go-to treat in our house. I love that they're simple to make and I can feel good giving them to my son. Thanks for another wonderful recipe!

RUTH: I make these so often that I have the recipe memorized. Seriously, they're that good!

double chocolate whole-wheat brownies

You may win the favorite parent award with these whole-wheat brownies. They're a bit more healthful and lighter than traditional brownies, without sacrificing an ounce of the indulgence. Made with applesauce in lieu of some of the butter to cut down on the fat and white whole-wheat flour for a bit of additional nutrition, they also boast a deep chocolate flavor and are speckled with mini chocolate chips, which only add to the glee of discovering one of these little treasures in the middle of the day.

1. Preheat the oven to 350°F. Spray an 8-inch baking pan with cooking spray and add a layer of parchment to fit up two sides of the pan.

2. In a medium bowl, whisk together the flour, cocoa powder, baking powder, and salt.

3. In a large bowl, whisk together the butter, brown sugar, applesauce, eggs, and vanilla.

4. Stir the dry ingredients into the wet ingredients until combined and fold in the chocolate chips.

5. Pour the batter into the prepared pan and bake for 20 minutes, or until a wooden pick inserted in the center comes out clean. Allow the brownies to cool in the pan.

6. Using the parchment, transfer the brownies to a cutting board and cut into 25 even squares.

Makes 25 square brownies

Cooking spray

1 cup white whole-wheat flour

½ cup unsweetened cocoa powder, sifted

½ teaspoon baking powder

½ teaspoon salt

¼ cup (½ stick) unsalted butter, melted

½ cup packed brown sugar

½ cup unsweetened applesauce

2 large eggs

1 teaspoon pure vanilla extract

½ cup mini chocolate chips

whole-wheat lemon blueberry muffins

Makes 12 muffins

Cooking spray (optional)

2 cups whole-wheat flour

¾ cup packed brown sugar

¾ teaspoon salt

1 teaspoon baking powder

½ teaspoon baking soda

⅓ cup vegetable or canola oil

1⅓ cups low-fat or whole milk

1 teaspoon pure vanilla extract

Juice of 1 lemon, about 2 tablespoons

Zest of 1 lemon

1 cup blueberries, fresh or frozen

I was a muffin lover from an early age. On occasion my mother would make blueberry muffins out of the box for my brother and me. As they came piping hot right out of the oven, I would peel off the paper and devour every last crumb. But why make muffins from a box when they're so easy to make from scratch?

It doesn't have to be summertime, when blueberries are in season, to make these muffins. They're just as delicious in the depths of winter, because you can rely on frozen blueberries (you'll never know the difference when they're all baked up). And with the addition of lemon to the toasty, wholesome, whole-grain flour in these muffins, you're in for a real treat.

1. Preheat the oven to 400°F and spray a muffin pan with cooking spray or line it with paper liners.

2. In a medium bowl, whisk the flour, brown sugar, salt, baking powder, and baking soda.

3. In a large bowl, whisk the oil, milk, vanilla, lemon juice, and zest.

4. Mix the dry ingredients into the wet ingredients until just combined and gently fold in the blueberries.

5. Pour the batter into the prepared muffin cups, filling them about ⅔ of the way up.

6. Bake for 18 to 20 minutes, or until a toothpick inserted in the center comes out clean.

7. Transfer to a wire rack to cool.

NOTE: These can also be made with white whole-wheat flour for a slightly lighter texture.

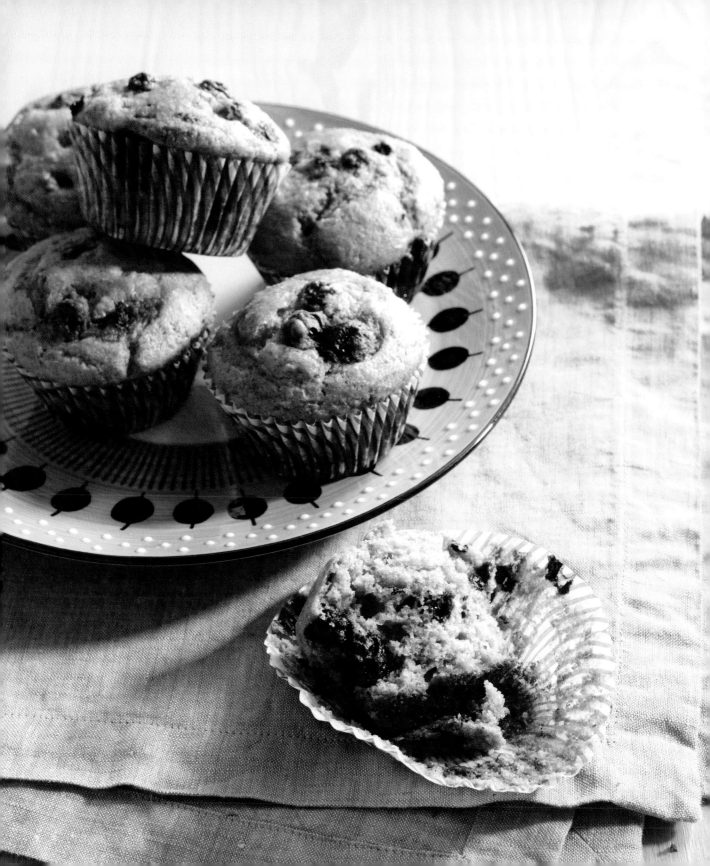

whole-wheat crepes

Makes 14 crepes

2 large eggs

1 cup white whole-wheat flour

¾ cup milk

½ teaspoon pure vanilla extract

2 tablespoons butter, melted

Chocolate-Hazelnut Spread (page 218) or other desired filling (see Tip)

From the very beginning, weelicious has always been something of a science experiment. Cooking for kids is not always the easiest road to navigate, and no matter how much I think I know, I continue to learn more daily about their food preferences, behaviors, likes, and dislikes. What I have found to work one day may not be as successful the next, while other recipes have surprised me as surefire hits every time I make them.

The latter has been the case with my kids and crepes. They fell in love the first time I made them. And I'm wild about crepes because I can do all the prep work the night before. In the morning all I have to do is pour the batter into a pan, layer the crepes with whatever sweet or savory fillings my kids desire, and voilà! To make this simple crepe recipe just a bit more nutritious, I use white whole-wheat flour in place of all-purpose white.

Just when you think your kids won't be open to trying anything new, pull out the ingredients for these special crepes and let them help you create a dish it's almost impossible not to love.

1. Place all the ingredients except the Nutella in a blender with ½ cup water and puree until smooth. Refrigerate for 1 hour to overnight.

2. Heat a crepe or sauté pan over medium-low heat and grease with butter. Pour in 2 tablespoons of the batter and swirl around the pan to evenly coat the entire bottom.

3. Cook for 1 minute, use a spatula to gently flip the crepe over, and cook the other side another 30 seconds, or until it just starts to become golden.

4. Repeat to make the rest of the crepes. Stack them on a plate as you finish them, then fill them all at once.

TIP: You can fill crepes with sweet or savory fillings such as ham and cheese, butter and honey, Chocolate-Hazelnut Spread, strawberries and preserves, spinach, sauteed mushrooms and chopped herbs, peanut butter and banana, and more!

acknowledgments

To Kenya, Chloe, and Jon, who eat, laugh, and love with me every day.

To Sarah Glyer. You're the glue that keeps it all together. Grateful for the day I met you.

To Cassie Jones, editor extraordinaire. What more can I say that I haven't said already. You make me feel like the luckiest girl in the world. I dig you. A lot.

To Kara Zauberman, Megan Swartz, Tavia Kowalchuk, Megan Traynor, Liate Stehlik, Lynn Grady, Joyce Wong, Kris Tobiassen, Paula Szafranski, and Karen Lumley. You gave me the freedom to create this book and lavished it with your talents and attention.

To Dorian Karchmar and Josh Bider for having my back.

To Rebecca Brooks, Brianne Perea, and Emily Banks—my sweet Brookettes—for always having my front.

To the brilliant team of Maren Caruso, Robyn Valarik, Brandon Kalpin, Jennifer Barguiarena, Erik Hillard, Alex Mosier, Sarah Keys, Joanna Chan, and Danny Ventrella. You are bottomless pits of creativity and endlessly talented.

To Jack, Frankie, Sloane, Jessica, Flynn, Audrey, Luella, August, Rohan, Malli, Luca, Sofia, Esme, Siena, Eliza, Noah, Jack, Sam, Mia, Ethan, and Luca for coming out to play!

To Graze Organics, LapTop Lunches, Planet Box, Oots, Black + Blum, So Young, Ella's Kitchen, Brinware, Pottery Barn Kids, Lunchbots, Wawabots, Wean Green, Zojirushi, Acme Party Box, BA Friend, and House Jewels for furnishing me with your incredible products and making reusable lunchware a joy to use day after day.

To Melissa's Produce and all the vendors at the Hollywood Farmers' Market for the exquisite fruits and veggies you grow.

My mama mafia (you know who you are). You are my rocks. I am blessed by your friendships.

To my blogger buddies and food posse. What a beautiful, supportive, and inspiring community. I feel so lucky to be a part of it. You are my sorority.

Thanks to Mom, Dad, Viv, and Sonny for supporting me every day and for being the most rockin' grandparents of all time.

Most of all, this book is for every weelicious reader. You and your families make weelicious what it is. You encouraged this book to happen and I hope it will bring you years of great lunch ideas.

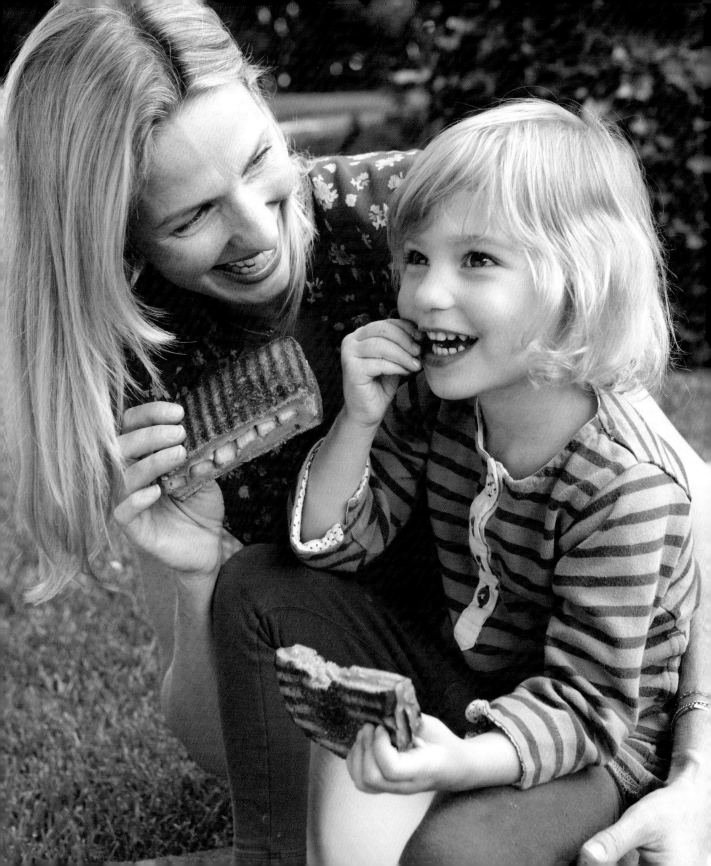

index

Note: Page references in *italics* indicate photographs.